# An Industrious Art

### Innovation in Pattern & Print at

# The Fabric Workshop

Edited by

Marion Boulton Stroud

The Fabric Workshop, Philadelphia, Pennsylvania

W. W. Norton & Company, New York • London

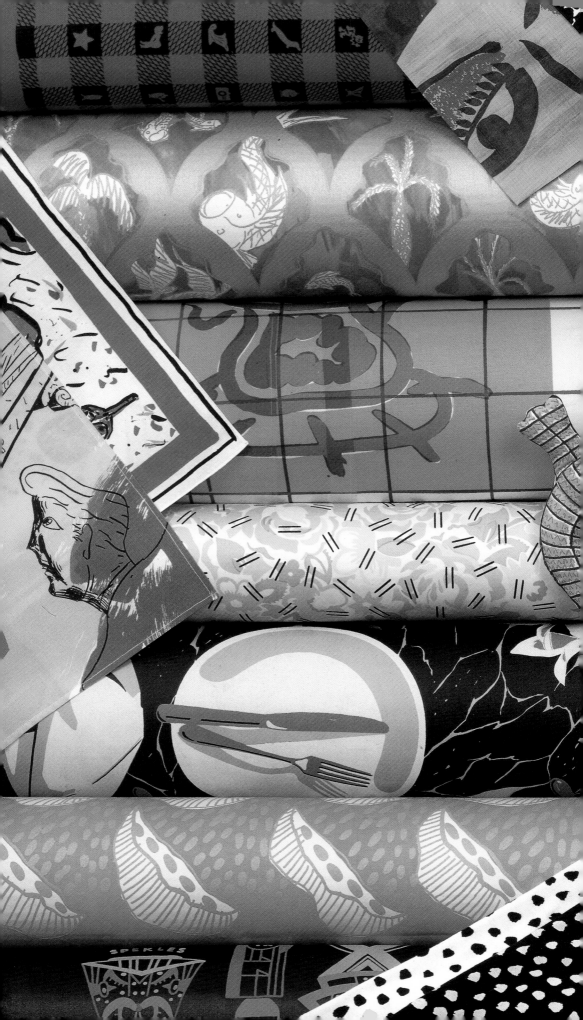

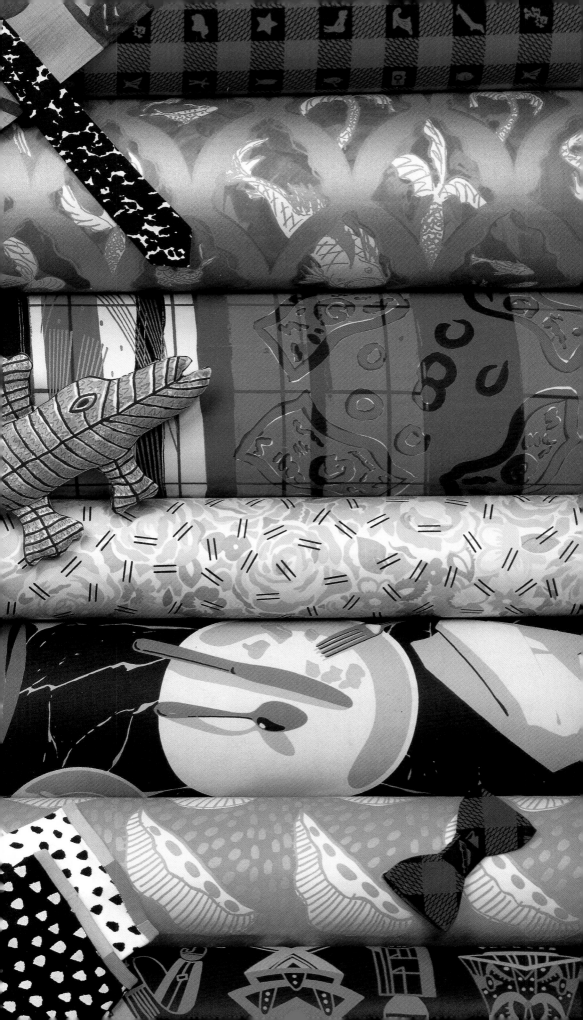

*Cloth Jacket*
**Kim MacConnel**
*Kim's Plaid,* 1978
Pigment on upholstery-weight natural cotton sateen
Width: 50 inches
In 1991, specially printed forty-four inches wide for the limited-edition cover of this book.

*Preceding pages, from top to bottom:*
Robert Venturi's *Notebook* necktie, Robert Kushner's *Louella* silk scarf, Harry Anderson's *Harry's Hunt,* Ned Smyth's *Pattern Palm,* Italo Scanga's *Vegetable* napkin, Pat Siler's *Blaster* scarf, Kim MacConnel's *Kim's Plaid,* Will Stokes, Jr.'s *Alligator,* Robert Venturi's *Grandmother* (with roses), John Moore's *Dinner* tablecloth, Frank Faulkner's peach *Pea Pods,* Jun Kaneko's white and black cotton shirts, and Karl Wirsum's *A Bird in the Hand Is Worth Two in the Bus* on black chintz.

The publication of this book is supported in part by funds from the National Endowment for the Arts, the Pennsylvania Council on the Arts, and Best Products Foundation.

*Original Design*
Phillip Unetic
*Design*
Katy Homans
*Principal photographer*
Will Brown
*Project Coordinator*
Anell Alexander
*Typography*
Duke & Company, Devon, Pennsylvania, and Trufont Typographers, Hicksville, New York, in Sabon and Univers
*Printing*
Nissha Printing Co., Ltd., Kyoto, Japan

First Edition

Library of Congress
Cataloging-in-Publication Data

An Industrious art : innovation in pattern and print at the Fabric Workshop.
    p.    cm.
    Includes index.
    1. Textile printing.    I. Fabric Workshop.
    TT852.I53    1991
    746—dc20            91-23503
                        CIP

ISBN 0-393-03057-1

The Fabric Workshop,
1100 Vine Street,
Philadelphia, PA 19107

W. W. Norton & Company, Inc.,
500 Fifth Avenue,
New York, NY 10110

W. W. Norton & Company, Ltd.,
10 Coptic Street,
London WC1A 1PU

Printed in Japan

1 2 3 4 5 6 7 8 9 0

Unless otherwise noted, all works are part of the permanent collection and museum archives of The Fabric Workshop.

Height precedes width precedes depth. Fabric yardage is measured from left to right, from one edge of the printed image to the other.

The date given is of the beginning of the project. The majority of the works in the catalog continue to be printed, sewn, or fabricated at The Fabric Workshop and are on display in the Workshop's museum sales shop as well as in galleries and museums around the world.

## Photography Credits

Robert Adelman (from *Life*): 27; Gregory Amenoff: 98; Tom Bernard: 28 (upper); Bob Bingham: 8 (upper); Jeff Blechman: 76; Will Brown: 2 (design, Phillip Unetic), 6, 12, 15, 16, 17, 18, 19, 20, 23 (upper), 24, 28 (lower), 29, 30, 31, 32, 34, 37, 38, 40, 41, 42, 43, 45, 46, 47, 48, 49, 51, 53 (upper), 54, 55, 56, 57, 59, 62 (lower), 63, 65, 67, 69, 70, 71, 73, 75, 77, 79, 81, 83, 85, 88 (lower), 89, 91, 92, 93, 95, 97, 102 (upper), 104, 106, 108, 109, 110, 112, 114, 115, 117, 118, 119, 193, 120, 121, 122, 180, 204, 210; Albert Chong: 84; John Condax: 14 (lower), 190; Dennis Cowley: 167; Dominic Episcopo: 9 (lower); Mary Anne Friel: 166, 192 (upper), 210 (lower), 220, 221; Ken Howard: 140, 141; Marie Keller: 135 (lower); Donald Lipski: 170; Martha Madigan: 53 (lower); Peter McClennan (for American Craft Museum, New York): 111; Eugene Mopsik: 10 (middle), 14 (middle), 208, 212; Simo Neri: 9 (upper); Dan Peeples (for *San Francisco Magazine*): 72; Princeton University Press: 185 (upper); Stan Rhys: 61; Christoph Scharff: 96; Marion Boulton Stroud: 13, 36, 39, 44, 50, 52, 64, 74, 78, 80, 86, 88 (upper), 90, 94, 102 (lower, middle), 116, 195; Pamela Vander Zwan: 8 (lower), 11 (lower), 22 (middle), 82, 129; Ken Winokur: 144; The Fabric Workshop staff: 10 (upper, lower), 11 (upper), 14 (upper), 21, 22 (upper and lower), 23 (lower), 58, 60, 62, 66, 103; photographs courtesy *Artforum* magazine and Blum Helman Gallery, New York: 15, 185, 186.

# Contents

# Foreword: An Industrious Art

Marion Boulton Stroud

This book documents nearly fourteen years of experimentation and adventure, during which artists, printers, apprentices, and patrons with vision have explored together the use of an industrial process—repeat yardage—as a new art form. In that time, the limits of this commonplace procedure have been stretched far beyond our expectations and hopes. Artists of all disciplines are now turning to our materials and techniques in their own work. Concurrently, industries of nearly every kind are pursuing artists, architects, and designers for a fresh approach. It's been amazing and gratifying to witness these developments.

When we started The Fabric Workshop, in 1977, our goal was to explore, to take liberties, to be a studio and laboratory of new design, unhampered by rules and precedents. The same is still true today. When an artist agrees to work with us, it's important that he or she has the courage to enter into this spirit of adventure, to dive in and try something new. Artists may be well known in their fields, but when they first work with us, they're often students again, away from their studios and customary materials. Soon, though, our visiting artists realize that we at the Workshop—printers, staff, apprentices—want to learn from *them*, to see the world through *their* eyes, so our collaborations can be most effective. We often say that we want to help them make the best work they have ever made; and our archival collection of more than 2,200 objects reflects this. In this sense, everyone at the Workshop is an artist. Our common vision, our excitement over the projects at hand, and the feeling of a family working together to create something new and beautiful have always been at the heart of what we do.

This enthusiasm, the willingness to work on a project well beyond "regular hours," is one of the most valuable examples we can give the apprentices who train with us. As everyone knows who is familiar with the Workshop, in addition to the artist-in-residence and exhibition programs one of our primary goals is education, to teach fabric printing to inner-city youth and place them in industry. They are the backbone of the program and the strength from which the concept of the Workshop first developed. Most apprentices are selected by portfolio, reference, and application from Philadelphia high schools, although we have also trained numerous college and graduate-level students (including a sixty-year-old nun from Dublin). They learn all phases of print production in one- to three-color printing. Before they are even halfway through their apprenticeship, the master printers have taught them how to put their designs onto acetates, the principles of trap and overlay, how to shoot screens on a vacuum frame, how to pin the fabric to the print tables, how to mix the pigments or dyes, how to print, heat set, and sew. They even help our office staff with the crucial business (for art is also a business) of mailings, solicitations, sales, gallery tours, and working in the museum archives, gallery, and sales shop. If we have an order for Italo Scanga napkins (pp. 114–15, 58–59) or Betty Woodman fabric for tablecloths, or an order for upholstery or perhaps wallpaper (p. 14), canvas bags, or silk scarves, we're proud to say that the advanced apprentices are able to do it all on their own. They are also able to sew their own fabrics into banners and help price them for sale at our annual apprentices' exhibition. It's always exciting when former apprentices come back and tell us that they've found a teaching position or have a job with firms like J. G. Hook, Jack Lenor Larsen, and Fieldcrest Cannon.

**Dale Chihuly**
Untitled scarves, 1989
Acid dyes on silk crepe de chine
Each 96 x 20 inches
Produced in various colors and silks, including crepe de chine, Jacquard, and charmeuse. Image derived from the Venetian series; also done by the color-discharge printing technique.

Sculptor Mark diSuvero handpaints with water-based pigments on a muslin prototype for his white wool cape, 1987.

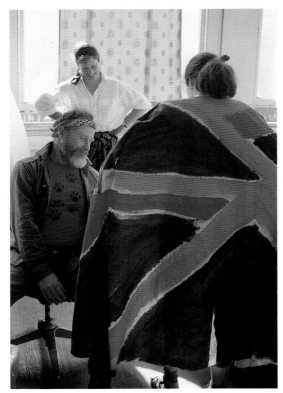

Mark diSuvero and Marion Boulton Stroud, artistic director, with model, 1987.

Some apprentices stay on with us and become master printers. Most of our master printers are already professional artists who have put their own careers on hold to help the visiting artists. It's demanding work for, in addition to their other duties, our printers are teachers and mediators, coordinating the work of the apprentices and being available to resident artists day and night—answering questions, making fast technical changes on request, even entertaining them into the wee hours of the morning. Often, I've found one of our master printers asleep on the couch late at night, waiting to take the dyes out of the steamer. Or another master printer may show up at dawn because the newly made gray felt needs to be treated once more before the artist, Ursula von Rydingsvärd, arrives. This goes on all the time. The artists are invariably grateful that we do so much of the technical work for them. They may be frustrated at times by the limita-tions of the medium—and they are always surprised at how labor-inten-sive the process is—but it's forever rewarding when the work comes together, is shown in a museum or gallery, and we can say, "Wow! We did it together." It was the artist's idea, but we all made it happen.

**David Ireland**
*Dumb Ball,* 1988 (in process)
Hand-thrown cement
Diameter: 4 inches

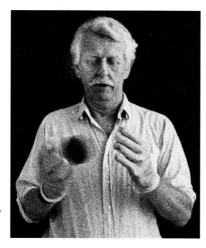

Aoko Omwony, an apprentice from Kenya, models her coat, newly printed, dyed, and sewn, at the 1989 benefit.

The artists who work with us are selected by the artistic director and a committee of curators, museum heads, and other artists. We pool our mailing lists for suggestions, often drawing from the artists who have worked with us before, but we are always searching in new directions—among architects, for example, and industrial and graphic designers. When we've made our decision, we invite the artists by phone. Usually they agree, but a few apologize and say they haven't any ideas or they aren't interested or are too busy. I've learned not to take no for an answer. In 1984, after Red

Grooms declined our invitation, an envelope arrived from him with a drawing of a baby elephant inside. He and Lysiane Luong had just returned from a Nile trip that inspired *Tut's Fever,* a series of objects done in the Egyptian style, including a man's traveling suit bag in the form of a mummy and a chaircover with Rita Hayworth as Queen Nefertiti (pp. 152–53). Richard Tuttle also said no at first, but then sent us a pattern of hand prints, which began a twelve-year series of conceptual patterns (pp. 56–57).

It doesn't take long for new artists to become incorporated into the Workshop family. We eat with them, we go to their openings and studios, and we help them communicate their personal vision to the larger art world. Essentially, all we ask in return is that they become problem solvers with us in the new medium. Things happen so fast on so many levels here that we feel as though we're continually reinventing the wheel on every new project we undertake.

As in any family, we have had our moments of hilarity, hysteria, and sadness. Karl Wirsum arrived by train from Chicago wearing cotton, anti-noise-pollution earplugs, and splendidly dissimilar socks. He was carrying a tiny blue airplane made from a child's shirt, with a white bow tie for a propeller. While he was with us, Karl made another, gigantic printed airplane and "nightmare" pajamas—satanic figures in Day-Glo pink on shiny, black cotton (pp. 10, 16–17). For me, the nightmare came at the end of his visit when I delivered Karl to the station with only moments to spare. I rushed his bags onto the train, but when I looked around, there was no Karl. He was still in the parking lot, trying to extricate his plane from my car. Only a heart-stopping leap from the moving train saved me from an unnecessary trip to Chicago. Karl caught the train the next day.

Chicago artist Karl Wirsum with his model airplanes, the smaller of which is made from a child's shirt, with a bow-tie propeller, 1987.

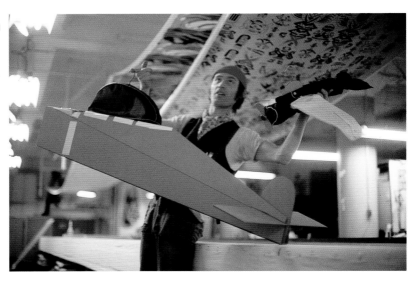

In his studio at The Fabric Workshop, Will Stokes, Jr., paints his umbrella pattern with pigment on cotton sateen, 1988.

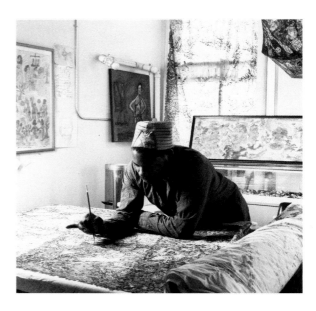

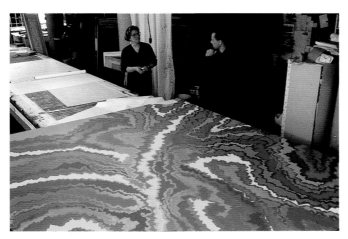

Visiting artist Houston Conwill discusses his street umbrella project *Second Lining* (height, 80 inches; diameter, 108 inches) with master printer Elizabeth McIlvaine, 1987.

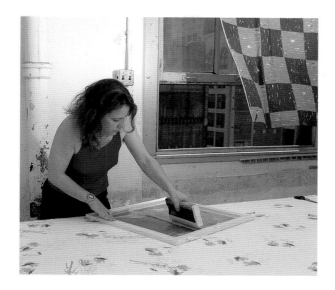

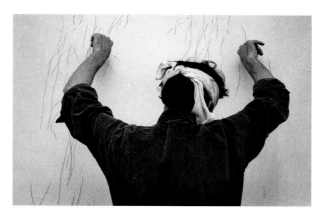

With a small hand-registered silkscreen and squeegee, Louisiana artist Tina Girouard prints a series of forty test fabric designs for her Poteau Mitan apparel line, 1987.

William Anastasi in his New York studio, blindfolded, draws on frosted acetate for his *Same Salt I—V*, 1986.

scarves, a realistic, pink nosebleed. (We had to print the edition of 150 scarves over again and steam them ourselves.) And there was our benefit at the Athenaeum, in Philadelphia, when we discovered that the ice for drinks, kept in Workshop tubs, had turned a brilliant blue from our dyes.

We have managed to regain our equilibrium after crises great and small. A typical day at the Workshop is like playing football or baseball; we rely on good reflexes to deal with what's happening at the moment— so much happens and so fast. Still, some setbacks will never be resolved. Recently, we lost our good friends Scott Burton and Phillip Warner to AIDS. Both were generous supporters and promoters of the Workshop. I remember the time, in our early days, when Scott braved a blizzard to come down from New York to do his own work and help out on our benefit performance with the Pennsylvania Ballet (p. 197). He also gave us wonderful ideas for our first show, at Patterson College, including mannequins in the gallery to "populate" the crowd at the opening! Phillip Warner, who was a designer at Jack Lenor Larsen, Inc., gave free lectures to art students about possible careers in the fabric industry (p. 137).

We can no longer call Scott and Phillip for advice. We must carry on without their wisdom and enthusiasm. Yet, we do carry on, encouraged by the generosity of supporters, public and private, and by the evidence that The Fabric Workshop is making a difference. Last winter, I went to the post office to mail a grant proposal and bumped into one of our first apprentices, Margarita Mercado. She had a secure and interesting job working as a graphic artist for the U.S. Postal Service. These gratifying moments show that the Workshop really makes a difference in people's lives.

Houston Conwill was another artist who operated in unpredictable and sometimes mysterious ways. He had us disassemble our light tables to accommodate a huge painting that was a study for his installation of enormous street umbrellas (p. 10). He preferred working at night and on weekends with apprentices Louis Williams and Will Stokes, Jr., who, by the time Houston finished, felt as though they had collaborated on the Sistine Chapel ceiling.

There are many more ups and downs in our family history. I remember Ms. Zhou, "Miss Jo," an artist from Tianjin, China, who spoke no English and therefore was unable to warn our printer that riding in the car was making her carsick. We will never forget the time a commercial dye-steaming company gave Robert Kushner's portrait of *Louella* (p. 32), intended for an edition of silk

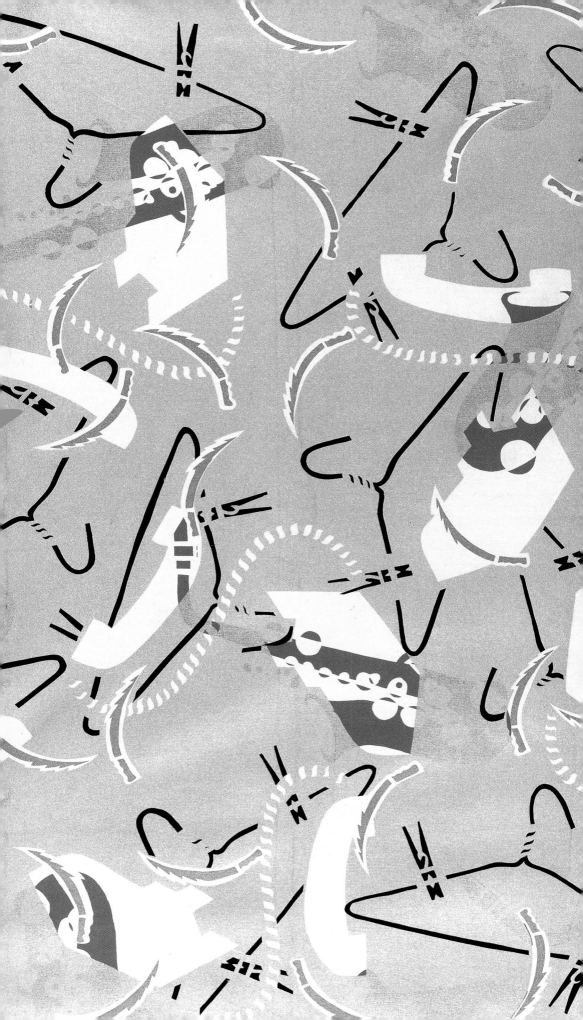

# Acknowledgments
Marion Boulton Stroud

**Tina Girouard**
*Tools* banner, 1984
Pigment on cotton
sateen (white colorway)
Width: 50 inches

We wish to acknowledge the individuals who played an active role in the creation of this book, without whom we could not offer as complete a view of the fourteen-year history of The Fabric Workshop.

A special thanks to our designer, Katy Homans, whose vision has seen us through. Phillip Unetic, the creator of award-winning publications for the Workshop, was an early participant in the design process. Our photographer of fourteen years, Will Brown, created the majority of images that brighten these pages. Eugene Mopsik, who took many of the candid shots, added a strong personal touch.

Paula Marincola, as editorial consultant, was instrumental in shaping the book. Gerald Zeigerman edited the text. Sam Young provided invaluable editorial advice. Project coordinator Anell Alexander did an exemplary job compiling the manuscript copy and photographic record.

*An Industrious Art* is more than a series of visual images; it is the history of the Workshop—the sum of its activities made possible by the artistic and administrative staff as well as the countless artists, friends, and volunteers who have worked in so many capacities. The Workshop is also very proud of its apprentice

program, the dedicated people who have come from around the world— Kenya, China, Japan, the Netherlands—and, during their time with us, given so extraordinarily of themselves.

The following is a list of the many individuals, both past and present, who have helped the Workshop. They represent the industrial and print talents we have drawn on as resources; our administrative and artistic staff, including the master printers, construction and installation technicians, and design workers; members of the advisory board and board of directors; and sundry and vital others: Doina Adam, Theodore Aronson, Penny Balkin Bach, Ingrid Bachman, Joel Bacon, Mimi Balderston, Steven Beyer, Grace Bishko, Tracey Blackman, Joan Blaine, Jill Bonovitz, Sheldon Bonovitz, Nancy Bove, Michele Bregande, Moe Brooker, Kathan Brown, Stewart Cades, Mark Campbell, James Carpenter, Paolo Colombo, Mary Jeanne Connors, Diene Cooper, Helen Cunningham, Carolyn Curran, Randall Dalton, Marcella De Keyser, Anne d'Harnoncourt, Daniel Dietrich II, Margo Dolan, Bob Douglas, Matthew Drutt, Allan Edmunds, Ann Edmunds, Letty Lou Eisenhauer, Gee Elliot, Helen Drutt English, Kim Erskine, Charles Fahlen, Chris Fahlen, Noelle Fahlen, Eugene Feld-

Master printers, sewers, and apprentices at a 1988 staff party. From left: Rebekah Lord, Maritza Mosquera, Betsy Damos, Mary Anne Friel, Robert Smith, Will Stokes, Jr., Louis Williams, Cassandra Lozano.

14

Master printers Robert
Smith and Lucile
Michels print Roy
Lichtenstein's silk shirt,
1979.

Robert Smith (in
background) and an
apprentice inspect
their off-register
printing technique of
green fluorescent over
white blockout on
black cotton canvas by
Steve Keister, 1983.

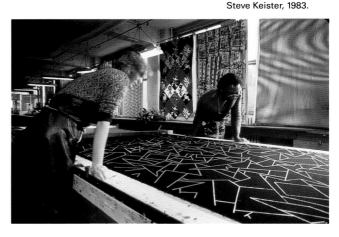

From left: Anne
d'Harnoncourt, then
curator of twentieth-
century art at the
Philadelphia Museum
of Art and now the
museum's director;
Marion Boulton Stroud,
artistic director of The
Fabric Workshop;
Janet Kardon, then
director of the Institute
of Contemporary Art
and now director of
the American Craft
Museum; Sara Wood,
former president of
The Fabric Workshop;
and Helen Cunningham
(hidden in Jeff Way's
costume), former
Workshop director of
development; 1978.

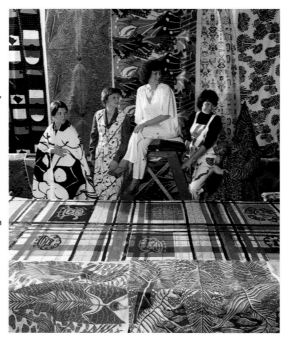

**Steve Keister**
*USO #76,* 1981
Fluorescent pigment
and acrylic paint on
cotton canvas and
plywood
47½ x 27 x 26 inches

man, Rosina Feldman, Sherry Feldman, Stuart Feldman, Carol Fertig, Anne Freeman, Annette Friedland, Mary Anne Friel, Carl Fudge, Vivian Gast, Claudia Gatling, Sarah Goldfine, Megan Granda, Amelia Grazioso, Oscar Gunther, Kathy Halton, Deborah Heap-of-Birds, Charlotte Herring, Katherine Hiesinger, Dina Levy Hitchcock, Elizabeth Hopkins, Steve Izenour, Homer Jackson, Richard Jaffe, Barbara Johnson, Diane Karp, Marie Keller, Jane Korman, Brigitte Krauss, Joan Kremer, Meredith Kurtzman, Yuk Yin Lam, Gerrit Lansing, Sydie Lansing, Jack Lenor Larsen, Betty Leacraft-Cameron, Mrs. B. Herbert Lee, Eugene Lefevre, Caroline Leland, Judy Lieb, Nathaniel Lieb, Betsy Lightbourn, Shanna Linn, Gates Lloyd, H. Gates Lloyd, III, Lallie Lloyd, Martie Lobb, Bill Longhauser, Elsa Longhauser, Rebekah Lord, Cassandra Lozano, Judith Lyczyko, George Marcus, Virgil Marti, Jay Massey, Mary MacGregor Mather, Elizabeth McIlvaine, James Melchert, Lucile Michels, Harvey S. Shipley Miller, Samuel Miller, John Moore, Toshiko Mori, Peter Morrin, Roland Morris, Martiza Mosquera, Benjamin Neilson, Robin Nemlich, Ann Ollman, John Ollman, Kathryn Ollman, Doris Palca, Erin Parish, Sue Patterson, Ann Percy, Lisa Phillips, Jody Pinto, Helaine Posner, Cynthia Porter, Michael Quigley, Carolyn Ray, Jenny Reeve, Joseph Rishel, Christina Roberts, Annabeth Rosen, Eileen Rosenau, Laura Rosenthal, Patsy Rugart, Bill Rumley, Betye Saar, Audrey Sabol, Italo Scanga, Ella Schaap, Marianne Schoettle, Carl Shaw, Anne Sims, Bruce Slaff, Stephanie Smedley, Robert Smith, Katherine Sokolnikoff, Silvano Solé, Liz Spungen, Jonathan Stein, Judith Stein, Marilyn Steinbright, Christopher Stewart, Will Stokes, Jr., Arthur Strassler, Alice Strickland, Mark Thompson, Barbara Toll, Stephanie Tyiska, Susan van Campen, Tim van Campen, Diane Perry Vanderlip, Pamela Vander Zwan, Bertha von Moschzisker, Karen Wagner, Emily Wallace, Maurice Weintraub, John Wessel, Anne Wetzel, Joyce Wiener, Ed Wilson, Ellen Wolf, Walter Wolf, Acey Wolgin, Michael Womack, Sara Wood, William P. Wood, Betty Woodman, Laura Lee Woods, Larry Wright, and Claire Zeisler.

We especially wish to thank the National Endowment for the Arts, the Pennsylvania Council on the Arts, and Best Products Foundation for their generous support. We also wish to acknowledge the Stroud and Rosengarten families for making so many of the activities at The Fabric Workshop possible.

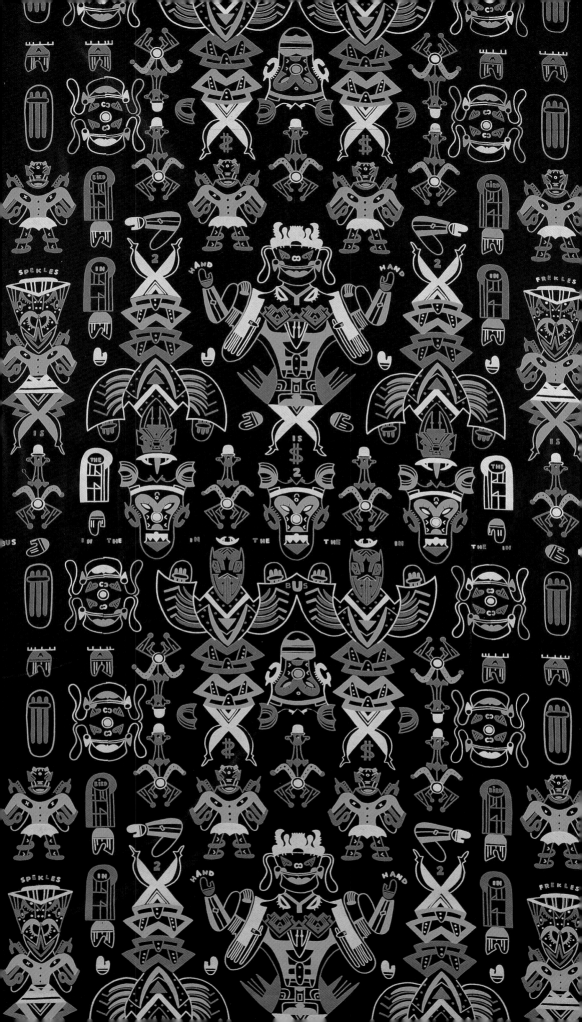

# A Decade of Fabric and Art
Charles Stuckey

**Karl Wirsum**
*A Bird in the Hand Is Worth Two in the Bus*
banner, 1978
Pigments printed on prechintzed cotton
Width: 50 inches

When she founded The Fabric Workshop in Philadelphia, in 1977, Marion Boulton Stroud surreptitiously left out any reference to art in its name. Yet, that is all that The Fabric Workshop has been, or ever will be, about. Conceived as two interlocking programs, one to train apprentices in textile design and production, the other to serve artists interested in experimenting with fabric, the Workshop has achieved an international reputation with the wide range of original and beautiful artworks produced there during its initial decade.

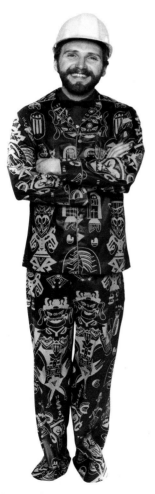

Michael Quigley, former director of The Fabric Workshop (1979–84), wears pajamas made from Wirsum's design.

Part imp, part impresario, Stroud has gone everywhere to scout artists at work in every medium, young and old, luring many of the best to fulfill some special project at The Fabric Workshop. Her administrative role is hardly less exacting or creative than the actual resulting collaborative fabric production. Although there are exceptions to the rule, many busy artists are at first reluctant to try fabric as a medium of self-expression, and some others need to be convinced that the expressive range of decorative-arts projects is no more limited than that of any other art form. Fundamentally, Stroud believes that there are neither great painters nor great architects nor great ceramists—rather, that there are only great artists who have the ability to extend whatever form of expression that they use.

Faced with the challenge of such extraordinary precedents as the tapestries designed in the 1960s by Alexander Calder, a sculptor foremost, Stroud has encouraged several sculptors to project their remarkable attitudes toward plasticity onto two-dimensional fabric skins. Extending the conceptual premises of his furniture sculpture, Scott Burton designed his *Window Curtains* (1978) (pp. 44–45), which was among the Workshop's earliest triumphs, to stress the plastic architectural role of all furnishings. Much more recently, Louise Nevelson, whose dedicated investigation of shadowy silhouettes resulted in massive sculptures that somehow appear to be kinetic, created *Opera Costume* (1985) at the Workshop (pp. 140–41), translating her unique vision into a new format that literally enfolds the singer's body movements.

Artists responding to urgent social and ethical issues are especially well positioned to make the most of the Workshop's utilitarian art priorities. For example, Robert Morris's 1981 *Restless Sleepers/Atomic Shroud* design for sheets and pillowcases (pp. 60–61, 198) is an invitation for an art spectator to literally get into

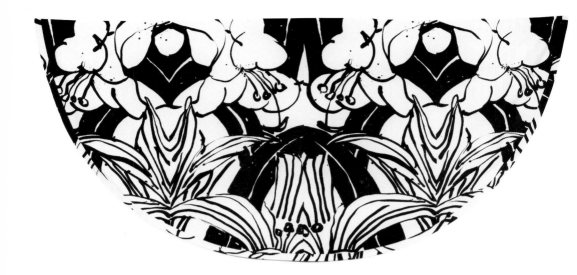

**Robert Kushner**
*Lilies* cape, 1977
Pigment on unbleached
cotton twill
54 x 108 inches

bed with the artist's imagination, sharing its worst nightmares. And Rebecca Howland's 1984 *Toxicological Tablecloth* (p. 120) invites a would-be diner/spectator to confront wrongheaded attitudes toward health and ecology, no matter how out of place such issues may be regarded at the dinner table. A complete setting, comprising a tablecloth printed with abstract diagrams of petrochemical formations and deformations, along with ceramic ashtrays in the form of cancerous lungs and cups in the form of barrels for toxic wastes, Howland's "sculpture" demonstrates how the Workshop can serve as a catalyst for biting satire. Recently, Tim Rollins, who often makes art based on great books, executed a white, unisex dress shirt in the spirit of Nathaniel Hawthorne's *Scarlet Letter* (p. 89). To try on this item is an admission of the "A" for adulterer/adulteress that resides, unfortunately, somewhere in nearly everyone's guilty fantasies.

Like the sculptors, the ceramic artists who have undertaken projects at The Fabric Workshop have taken advantage of the special opportunity it provides to extend their most basic premises. For example, Jun Kaneko's canvas *Bag* (1980), one of

the best selling of all the objects produced by The Fabric Workshop, amounts to a flexible portable vase (p. 117). No less extraordinary, Mineo Mizuno's *Peppers* tablecloth and napkins (1979) was conceived in tandem with dinnerware decorated with an identical design (p. 19), with the result that the characteristics of the two genres integrate into a single visual continuum.

Just this sort of continuity between object and context, or figure and ground, has fascinated scores of twentieth-century artists with a sensitivity to fabric from Vuillard and Matisse, whose genre and still-life paintings portray a utopian world enriched with printed textiles, to Robert Rauschenberg, in whose antic assemblages everything from broken-down umbrellas to photographs of astronauts are brought together into quiltwork. Faced with such a rich tradition, the painters or image-oriented artists who have carried out projects at the Workshop have produced some of the most exciting works of all. Creating in fabric has allowed such artists as

**Mineo Mizuno**
*Peppers* tablecloth and
napkins, 1980
Pigment on cotton
sateen (green
colorway), with
matching ceramics by
the artist
Tablecloth:
46 x 46 inches
Napkins: 18 x 18 inches

Robert Morris, Gladys Nilsson, and Karl Wirsum to translate erotic or nightmare visions into the literal, functional realms of bed sheets or pajamas. The results rival, if they do not surpass, some of the conventional art objects made by the same artists with the same images in other media. Of course, for such so-called pattern and decoration artists as Robert Kushner (p. 18), Brad Davis (p. 40), and Ned Smyth (pp. 148–49), whose paintings and sculptures are extensions of their Matisselike obsession with the abstract, pictorial, and cultural implications of repeat patterns, working with fabric is an ideological fulfillment, and their Fabric Workshop projects are especially exuberant.

At the enlightened suggestion of Patterson Sims, the Workshop invited more than two dozen artists (the number keeps growing) to design umbrellas for a special touring exhibition entitled "Rain of Talent: Umbrella Art" (pp. 106–11), which opened in 1989 and is still touring museums around the country. My own favorites so far include the surrealistic umbrella designed by Richard Haas to look like a shingled shack roof (p. 110), with tin patches as a symbol of any umbrella's functional shortcomings, and the even

more fanciful one designed by sculptor Claire Zeisler. Called *Reigning Roses,* Zeisler's umbrella has a long fringe all around its rim, similar to the hanging fringes on Nigerian headdresses. In this case, however, the long threads look like falling raindrops and amount to a sort of raincoat extension of the more limited everyday "artless" umbrella (p. 109).

Opening her Workshop to more than two hundred artists in the past years, Stroud has maintained, if not initiated, a dialogue between the fine arts and the stuffs of life. Stroud created The Fabric Workshop expressly to continue this ongoing dialogue about fabric and art, hurrying the day, utopian that she is at heart, when all of us can dress, eat, sleep, and live surrounded by works of art to suit every mood and need.

# The Context of Creativity
Richard Siegesmund

**Ned Smyth**
*Pattern Palm* banner,
1979
Metallic pigment over
marbled background
on upholstery-weight
cotton sateen (blue
colorway)
Width: 48 inches

When The Fabric Workshop was first conceptualized, crafts was generally considered a lesser medium and not in the purview of most museums devoted to the serious explication of fine art. The Workshop consciously set out to challenge these traditional boundaries between art and craft, and its growth and success in doing so over fourteen years is based on many factors.

The Workshop owes its founding and continuing vision to the energy of its artistic director, Marion Boulton Stroud (p. 8). For her, the Workshop has been a labor of love. A significant part of her skill in building this dream has been her ability to draw on the resources around her. In this regard, the city of Philadelphia itself has been a wellspring that has nurtured the Workshop.

Philadelphia has provided a historic sensitivity to the creative ideas that the Workshop has chosen to engage. As the home of Frank Furness, Moore College of Art and Design, and the University of the Arts, Philadelphia is a historic center for the Arts and Crafts movement. Even though the principles of the movement had been in general decline since the rise of modernism, the Workshop unabashedly adopted many of the movement's ideals. Besides the obvious concerns with the aesthetics of the functional ob-

ject, it is no coincidence that the issues of the empowerment of women and people of culturally diverse heritage, so central to the Arts and Crafts movement, are also at the conceptual center of the Workshop's activities.

At the same time, from the Duchamp collection in the Philadelphia Museum of Art to the work of architects Robert Venturi and Denise Scott Brown (p. 27), Philadelphia has been home to some of the great pioneering spirits of modern art. The Workshop has consciously attempted to fuse these traditions in order to create a distinctive position in the art world.

On a practical level, the city's heritage from the turn of the century, as a center for light industry, has left an extraordinary inventory of attainable space in Center City (the downtown area) where the arts are free to experiment and flourish. This legacy has provided the physical space in which to be adventurous—including the accommodation of the twenty-five-yard-long print tables that are necessary for handprinting textiles—while the Workshop's accessibility to the general public has allowed it to build an audience for its activities.

Contemporary Philadelphia is home to three major art museums and five art schools, as well as one of the most vigorous artistic communities in the United States. This base has provided the skilled and knowledgeable artists who have served on the Workshop's technical staff and given so much of themselves to realize the ambitions of the Workshop's artists-in-residence. Philadelphia also has a well-educated contemporary art audience, and this audience has responded with the institutional support that has in turn converted the ambitions of the organization to reality.

From its beginnings, with a grant from the National Endowment for the Arts to underwrite a series of fabric printing workshops, the Workshop has built on these resources to explore the ambiguous territory

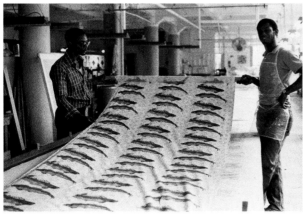

Master printer Robert
Smith (left) and
workshop assistant
Homer Jackson air dry
Robert Smith's *Fish*
design, 1978.

Robert Smith
demonstrates the color
registration of Edna
Andrade's *Maze*
acetates during a
tour for high school
students, 1988.

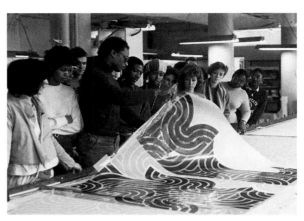

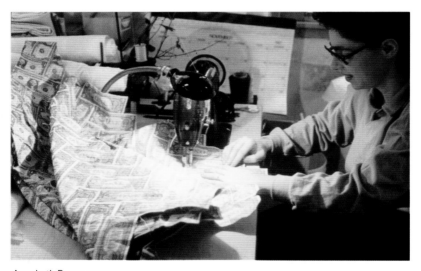

Annabeth Rosen sews
dollar bills into money
dress by Ken Dawson
Little, 1987.

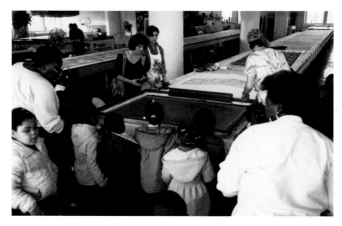

Education coordinator
Maritza Mosquera
conducts a children's
tour of the Workshop,
1989.

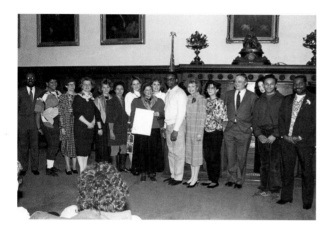

Workshop supporters improvise with cloth at the 1981 benefit at the Athenaeum of Philadelphia. Among them: Bonnie Wintersteen (far left), former president, Philadelphia Museum of Art; Lallie Lloyd (far right), founder of Philadelphia's Institute of Contemporary Art; and Joe Rishel (kneeling, far right), curator of European painting at the Philadelphia Museum of Art.

Marion Boulton Stroud and staff receive a certificate of recognition from the City of Philadelphia at City Hall, 1986.

reconsider the possible place of such textiles within the context of the formal museum. Not only has the work created here been exhibited by such leading national institutions as the Museum of Modern Art, the Philadelphia Museum of Art, and the Art Institute of Chicago, but it has also figured in experimental productions at the Kitchen, the Walker Art Center, M.I.T.'s List Visual Arts Center (p. 144), and the Washington Project for the Arts, among other noted platforms of the avant-garde.

As the Workshop faces the future, it finds the sensibility of many in the art world aligned with its long-standing values and perceptions. The Workshop never intended its work to be tangential; that its productions are now generally considered to be within the mainstream of contemporary art is exciting, but it represents a new challenge as well. Success, and the attention it brings, can never be allowed to impinge on the free and open reign of experimentation—with its inherent risk of failure—which has served the Workshop so well over its first fourteen years.

between craft and high art. That course has been maintained through the continuing assumption that any artist who comes to the Workshop—painter, sculptor, architect, ceramist, or filmmaker—is creating work within the mainstream of contemporary art. The artists have led the Workshop in totally unexpected ways—from the first experiments in repeat patterns by Robert Kushner to the unique sculpture of Ursula von Rydingsvärd and the site-specific installations of David Ireland.

This record of experimentation has earned the Workshop a reputation as a major center for the creation of new art in the United States. The Fabric Workshop has cut across preexisting definitions and, through the force of the images and objects created in its studio, compelled artists, curators, and art audiences to

Each artist who comes to The Fabric Workshop and embraces its collaborative process redefines the institution as well as his or her own art. The discovery of aesthetic possibilities and applications, by searching out the artist's ideas, is the daily activity. The unbridled exploration of potential within the creative process has been and will continue to be the essence of the organization.

# Design for Living
Paula Marincola

**Robert Venturi,**
of Venturi, Rauch and
Scott Brown, Inc.
*Grandmother* banner,
1983
Pigment on cotton
sateen
Width: 56 inches

Robert Venturi and Denise Scott Brown are partners in the internationally recognized, award-winning architectural design firm Venturi, Scott Brown and Associates. Based in Philadelphia, their influence as architectural theoreticians and practitioners has been far-reaching; they have exerted a significant influence on a new generation of architects and designers. Their books *Complexity and Contradiction in Architecture* and *Learning from Las Vegas,* the latter written in collaboration with Steven Izenour, have been seminal texts in the development of postmodern architectural theory.

Venturi and Scott Brown's work has reached beyond the restrictive tenets of modernism to offer a new context for reconsidering the importance of both historical styles and the vernacular on building. Venturi's reformulation of Mies van der Rohe's famous dictum from "less is more" to "less is a bore" is given realization in architecture that embraces complexity and contradiction and generally counterbalances the polemical with a sophisticated playfulness.

The spectrum of Venturi and Scott Brown's professional activities is broad and diverse, encompassing city planning projects as well as exhibition and graphic design. Completed architectural projects that have generated critical attention include the early Guild House, in Philadelphia; Vanna House, for Venturi's mother, in Chestnut Hill, Philadelphia; the exterior facade design for Best Products, Oxford Valley, Pennsylvania (p. 28); the restoration of Franklin Court, in Philadelphia; and Gordon Wu Hall for Princeton University. City planning studies include a preservation planning strategy for Jim Thorpe, Pennsylvania, and a preliminary design for a prototypical neighborhood and community shopping centers for Saga Harbor, a new community south of Miami. Among the firm's current list of notable architectural projects are a new building for the Seattle Art Museum, a wing onto the National Gallery, in London, and extensive design and building projects for the Philadelphia Museum of Art and Princeton University.

The 1980s particularly witnessed a proliferation of interest on the part of both architects and artists in the design arts. Venturi and Scott Brown have been an integral part of this movement and closely involved with various aspects of design over the last ten years. They have, for example, designed museum exhibitions of sculpture, painting, furniture, antiques, and decorative objects, such as "High Styles: 20th-Century American Design," for the Whitney Museum of American Art, in New York City, and "Contemporary American Realism since 1960," at the Pennsylvania Academy of the Fine Arts, in Philadelphia.

From 1980 to 1982, they brought their distinctive vision to The Fabric Workshop, where Venturi produced *Grandmother* and *Notebook* (pp. 24, 30). While *Grandmother* was created for Knoll International, and *Notebook* for the Workshop, both these fabrics were developed and perfected with the expertise and assistance of the Workshop's master printers and staff. Subsequent decorative-arts projects have included a silver tea service for Alessi International, glassware, candlesticks, and china for Swid Powell (p. 31), bed linens for Fieldcrest Cannon, as well as The Venturi Collection for Knoll (p. 29)—a series of chairs, tables, and a sofa that, in their creator's words, "break the boundary between traditional and modern design by adapting a series of historical styles to industrial processes." The conceptual and formal characteristics of Venturi and Scott Brown's buildings—an interest in pattern, historical quotation within a modern idiom, and an almost mannerist juxtaposition of scale—are also evident in their fabrics, housewares, and furniture.

The following excerpts are distilled from an extensive interview conducted in March 1990. The complete transcription is in the archives of The Fabric Workshop.

# Architecture, Design, Fabric
Observations by
Robert Venturi and
Denise Scott Brown

I.

**Robert Venturi**: As a designer, it's quite difficult for me to move between architecture and furniture. The differences in scale are crucial. A building, no matter how refined, is much cruder than a piece of furniture—particularly a chair that must accommodate the body.

**Denise Scott Brown**: As urbanistic architects, we work at several scales at the same time. When designing a house, we may consider the pattern of the fabric on a chair as well as the neighborhood the house is in, and we may view pattern and neighborhood from several vantage points. This is the urban designer's way. One moves along on three or four different fronts at the same time. For us, one of the fronts is the decorative arts, including fabrics.

**RV**: For pattern, I often refer to the work of Frank Furness; Philadelphia itself has had a great influence on me as an architect. Growing up in the city, the Philadelphia Museum of Art was one of my favorite buildings. Although one doesn't usually consider this building for its pattern, the ornamental capitals and friezes adorning the facade involve both pattern and color as part of the tradition of Greek temple architecture. The Philadelphia Museum of Art is with me all the time; it's in my consciousness. I'm sure it's because I loved it as a child.

Within the museum, the historical rooms were more important to me than the paintings, because I was oriented toward architecture and furniture. I've always loved furniture. My parents loved it, too; my mother collected books on the subject. If I were rich, with plenty of time for leisure, I'd collect furniture and decorative arts.

Learning to design furniture was frustrating and maddening, and it

has taken me a long time. In architecture—now that Denise and I have decades of experience—ideas come relatively quickly, and occasionally we can take shortcuts; but at the scale of the furniture, that's harder to do.

**DSB**: My earliest memory of color and pattern goes back to kindergarten. My South African kindergarten, in the 1930s, gave children pattern sets like the ones Frank Lloyd Wright played with as a child in the 1870s. The shiny, colored papers that one interwove to make patterns excited me very much.

The history of architecture was a subject I learned in books, for most of the architecture of Johannesburg was new. The city had fine Edwardian classical and Art Deco architecture; when I went back, I thought the buildings were stupendous, but growing up, they were just background. As a child, Modern architecture was very important to me, as were African architecture and art, and particularly fabrics.

Our working approach to history developed, in part, out of the social critiques of the 1960s and is tied to cultural relevance. One should borrow from history discriminatingly, bearing in mind the client and the scale one is working in. For the design of a house outside Princeton for a professor of French history, the French architect Ledoux may be a good source. Ledoux wouldn't be the appropriate inspiration for a house in a typical American suburb; housing imagery in America derives largely from the Italian architect Palladio—from the Palladian villa via the English country house and Mount Vernon.

When I'm working on something highly cerebral, I need fabrics to maintain a balance. I like the fingertip feel of fabric, and pattern and color are as exciting to me as when I was a child.

I adore Fortuny. The way his dress designs correspond to their fabrics appeals to my architectural taste. There are parallels between the detailing of clothes and the detailing of

Robert Venturi and Denise Scott Brown with *Queen Anne Chair* (left), 1979, and *Empire Chair,* 1979. Denise Scott Brown wears the *Grandmother* dress she designed.

architecture. For instance, both piping in fabric and beading in architecture join two surfaces. Sometimes, Fortuny literally used beads to make his piping. Sally Hammerman, the clothing designer, and I had great fun designing a coat to be made from our woven couch fabric, *Tapestry.* To hold the heavy fabric, we evolved structural details that produced a type of clothing architecture.

**RV:** When we went to Japan, we were genuinely surprised by the richness in the tradition of pattern and color. In this century, Western architects have emphasized the simplicity of Japanese traditional architecture, but they've ignored its counterpoint in the multiplicity of pattern and color that one finds in Japanese fabrics and objects. At the moment, this counterpoint intrigues us. I think the Japanese have a stronger tradition of pattern than any other nation. They also have an enormous love and respect for small objects of design of all kinds. When we came back, we were laden with perhaps two hundred small objects—ladies' hairpins, dolls, chopsticks, chopstick holders, toys, kimonos, and especially pottery and fabrics.

Japan inspired us. I want to continue to design decorative arts of all kinds.

**II.**

**DSB:** The *Grandmother* pattern grew out of our own house. When we were redecorating it, we brought home wonderful patterns on fabric and wallpaper samples. For the upper floor, we wanted bedroom wallpapers that were more domestic than most Art Nouveau or Art Deco patterns, but still large in scale. After looking everywhere for pretty, yet large-scale, floral patterns, we finally found one in New York. It had a green background and clusters of small flowers that made a big pattern. Later, our bedroom wallpaper became the basis for the

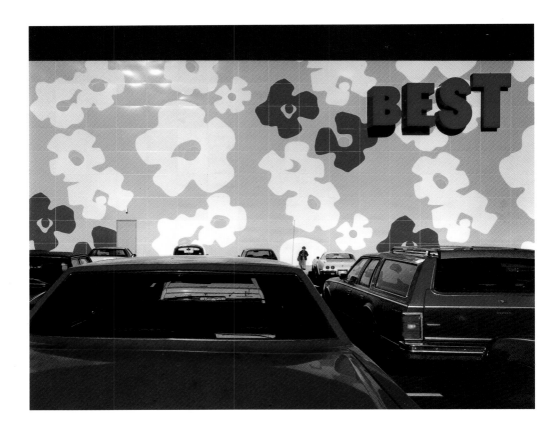

Best Products building, by Robert Venturi, of Venturi, Rauch and Scott Brown, Inc., at Oxford Valley Mall, in Langhorne, Pennsylvania, 1979.

Robert Venturi's 1979 preliminary design at The Fabric Workshop, which was never produced.

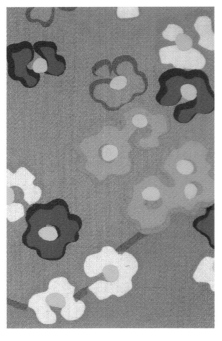

**Robert Venturi** and
**Denise Scott Brown,**
of Venturi, Rauch and
Scott Brown, Inc.
Installation at the
Institute of Contem-
porary Art, Phila-
delphia, 1987.
From left: *Chippendale
Chair,* 1979; *Queen
Anne Chair,* 1979;
*Chippendale Chair,*
1979; with *Notebook*
backdrop, 1982.
These chairs were
made from a molded
laminated plywood,
using a technique
pioneered by Alvar
Aalto, machine-
molding flat sheets to
form shapes that sug-
gest varying historical
styles. The chairs were
then finished with a
plastic laminated
*Grandmother* pattern.
Cushions of *Grand-
mother* on cotton
sateen.

pattern on the Best Products show-room building (p. 28). As we worked, the flowers grew bigger and closer together, and the juxtaposi-tions of pattern, color, scale, and architecture grew more strident.

For the Knoll furniture, we started with the same wallpaper but realized we needed a denser, more complex floral pattern. We tried overlaying the flowers with various pattern screens, but most were too rigid. During that process, our associate Fred Schwartz brought in a table-cloth that had belonged to his grand-mother. We evolved a good floral pattern from it, and eventually selected an overlay pattern called "ants" (the Japanese call it "chopsticks"). Orderly, but also random, "ants" went well, in its own clashing way, with the flowers. Someone called the *Grandmother* combination a mixed metaphor. That's a good definition.

**RV:** In designing both *Notebook* and *Grandmother,* we wanted to use ordinary and conventional elements in an extraordinary and unconven-tional way. In *Grandmother,* we tried to juxtapose soft and hard, pretty and geometric, and several different scales. It was difficult achieving an ordinary, sentimental, pretty floral pattern. While designing it, I visited a number of fabric sam-ple places, in particular the Paley Design Center, at the Philadelphia College of Textiles and Science. I spent some hours looking through its collection, and it was from a particular print that the idea arose of contrasting a dark, geometric pattern on a sentimental floral one.

**DSB:** The symbolism of *Notebook* was to be conventional and ordinary but somewhat out of date, like Pop Art. The original pattern came from an old cardboard filing box. It was a standard office-supply pattern but, as we developed it, it grew to look more like the black-and-white blobs on the covers of composition notebooks that American children use in school. Of course, our borrow-ings were influenced by the Pop Art use of conventional patterns in changed contexts. There's also a

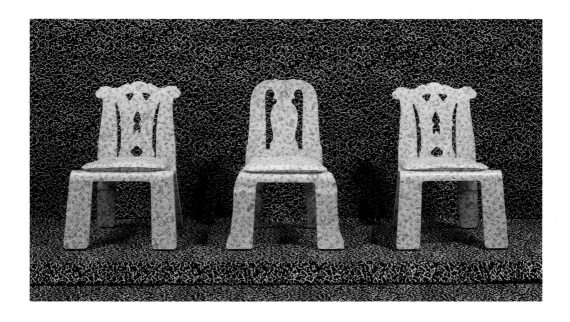

**Robert Venturi,**
of Venturi, Rauch and
Scott Brown, Inc.
*Notebook* banner, 1982
Pigment on cotton
sateen
Width: 50 inches

Enlarged version of
*Notebook* (in gray
colorway), printed by
The Fabric Workshop
for the 1991 exhibition
of the work of Venturi,
Scott Brown and
Associates, Inc., at
Knoll International in
Tokyo, Japan.

Venturi's *Notebook,*
1981, on cotton sateen
with fiber-reactive dye;
ceramics by Swid
Powell, New York.

connection to Roy Lichtenstein and his use of Benday dots (pp. 50–51).

**RV**: Our work was different from Pop, though; we wanted some of our patterns to be sentimental, pretty, and sensuous. At that time, it was unusual to be pretty in architecture, and Pop artists certainly weren't pretty. But the pattern artists—for example, the painter Robert Zakanitch—seem to strive for prettiness in high art.

The Fabric Workshop was the first workshop, or one of the first, in our time to invite artists to design textiles. Now, of course, several commercial houses have hired architects to do textile designs. It's in the air. Industry has taken up the call, and architects are doing decorative-art design.

We had feared we wouldn't be able to get *Grandmother* printed outside of The Fabric Workshop; sure enough, when we went to the industry roller printing experts, they couldn't match what the Workshop had done by hand. They couldn't conceive of the color balance or get the black equal signs exactly right; the rollers left an afterimage. The design had to be partially put back as a hand process, so *Grandmother*

came back to the Workshop for the equal signs to be handprinted.

If you're designing for commercial production, you must consider particular markets. The Fabric Workshop, however, was more interested in what we were thinking about and what was coming out of us at the moment. We didn't have to consider markets; we acted, for the most part, as high artists.

*At the request of Venturi, Scott Brown and Associates, the art-historical terms within this section of the book are capitalized, thereby being treated differently than they are in the rest of the book.*

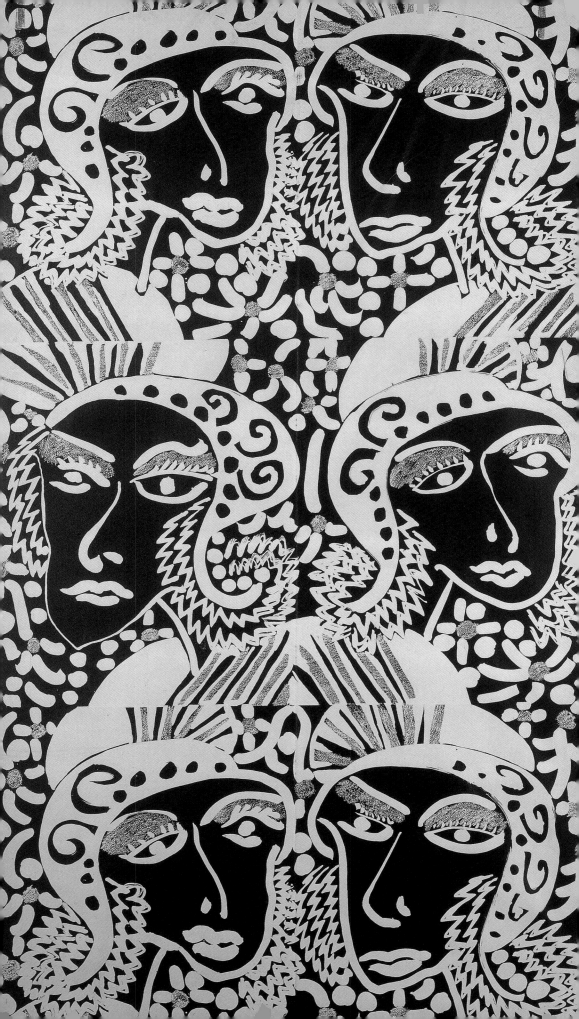

# Print Multiples
Ruth E. Fine

**Robert Kushner**
*Louella,* 1983
Pigment on chintzed
cotton (pink colorway)
Width: 48 inches

Although not a new genre by any means, art that is executed in editions of multiple originals is making a dynamic contribution to the aesthetic discourse of the late twentieth century. Over the past several decades, specially equipped editioning workshops have sprung up throughout the world. Run by technical wizards who are able to meet extraordinarily complex challenges, they have enabled the most creative of minds to explore visual ideas in a variety of media.

The Fabric Workshop's unique contribution to this mélange has taken many forms. Eschewing such traditional object categories as art/craft or functional/nonfunctional, artists who have participated in the Workshop's program have provided us with a rich variety of printed works to be sat upon, wrapped in, walked through, looked at. That these pieces have been produced in multiple allows them to be owned simultaneously by more than one admirer, creating links that extend well beyond the closely knit Fabric Workshop community.

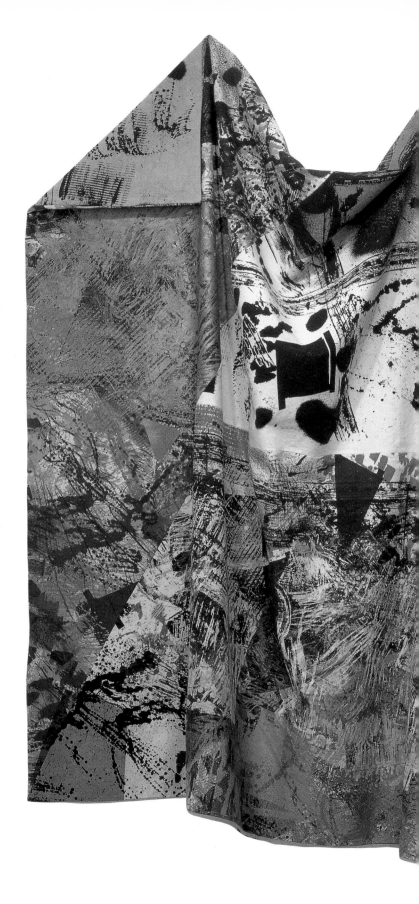

**Sam Gilliam**
*Philadelphia Soft,* 1977
Pigment on Belgian
linen and cotton canvas
51 x 86 inches (shown
draped)
Edition of six related
works, each using
nineteen separate
screens hand-placed
by the artist

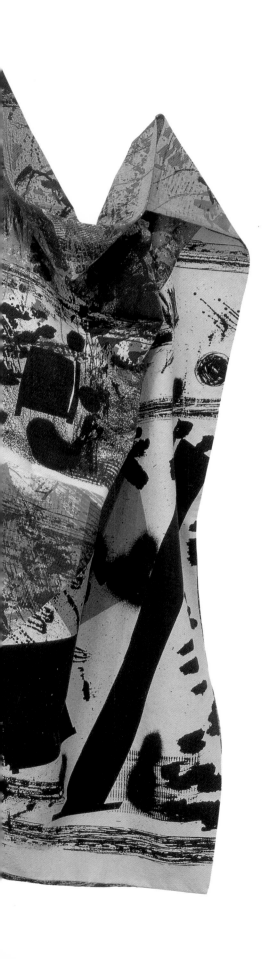

Robert Kushner
reclines in his *Hawaiian
Punch* cape, 1977.

**Robert Kushner**
*Hawaiian Punch* cape,
1977
Pigment on unbleached
cotton muslin
49 x 75 inches

**Judith Shea**
*Vests 1A, 1B, 2A, 2B,*
1977
Pigment on canvas
Each 24 x 24 inches

Judith Shea at the
Workshop, 1977.
*On wall:*
semaphore shirts
(top), paper jacket,
pants for *Four
Continents*

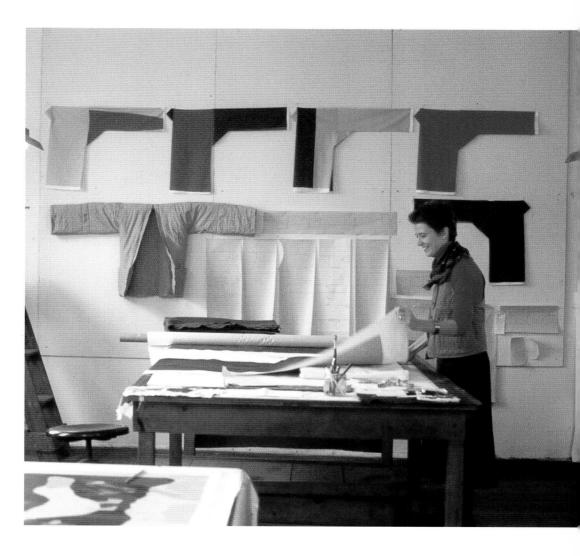

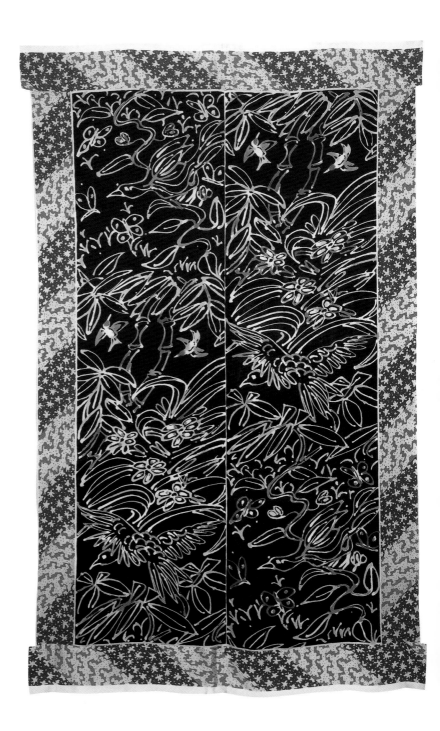

**Brad Davis**
*Silk Piece #1* (diptych),
1980
Pigment and fiber-
reactive dyes on silk
satin with handpainting
82 x 48 inches
Edition of five related
works

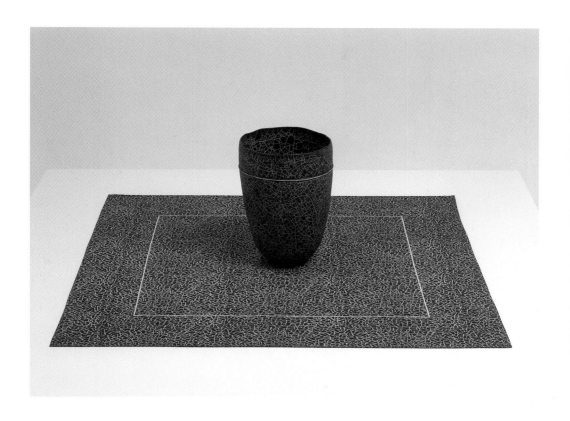

**Richard DeVore**
*Requiem,* 1980
Pigment on cotton,
with ceramic vessel by
the artist
7 x 30 x 30 inches
Edition of five related
works
Private collection

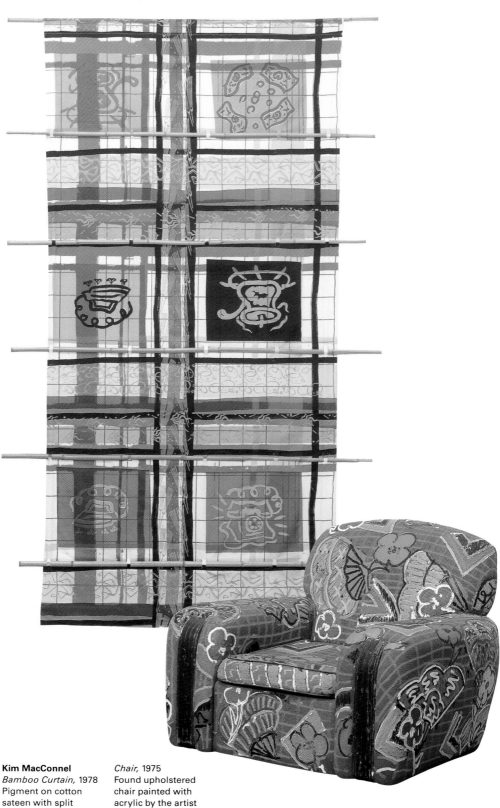

**Kim MacConnel**
*Bamboo Curtain,* 1978
Pigment on cotton
sateen with split
bamboo poles
104 x 63 inches

*Chair,* 1975
Found upholstered
chair painted with
acrylic by the artist
31½ x 40½ x 34½
inches
Collection of Janet and
Robert Kardon

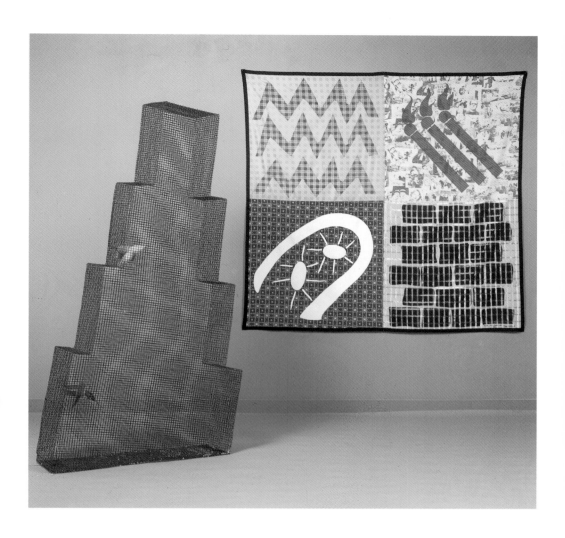

**Tina Girouard**
*Ziggurat Birdcage,* 1982
Welded steel wire cloth
and live birds
75 x 36½ x 12 inches
Produced for ARC
International, New York
Collection of the artist

*Water, Fire, Earth, Air,*
1980
Pigment on com-
mercially printed
fabrics
68 x 70 inches
Edition of forty-three
related works

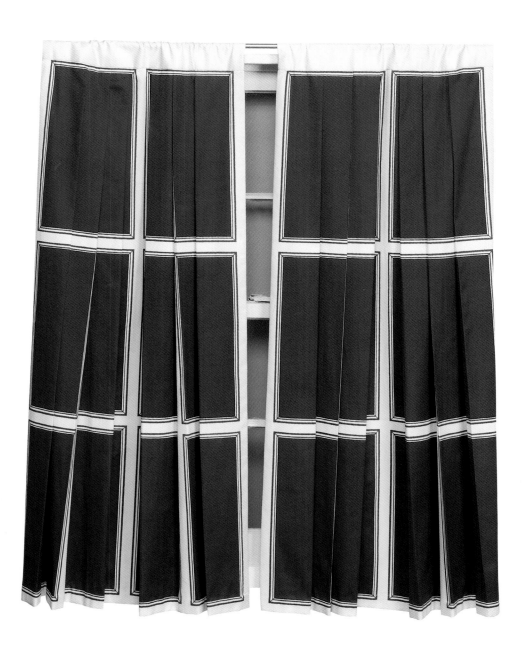

Scott Burton and
master printer Lucile
Michels check the print
for his *Window
Curtains,* 1978.

**Scott Burton**
*Window Curtains,* 1978
Pigment on cotton
sateen, with window
frame
40 x 30 x 6 inches

**Chuck Fahlen**
*Fresh Start,* 1978
Pigment on three-
quarter-inch die-cut
industrial felt
25½ x 15½ x ¾ inches
Edition of fifteen

**Warren Seelig**
*Checkerboard Awning,*
1981
Pigment on cotton,
with steel armature
72 x 20 x 20 inches

**Ned Smyth**
*Easy Street,* 1980
Metallic pigments
screen printed over
marbleized ground on
cotton sateen, with
gold fringe and glass
mosaic sculpture by
Smyth
48 x 48 x 4 inches
Collection of the artist

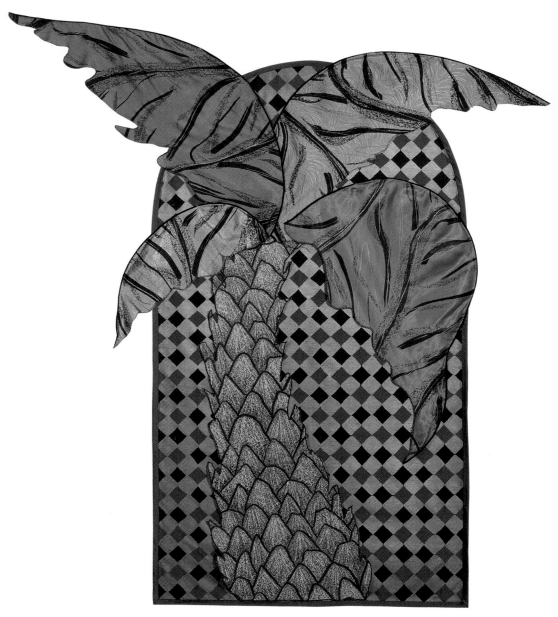

**Ned Smyth**
*Kippy Palm,* 1979
Pigment on wool
tweed and upholstery
sateens, with wire
armature
83 x 84 inches
Edition of six related
works

Lucile Michels and
Robert Smith print Roy
Lichtenstein's shirt,
1979.

**Roy Lichtenstein**
Untitled shirt, 1979
Pigment on silk sateen
30 x 36 inches
Edition of 150
Commissioned by
Artists Space, New York

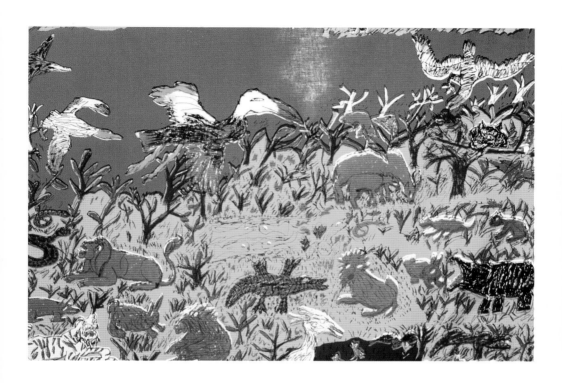

Will Stokes, Jr., works on the acetate for *Jungle* in his studio at the Workshop, 1978.

**Will Stokes, Jr.**
*Jungle* banner, 1978
Pigment on bleached muslin
Width: 50 inches

Will Stokes, Jr.'s wall assemblage, 1986.

**Joyce Kozloff**
Untitled silk (first
series), 1978
Pigment on silk and
cotton, predyed and
pieced together
57 x 60 inches
Edition of nine related
works

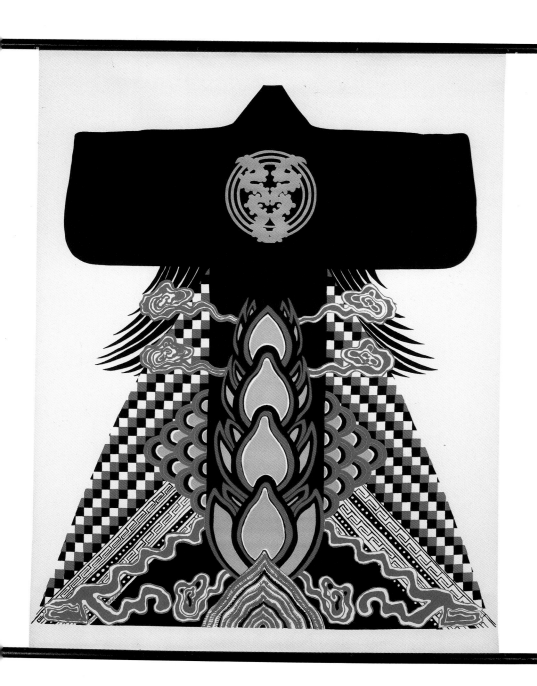

**Miriam Schapiro**
*Kimono,* 1979
Pigment on natural
cotton sateen, vinyl-
backed, with wood
poles
60 x 60 inches
Edition of six related
works

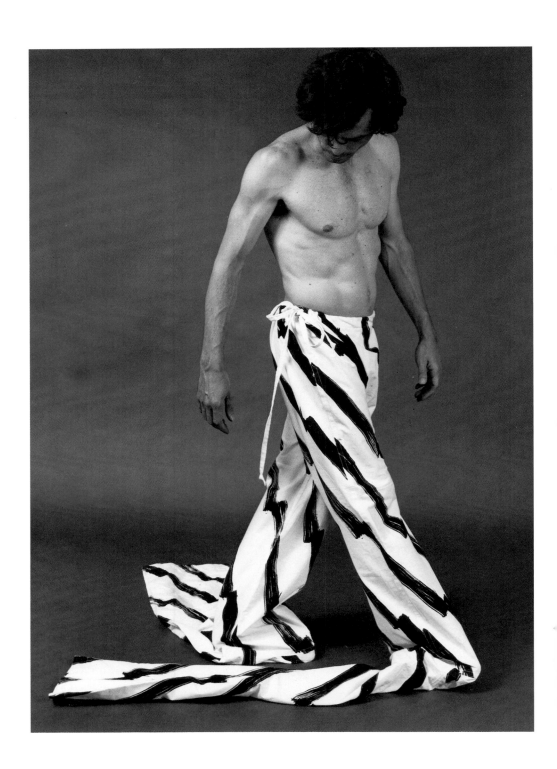

**Richard Tuttle**
*Pants,* 1979
Pigment on bleached
cotton muslin
72 x 26 inches
Edition of five
Worn by the artist

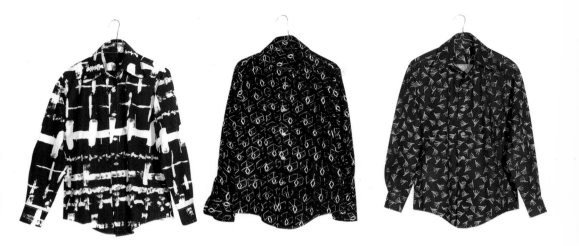

**Richard Tuttle**
*Shirts,* 1978
Pigment on bleached
cotton muslin
32 x 36 inches
Edition of five

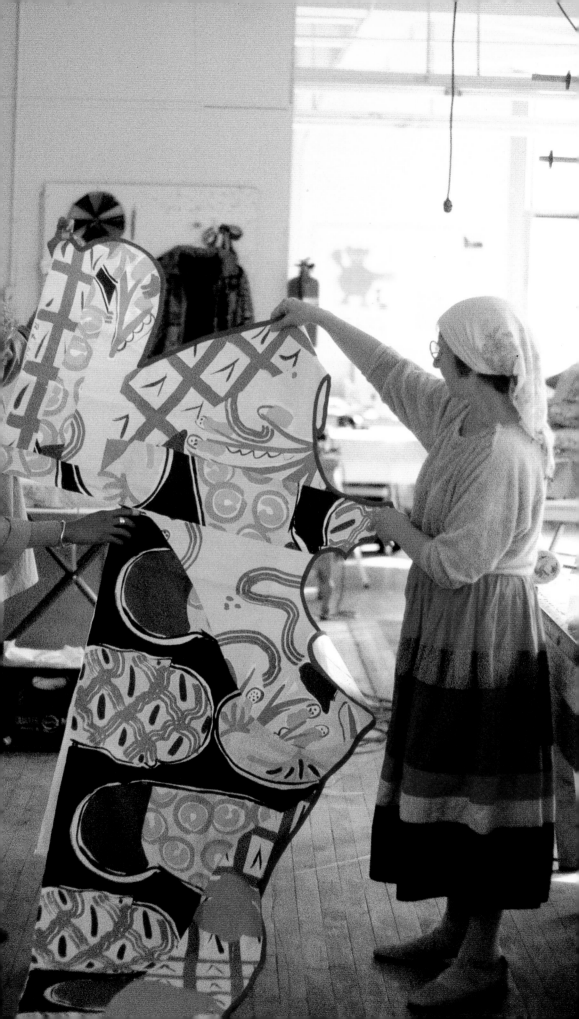

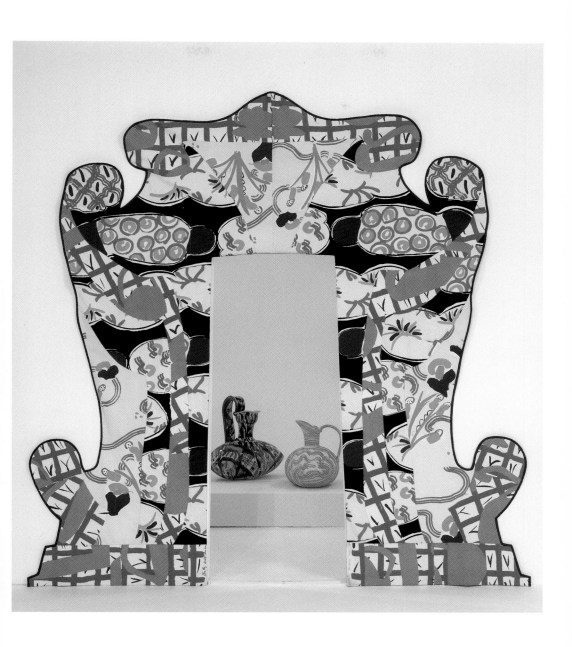

Betty Woodman (right) and construction technician Betty Leacraft-Cameron work on *Turandot Doorway,* 1980.

**Betty Woodman**
*Turandot Doorway,* 1980, at the Institute of Contemporary Art, Philadelphia
Pigment on cotton canvas and cotton sateen, cut and pieced together with three

repeat patterns:
*Floating Pots, Platters,* and *Meandering Stream*
Edition of seven related works

*Pillow Pitcher,* 1979
Earthenware
21½ x 21½ x 12 inches
Collection of the artist

*Pillow Pitcher,* 1979
Earthenware
16½ x 19 x 13½ inches
Private collection

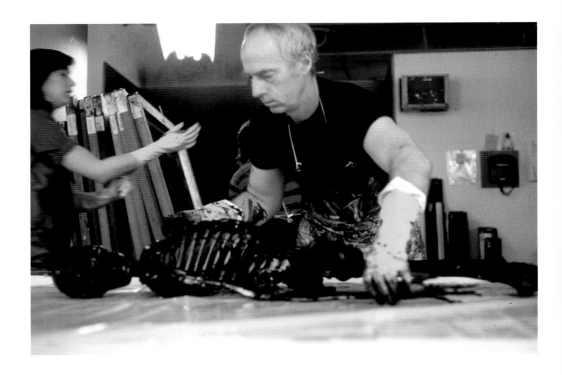

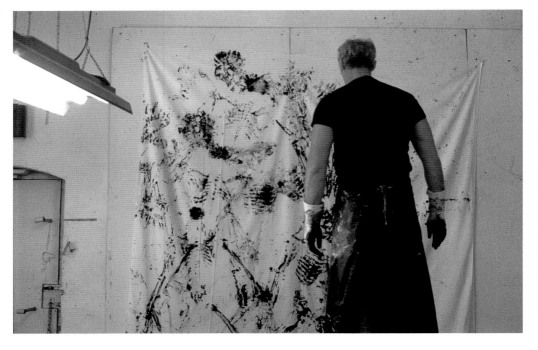

Robert Morris inks the
skeleton for his
*Restless Sleepers,* 1981.

Robert Morris examines
the preliminary study
for his *Restless
Sleepers,* 1981.

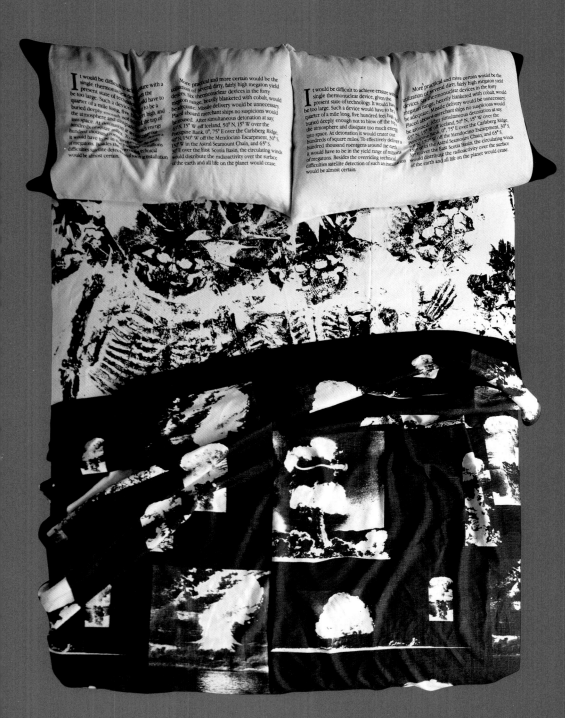

**Robert Morris**
*Restless Sleepers/*
*Atomic Shroud*
Pigment on linen
Two sheets,
each 114 x 90 inches
Two pillow cases, each
20 x 36 inches
Edition of eight related
works, five on linen
and three on satin

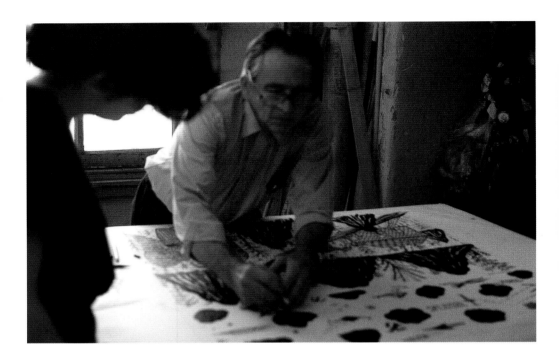

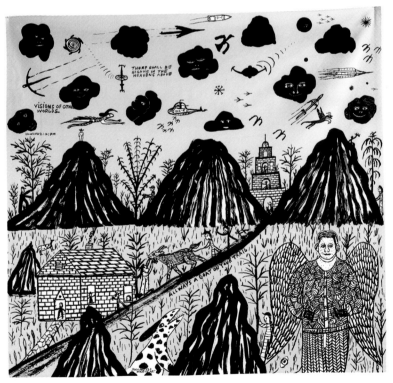

Howard Finster paints
the acetate for *Road to
Eternity* as master
printer Mary Anne Friel
looks on, 1984.

**Howard Finster**
*Road to Eternity,* 1984
Pigment on white
cotton sateen
36 x 36 inches
Unlimited edition

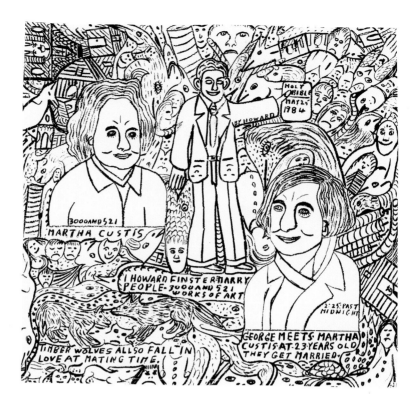

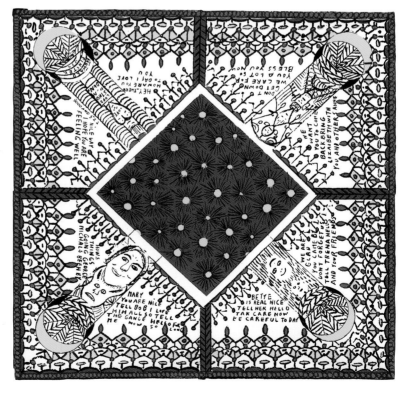

**Howard Finster**
*George Washington
Meets Martha Custis*
bandanna, 1984
Pigment on cotton
lawn
21½ x 21½ inches

**Howard Finster**
*Workshop Stars* napkin,
1984
Pigment on bleached
cotton muslin
21 x 21 inches

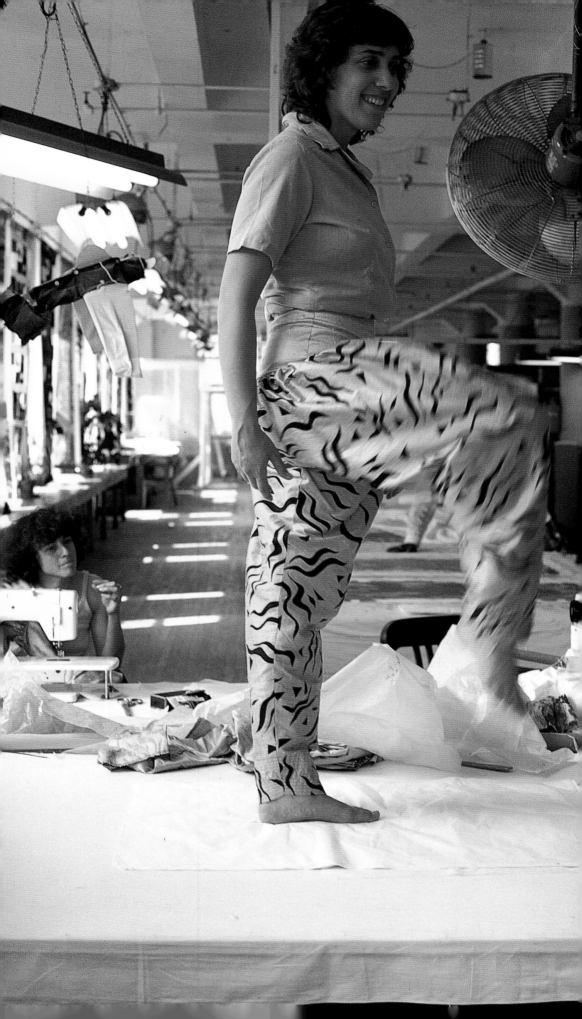

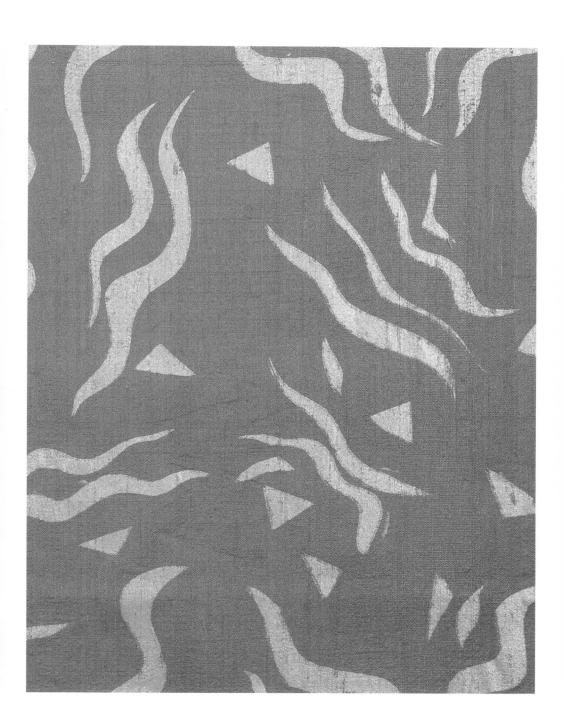

Master printer Lucile
Michels models Lynda
Benglis's *Ben* pants,
1980.

**Lynda Benglis**
*Ben* yardage (detail),
1980
Pigment on Indian silk
41 x 24 inches
Edition of nine related
works in numerous
colors

Michael Singer flocks
dirt onto freshly printed
adhesive for his limited
edition, 1983.

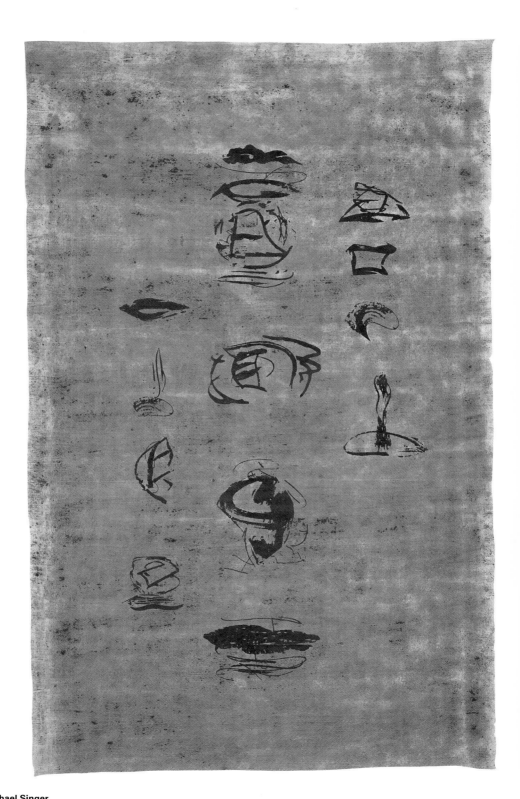

**Michael Singer**
Untitled, 1983
Dry pigment, dirt,
Sobo glue on silk
duppioni, mounted on
linen
70 x 43 inches
Edition of five related
works

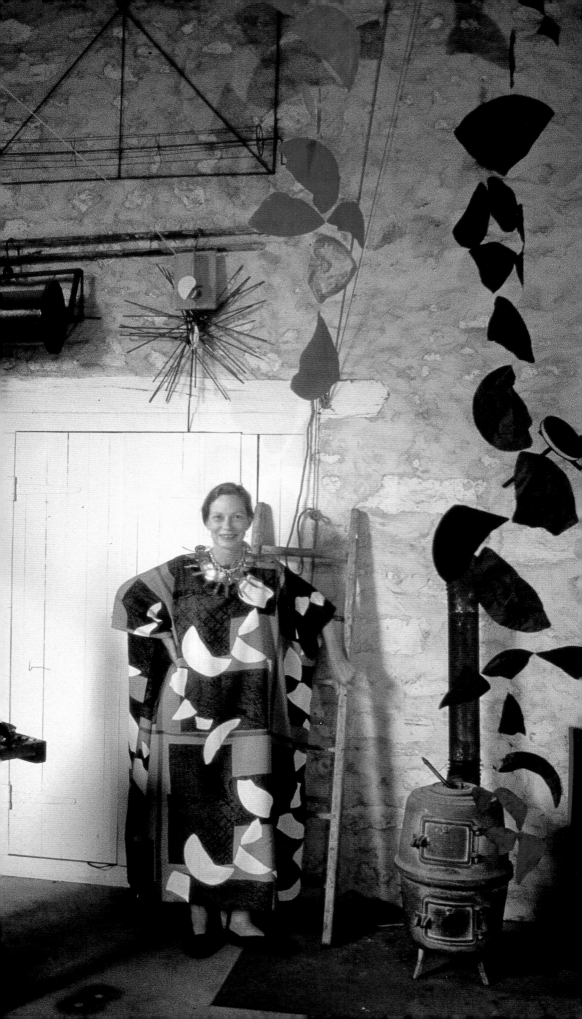

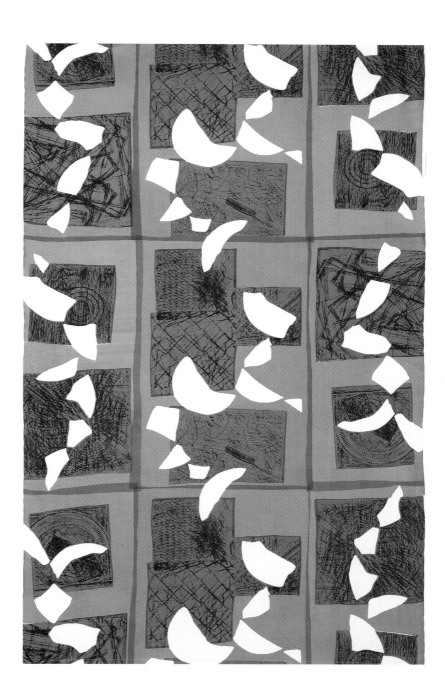

In her studio, outside of Paris, Jacqueline Matisse Monnier wears her *Moon Pieces* (Lexique de Lune) boubou.

**Jacqueline Matisse Monnier**
*Moon Pieces* (Lexique de Lune) yardage, 1981
Pigment on viscose rayon challis
Width: 44 inches
Related edition on cotton

**Pat Steir**
*Calligraphy Screen*
(cherry tree imagery),
1983
Black pigment on
unbleached cotton
muslin, stretched and
inserted in a traditional

Shoji frame of ashwood
80 x 191 x 2 inches
Related edition on
natural Belgian linen

Roy DeForest with his
dog, Pepe.

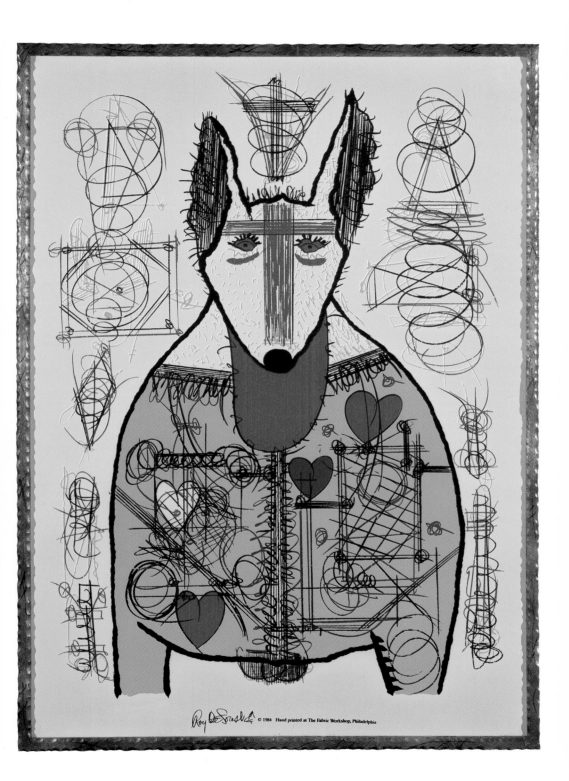

**Roy DeForest**
*Dog St. George,* 1984
Yellow edition, pigment
on canvas, stretched,
with handcarved and
handpainted frame
58 x 41 ½ x 2 ½ inches
Limited edition of
twenty-four works in
pink and yellow

Construction technician
Betty Leacraft-Cameron
wraps Betye Saar in
Saar's *Fantasies*
yardage, 1984.

**Betye Saar**
*Takin' a Chance on
Luv'* duvet cover, 1984
Pigment on pink cotton
sateen (pink colorway)
Edition of ten
86 ½ x 77 ½ inches

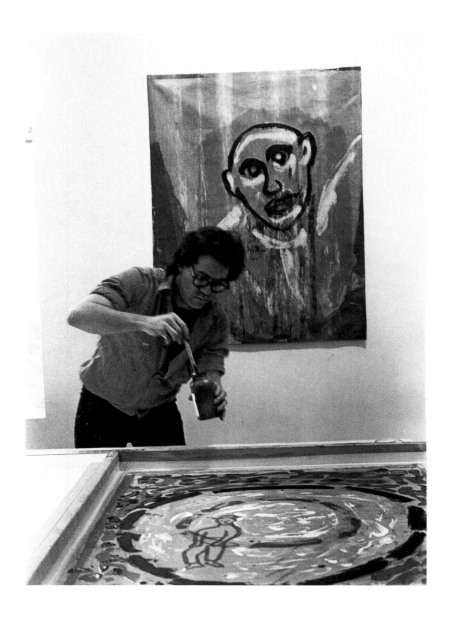

Robin Winters, in The
Fabric Workshop's New
York studio, applies
pigment to a screen for
his *Fressen zum
Denken: Bonaparte's
Party* installation, 1985.

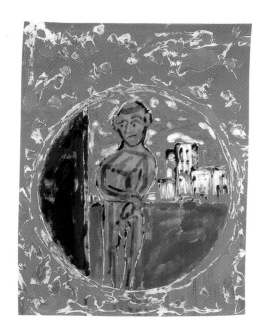

**Robin Winters**
Four untitled
monoprints, 1985
Pigment on cotton
44 x 33 inches

Italo Scanga (left)
watches as master
printer Robert Smith
(center) and workshop
assistant Homer
Jackson print Scanga's
*Blood and Thorns*
fabric, pigment on
cotton muslin, 50
inches, 1977.

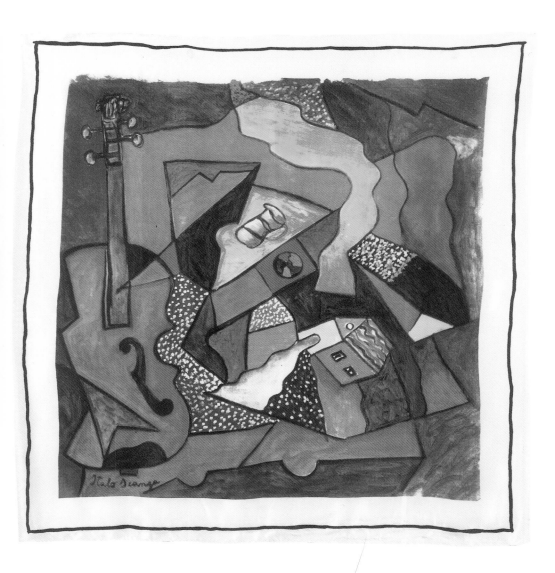

**Italo Scanga**
*Cubist* scarf, 1986
Four-color photo
separation, with acid
dyes on white silk
charmeuse, from an
original watercolor
painting
33¾ x 33¾ inches

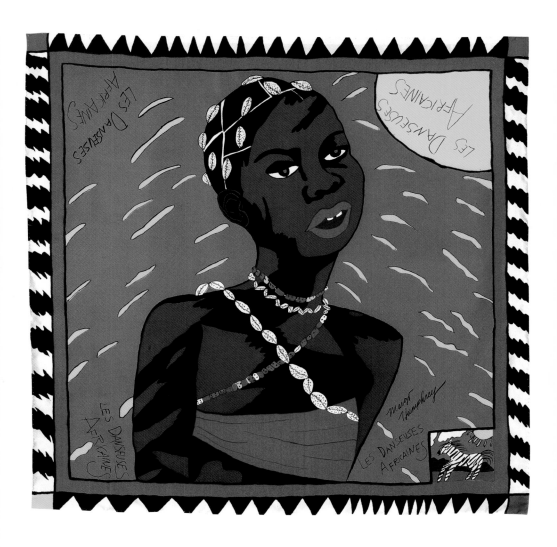

Margo Humphrey and
her *Les Danseuses
Africaines* scarf, 1987.

**Margo Humphrey**
*Les Danseuses
Africaines* scarf, 1987
Acid dyes on silk
charmeuse
35 x 35 inches

Sidney Goodman
discusses his proof
with master printer
Elizabeth McIlvaine.

**Sidney Goodman**
Untitled banner, 1988
Pigment on white
cotton sateen
88 x 53½ inches

85

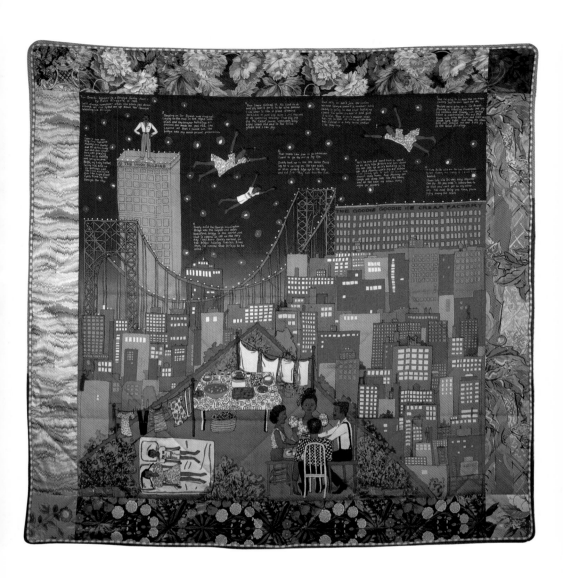

Faith Ringgold quilts
*Tar Beach 2.*

**Faith Ringgold**
*Tar Beach 2* quilt, 1990
Acid dyes on bleached
silk duppioni with a
border and backing of
commercially printed
fabrics, handquilted by
the artist and her
assistant, Gail Liebig
65 x 65 inches
Edition of 24

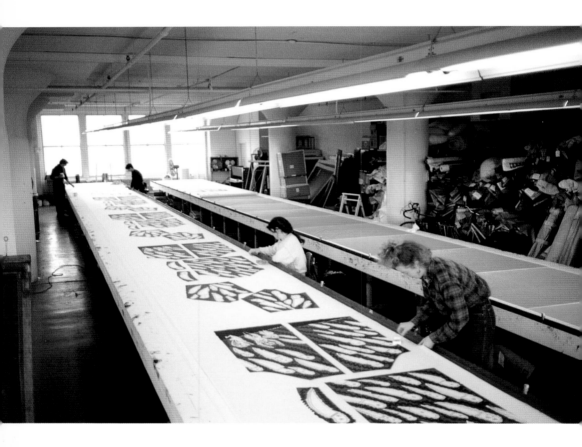

Master printer Christina
Roberts (foreground)
and apprentices work
on an edition of Luis
Cruz Azaceta's *Acid
Rain* coat.

**Luis Cruz Azaceta**
*Acid Rain* coat, 1990
Pigment on white
cotton upholstery
sateen, vinylized after
printing

Lining: cotton sateen
printed in rainbowing
(split-fountain)
technique with
fluorescent pigments
60 x 48 inches
Modeled by the artist
and his wife, Sharon
Jacques, in his Soho,
New York, studio

Tim Rollins (left) and members of Kids of Survival (K.O.S.), engaged in the *By Any Means Necessary* and *Scarlet Letter* projects, 1989.

**Tim Rollins + K.O.S.** *By Any Means Necessary* T-shirt, 1989 Pigment on cotton jersey

The collaborative artwork of Tim Rollins + K.O.S. is traditionally made at the Art and Knowledge Workshop, a program for artistically gifted teenagers. Founded in 1982, the workshop is located in

South Bronx, New York. In the summer of 1989, Tim Rollins and the students worked at The Fabric Workshop.

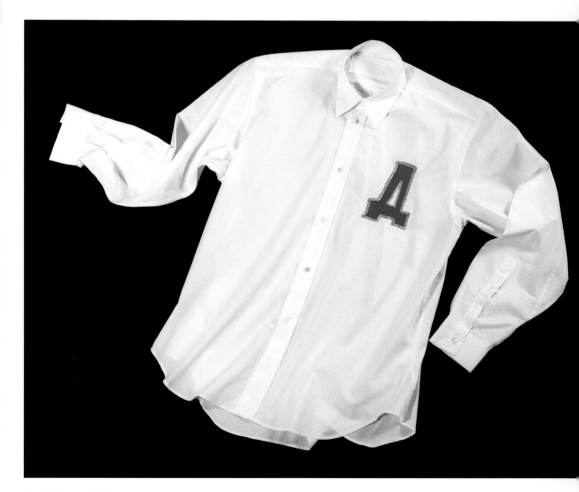

**Tim Rollins + K.O.S.**
*Scarlet Letter,* 1989
Embroidery on cotton
shirt
36 x 71 inches

Master printers Betsy
Damos and Robert
Smith discuss the
gouache for the Matt
Mullican project, 1990.

**Matt Mullican**
*Field of Cities* banner,
1990
Pigment on white
cotton upholstery
sateen
Width: 50 inches

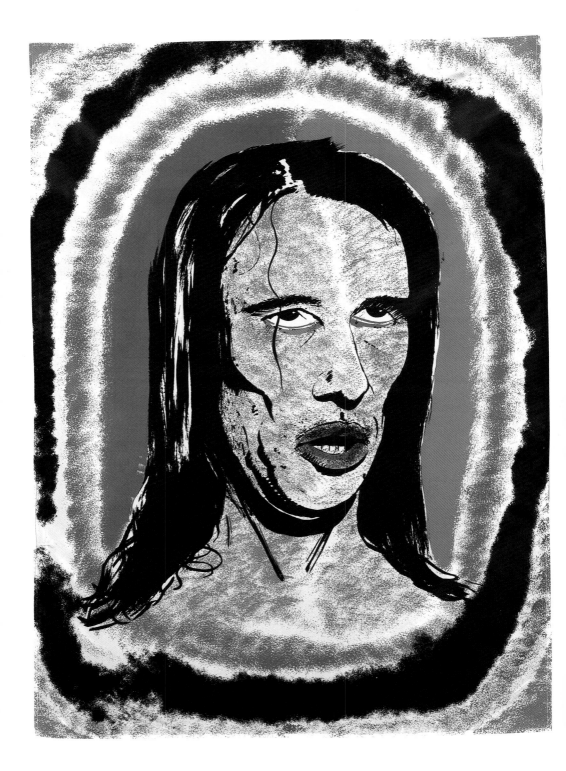

**Mike Kelley**
*The Orange and Green*
body scarf, 1989
From the edition
*PansyMetal/Clovered
Hoof,* 1989
Pigment on white silk
habutai

Five editions of ten
pieces
52¾ x 37¾ inches
Commissioned and
published by edition
Julie Sylvester

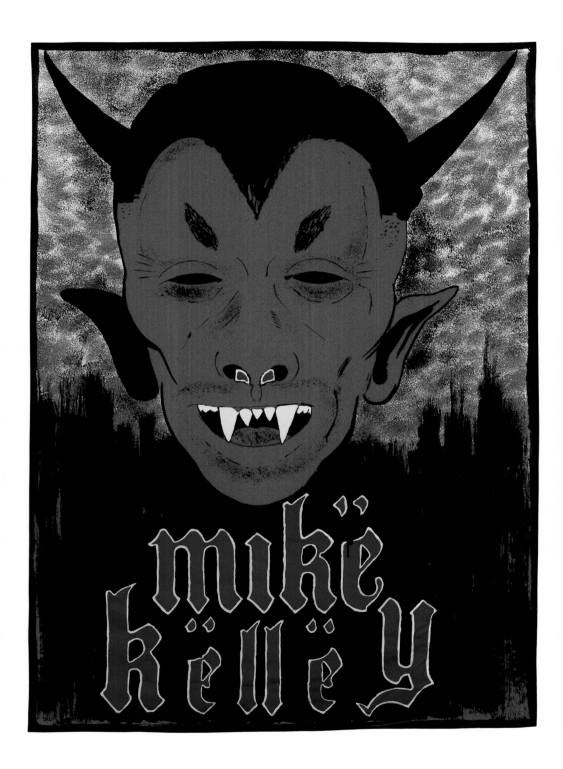

**Mike Kelley**
*Satan's Nostrils* body
scarf, 1989
From the edition
*PansyMetal/Clovered
Hoof*, 1989
Pigment on white silk
habutai

Five editions of ten
pieces
52¾ x 37¾ inches
Commissioned and
published by edition
Julie Sylvester

Michael Kessler applies red photographic film opaque to the acetate for his untitled yardage.

**Michael Kessler**
Untitled, 1990
Acid dyes on silk charmeuse
Width: 52 inches

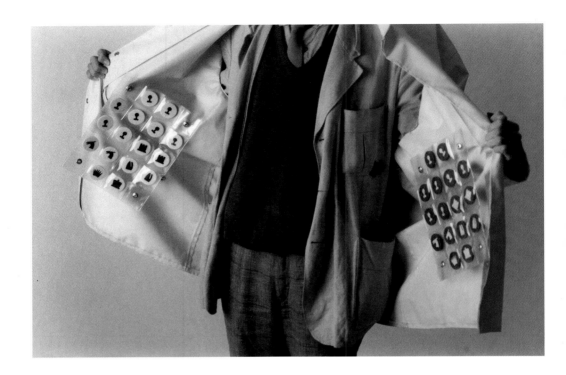

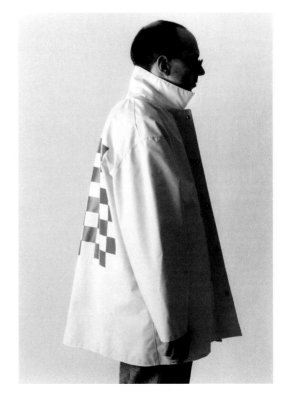

**Ecke Bonk**
*Chess-Jacket
(Checkett),* 1987–1991
Pigment on Gore-Tex
fabric with plastic
chess pieces
Large man's jacket
39 x 70 inches

Edition of thirty-two
Worn by the artist
Made possible with
substantial help from
Gore & Associates,
(Munich/Germany)

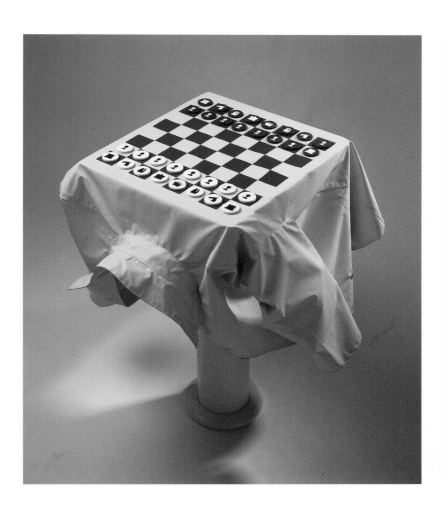

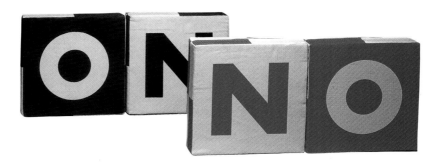

**Ecke Bonk**
*Chess-Jacket*
*(Checkett),* 1987–1991

**Ecke Bonk**
*NO/ON* pillows, 1990
Pigment on linen
15 x 15 x 3 inches

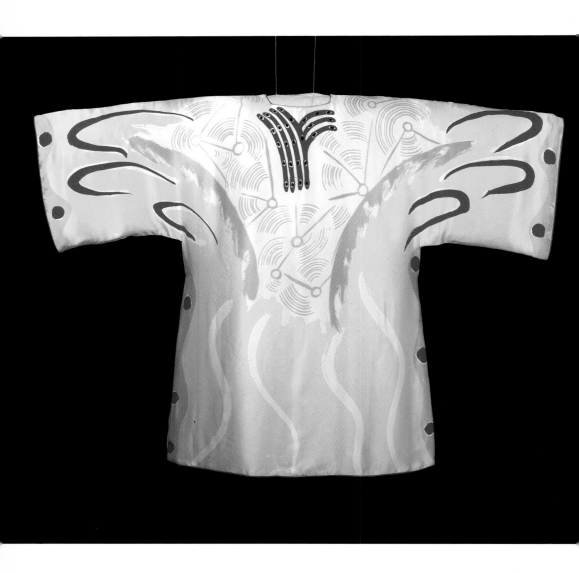

**Gregory Amenoff**
*Easter Sunday* deacon's
vestment, 1990 (front
and back)
Acid dyes on silk
charmeuse
49 x 62 inches
Silk provided by
Abraham Silks, Zurich,
Switzerland

Project for Saint Peter's
Church, Cologne,
Germany. Series of
three sets, including
priest and deacons'
vestments, stole, and
chalice cover for
Good Friday, Easter
Sunday, and everyday.

Howard Hodgkin discusses printing techniques for his silk scarf design (from a watercolor on rag paper) with master printer Christina Roberts, 1991.

An artists' scarf exhibition guest curated by Dilys Blum in 1991 will include works by Howard Hodgkin and Louise Bourgeois.

**Howard Hodgkin**
Untitled, 1991
Watercolor on rag paper:
22 x 22 inches
For scarf design to be printed on silk:
50 x 50 inches

**Donald Lipski**
*Who's Afraid of Red,
White & Blue? #18,*
1990
Plaited and sewn
cotton flags
72 x 72 inches

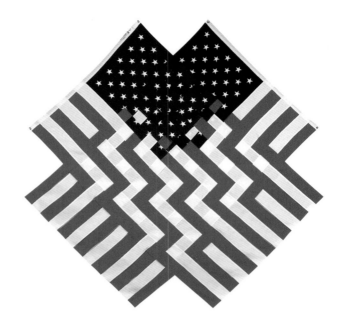

Workshop seamstresses
Cynthia Porter (left)
and Sue Patterson,
project coordinator,
work with Donald
Lipski (wearing his
Robert Mapplethorpe
T-shirt) on his *Who's
Afraid of Red, White &
Blue? #18,* 1990.

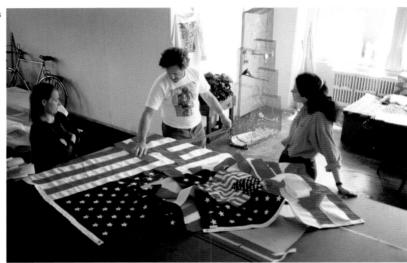

Cynthia Porter sews
Donald Lipski's *Who's
Afraid of Red, White &
Blue? #18,* 1990.

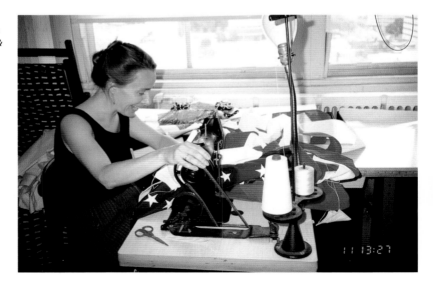

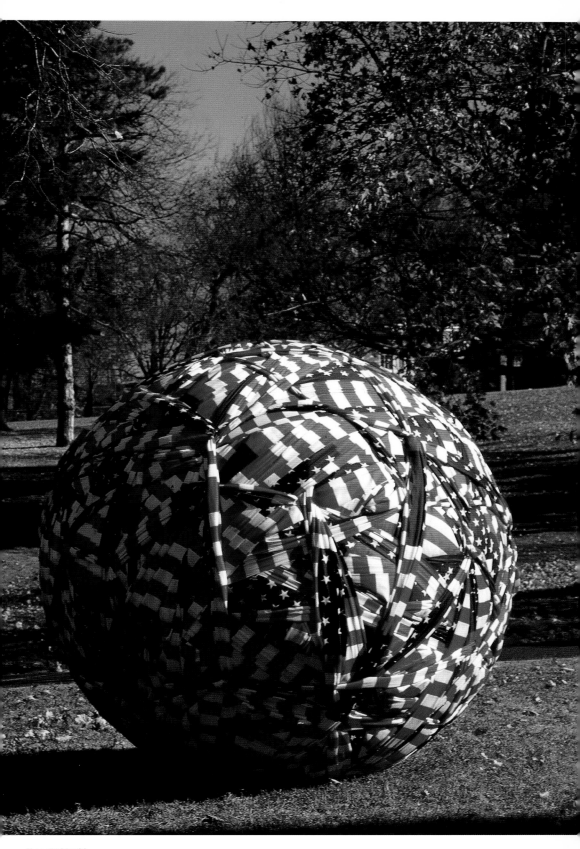

**Donald Lipski**
*American Flag Ball #3,*
1990
Styrofoam, cotton
batting, nylon
Diameter: 96 inches
(8 feet)
Installation at Beaver
College Art Gallery,
Glenside, Pennsylvania

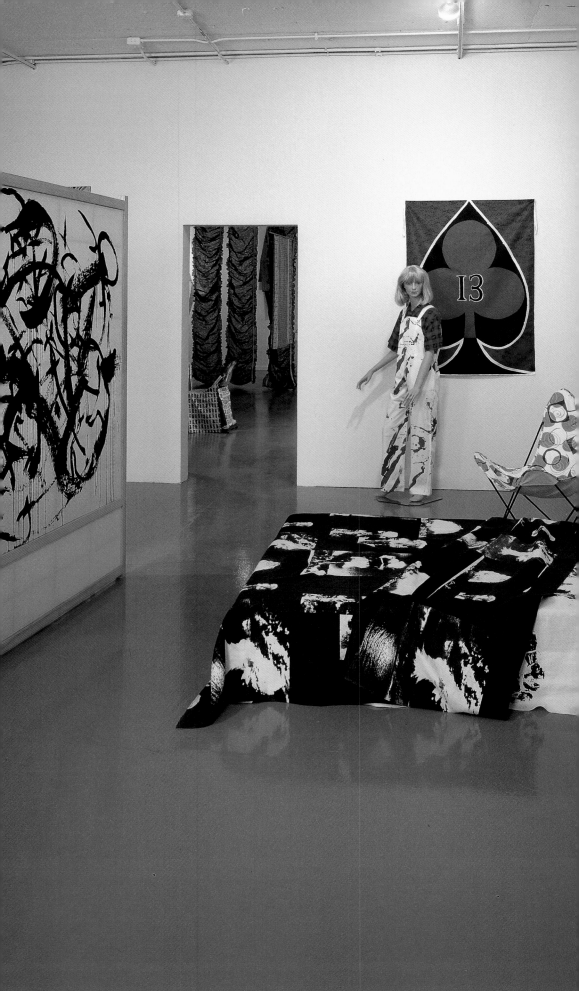

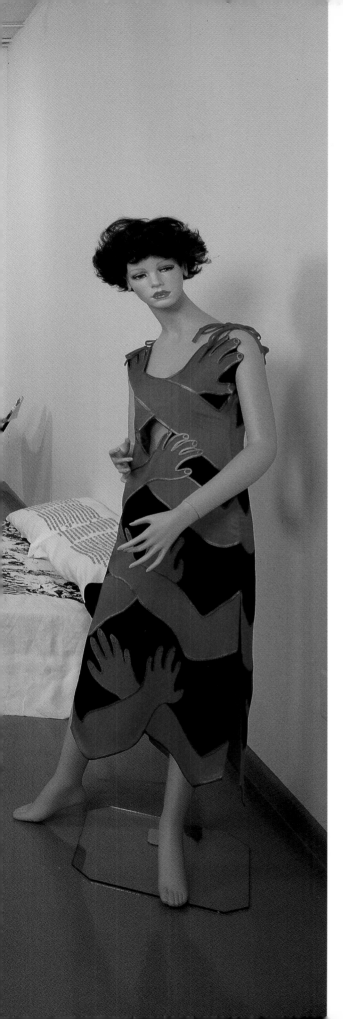

## Let's Play House

Ruth E. Fine
"Let's Play House" exhibition at
The Fabric Workshop, May 25–
September 7, 1990

The title is meant to suggest the
quality of fantasy that was nourished
when reviewing the extraordinary
parade of works made at The Fabric
Workshop and into which so many
distinguished artists have invested
their creative energy. These highly
personal responses to the pos-
sibilities of printing on fabric have
given us objects of decoration and
objects of function, often overlap-
ping both arenas. Executed with
consummate skill, these printed
pieces suggest the range of human
experience, providing us with humor,
beauty, and intellectual stimulation
as they present for our consideration
some of the pleasures as well as
some of the challenges that face us
as we approach the twenty-first
century.

From left: Pat Steir,
*Calligraphy Screen;*
Marjorie Strider,
*Painter's Pants;* Mike
Kelley, *Peat Spade;*
Phillip Maberry,
butterfly chair with
*Four Seasons* (autumn
colorway); Robert
Morris, *Restless
Sleepers/Atomic
Shroud* bed; and Alexa
Keinbard, *Hug Time*
dress—all pieces in the
1990 *Let's Play House*
exhibition, guest
curated by Ruth E. Fine
at The Fabric Workshop.

*If one were to imagine a
Workshop household,
one would envision a
situation in which
most, if not all, things
were made in a more
imaginative and
beautiful way than in
quotidian life.*
—Mark Rosenthal

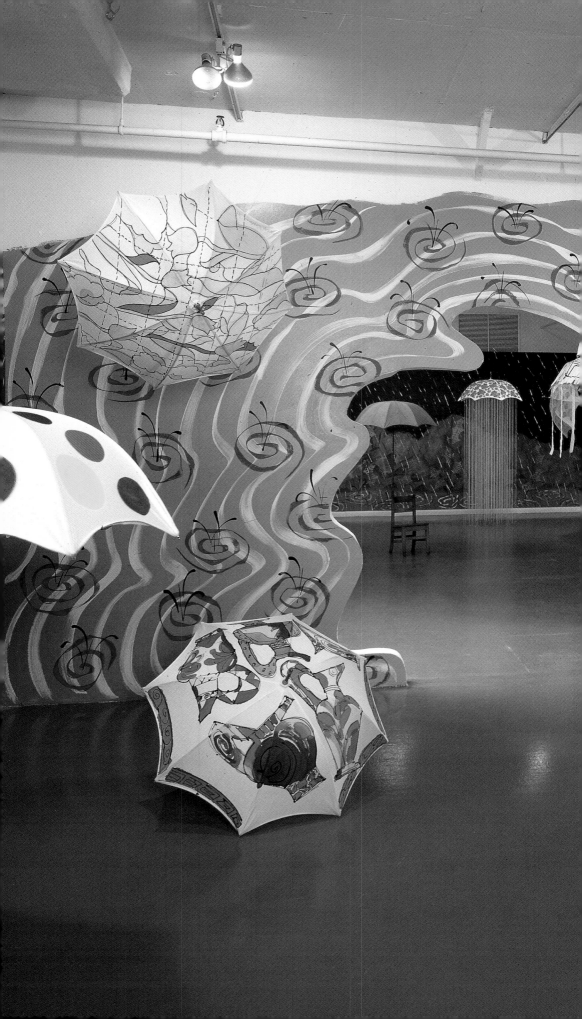

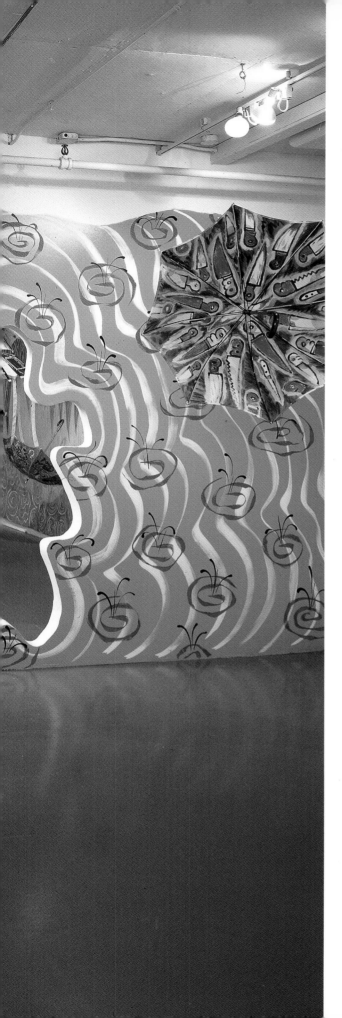

## Rain of Talent: Umbrella Art

Patterson Sims
"Rain of Talent: Umbrella Art"
traveling exhibition, May 1989–
September 1991

In late 1988, when asked to curate
an exhibition at The Fabric Work-
shop, I immediately thought of a
show of suspended umbrellas. This
dream image assumed reality a few
months later at the Workshop gal-
lery, and has since traveled to other
art museums and art spaces across
the United States, augmented at
each stop with a few additional
artists' umbrellas.

The exhibition is dedicated to the
season of spring, the Workshop's
first *Notebook* pattern umbrella,
made by Robert Venturi (the Phila-
delphia architect of the new, down-
town building of the Seattle Art
Museum), and the startling pos-
sibilities of the conjunction, via a
practical problem, of fabric and
artists.

In Seattle, one learns to collect um-
brellas—and what a range these
resourceful artists gave us.

*Rain of Talent:
Umbrella Art* traveling
exhibition; installation
design at The Fabric
Workshop by Phillip
Maberry.

**Richard Francisco**
*Have a Nice Day*
umbrella, 1990
Cloth, wood, copper,
tin globe
Height: 38 inches
Diameter: 48 inches

**Edward Henderson**
Untitled umbrella, 1989
Cotton sateen with
leather and wood
Height: 72½ inches
Diameter: 48 inches

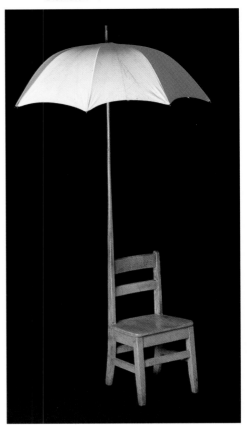

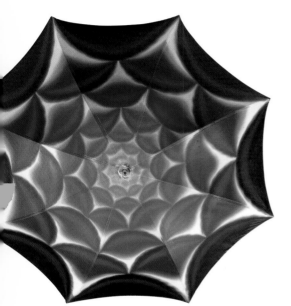

**Roger Brown**
*Blue Cloud* umbrella,
1990
Acrylic on cotton
sateen
Height: 34 inches
Diameter: 48 inches

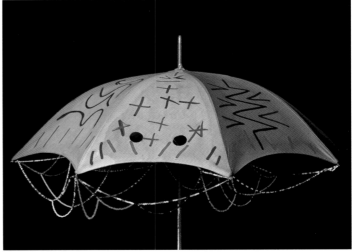

**Alan Shields**
*A Hand-Held Dream
Balloon* umbrella, 1989
Acrylic on cotton
sateen
Height: 34 inches
Diameter: 48 inches

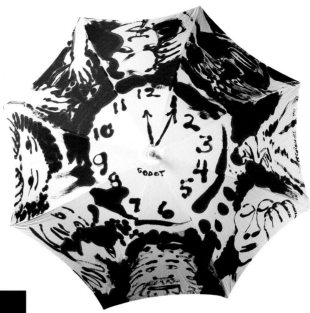

**Robert Colescott**
*Waiting for Godot*
umbrella, 1990
India ink on cotton
sateen
Height: 34 inches
Diameter: 48 inches

**Michael Lucero**
Untitled umbrella, 1989
Duct tape on cotton
sateen and ceramic
vase
Umbrella: 34 inches
Pestle: 12 x 6 inches

**Claire Zeisler**
*Reigning Roses*
umbrella, 1989
Chainette rayon,
acrylic, rose decals;
umbrella has acrylic
threads 64 inches long
Height: 84 inches
Diameter: 48 inches

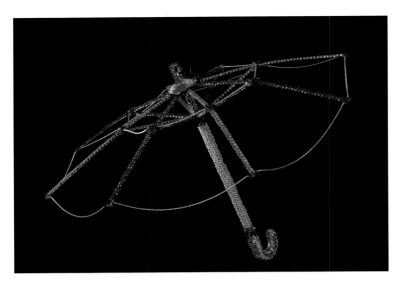

**Rhonda Zwillinger**
*Walking in between Raindrops* umbrella, 1989
Faux jewels and silicon on umbrella skeleton
Height: 34 inches
Diameter: 48 inches

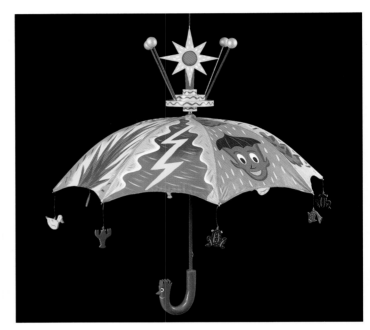

**Richard Haas**
Untitled umbrella, 1989
Acrylic on cotton sateen
Height: 34 inches
Diameter: 48 inches

**Rodney Alan Greenblat**
Untitled umbrella, 1989
Acrylic on wood and cotton sateen
Height: 44 inches
Diameter: 48 inches

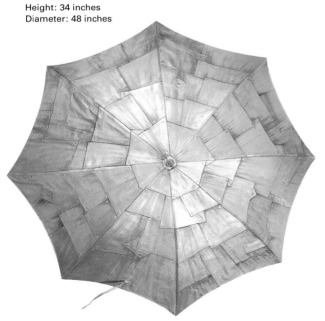

*Rain of Talent: Umbrella Art* traveling exhibition at American Craft Museum, in New York, with wall panels by Phillip Maberry, 1989.

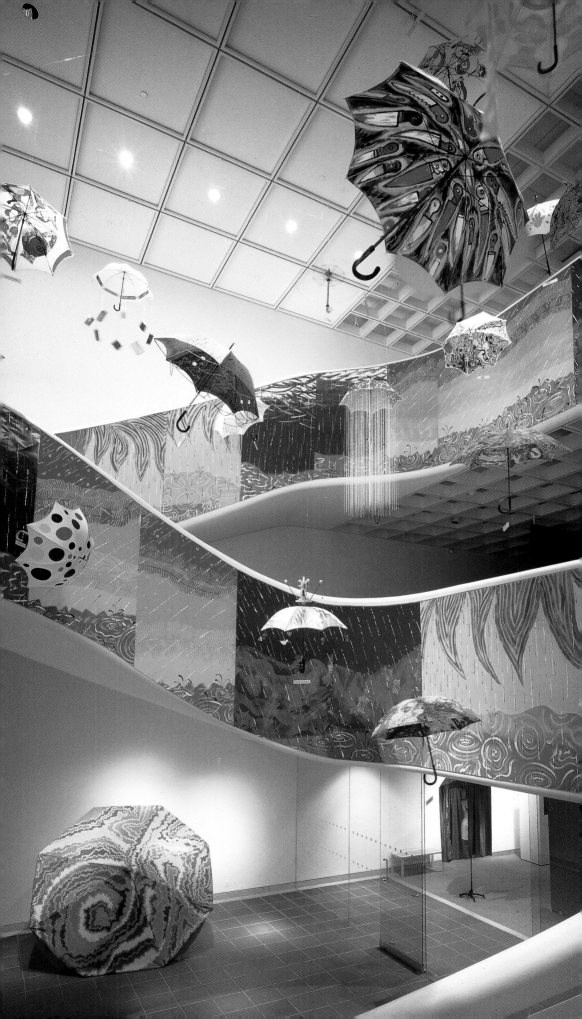

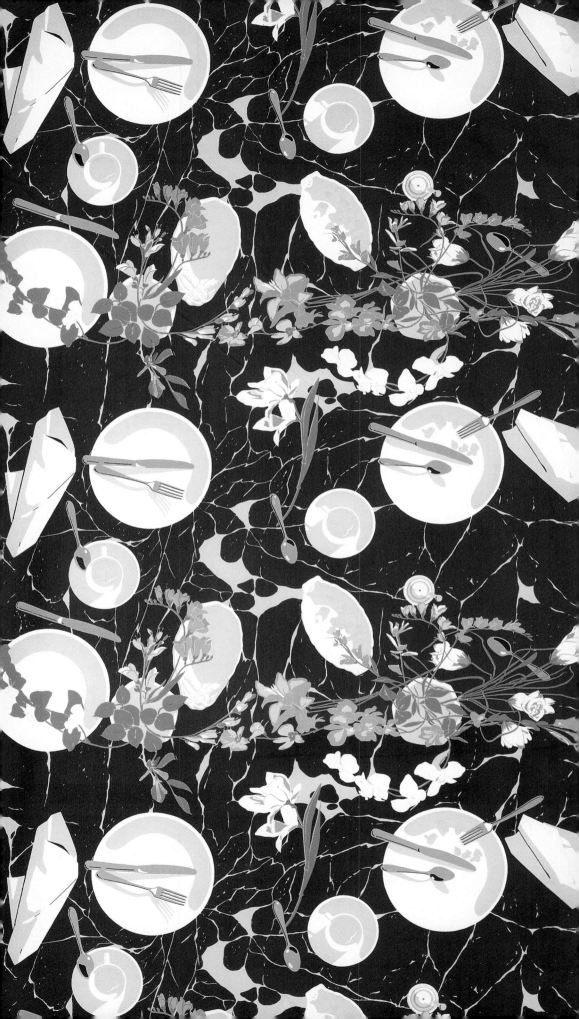

# Useful Objects
Janet Kardon

**John Moore**
*Dinner* tablecloth, 1981
Pigment on cotton
upholstery sateen
50 x 33-inch repeat

The creation of decorative objects that also perform a function is not a new endeavor. William Morris's Arts and Crafts movement and the Bauhaus are the most conspicuous historical predecessors of this interest on the part of certain painters, sculptors, and architects in creating useful objects—furniture, tableware, clothing, jewelry—as adornment for the home or body. A startling phenomenon, though, is that at the same time that painters and sculptors are crossing these borders, many artists working in traditional craft media are creating nonfunctional "sculptural" works. Works that have been created at The Fabric Workshop by painters, sculptors, architects, and artists working in craft media are evidence that the quality of any art object ultimately resides within the object itself rather than the confines of its discipline.

**Italo Scanga**
*Animal* napkins, 1981
Pigment on bleached
cotton muslin
21 x 21 inches
Sets of four

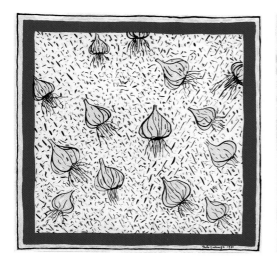
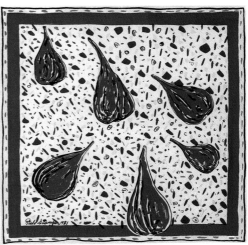
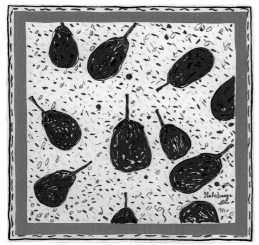
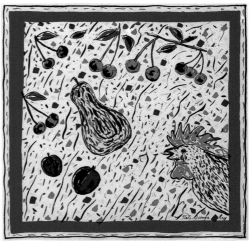

**Italo Scanga**
*Vegetable* napkins, 1981
Pigment on bleached
cotton muslin
21 x 21 inches
Sets of four

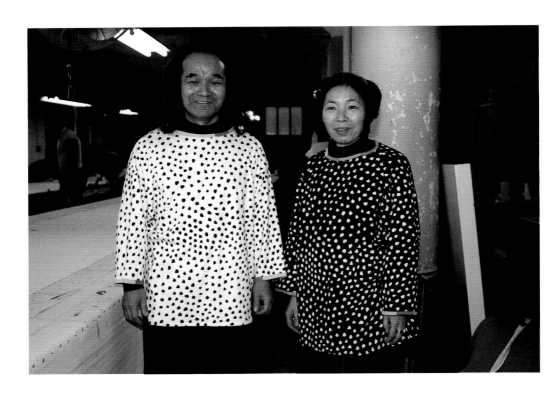

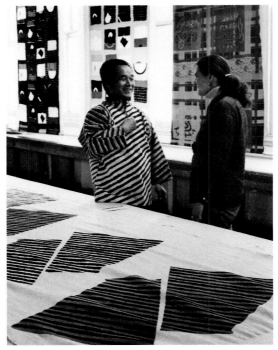

**Jun Kaneko**
*Dot* shirt, 1987
Pigment on cotton
jersey
27 x 56 inches
Modeled by the artist
and Fumi Kaneko at
the Workshop in 1987.

Jun Kaneko and
Stephanie Smedley,
with pattern for
Kaneko's canvas shirt,
1979.

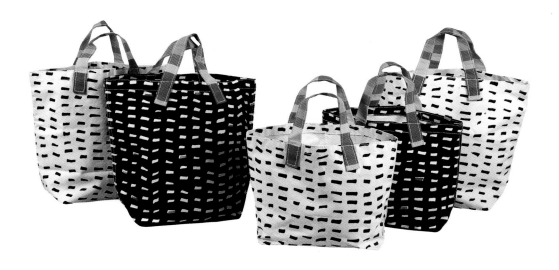

**Jun Kaneko**
*Coat,* 1980
Pigment on cotton
canvas with
handpainting
41 x 63 inches

**Jun Kaneko**
*Dash bags,* 1980
Pigment on cotton
canvas with
handpainting
Large bag:
18 x 21 x 9 inches
Small bag:
14 x 20 x 7 inches

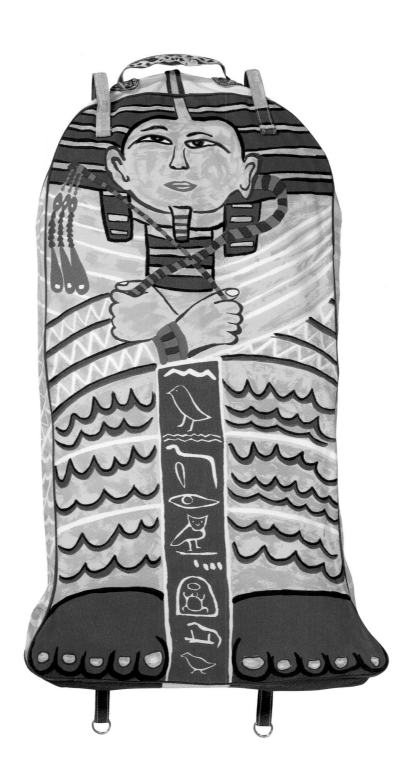

**Red Grooms** and
**Lysiane Luong**
*Mummy Bag* garment
bag, 1985
Pigment on cotton
canvas
48 x 26 inches

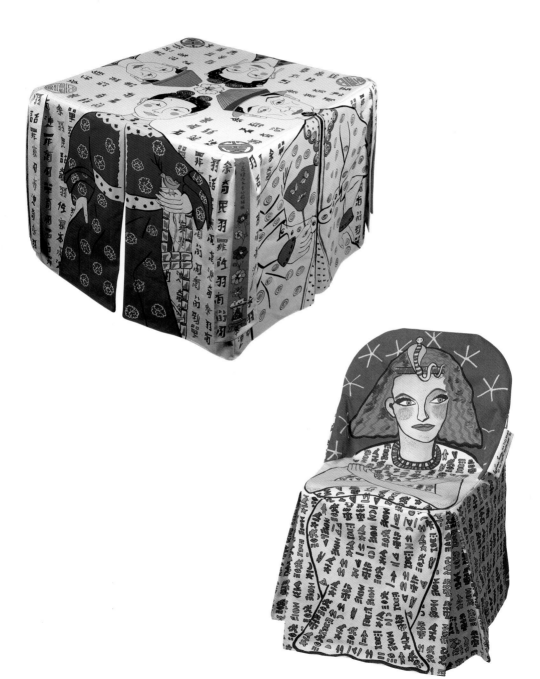

**Lysiane Luong**
*Mah-Jong Mandarins*
tablecover, 1985
Pigment on cotton
sateen
33½ x 27½ x 33½
inches

**Lysiane Luong**
*Rita Hayworth Meets
Nefertiti* chaircovers,
1985
Pigment on upholstery
sateen with
handpainting
30 x 19 x 16½ inches

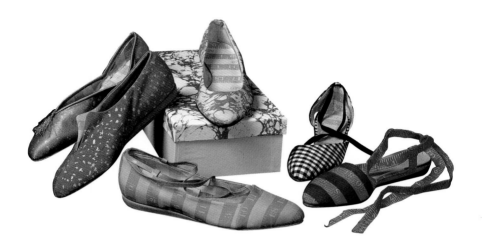

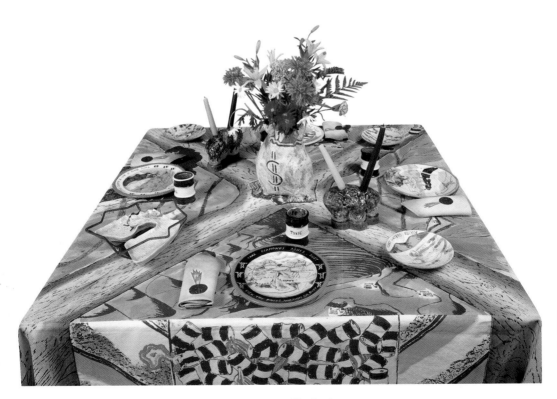

**James Carpenter,
Toshiko Mori, and
Seaver Leslie**
*Best Foot Forward*
shoes, 1981
Pigment and dyes on
silk with leather soles
*Americans for
Customary Weight and*

*Measure, The Toshiko*
and *The Marble Fabric,*
1980
Pigment on silk
broadcloth

**Rebecca Howland**
*Toxicological
Tablecloth,* 1984
Pigment and
handpainting on linen,
with *Cancer Lung*
ashtray, *Money Bag*
vase, and *Toxic Drum*
cups by the artist
85 x 85 inches

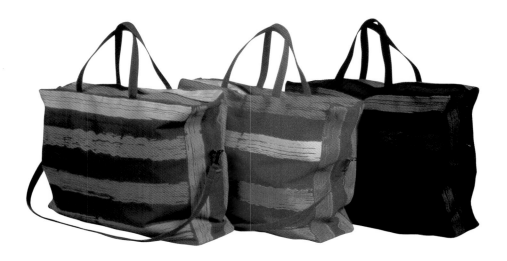

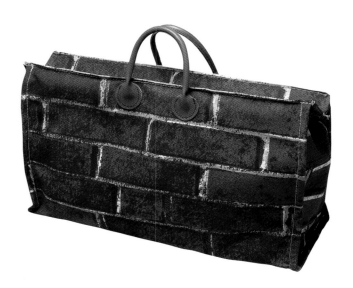

**Nancy Graves**
*Suitcase,* 1983
Pigment on cotton
canvas
20 x 26 x 7 inches

**Bob Bingham**
*Brick* bag, 1986
Pigment on cotton
canvas, leather handles
11 x 19 x 7 inches

**Roy DeForest**
*Gridley* bag, 1984
Pigment on cotton
canvas
32 x 22 x 9 inches

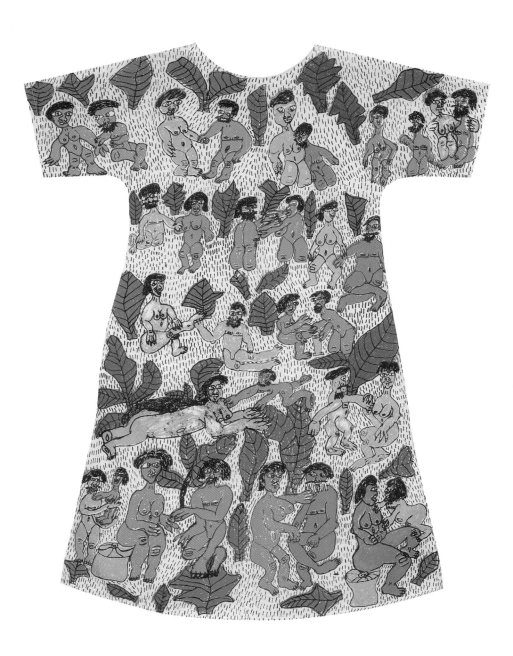

**Will Stokes, Jr.**
*People* dress, 1979
Pigment on cotton
45 x 35 inches
Private collection

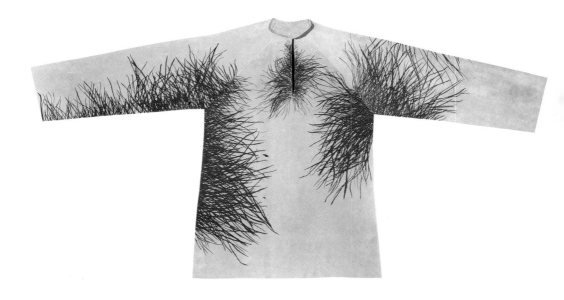

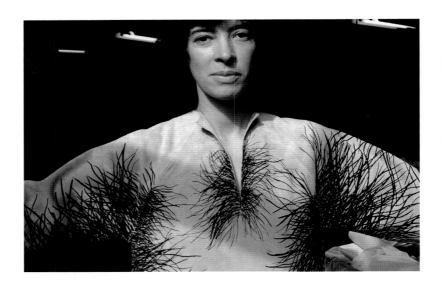

**Jody Pinto**
*Hair Shirt,* 1978
Pigment on pigskin
30 x 63 inches

Jody Pinto wears her
*Hair Shirt.*

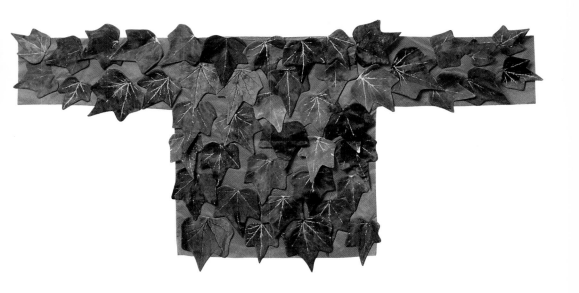

**Vito Acconci**
*Leaf Shirt,* unfinished
object, 1985
Pigment on polycotton
blend
23 x 51 inches

*Leaf Shirt* (detail).

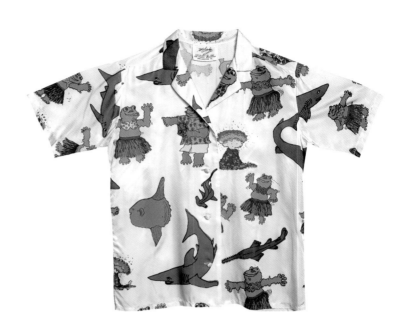

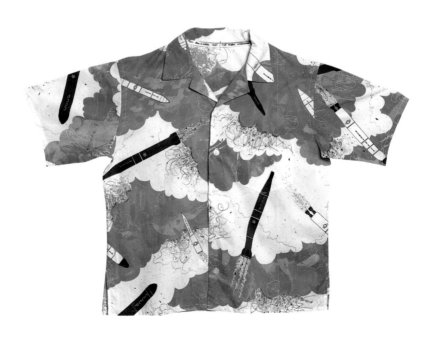

**David Gilhooly**
*Hawaiian Frog* shirt, 1981
Pigment on viscose
rayon challis
28 x 36 inches

**Ken Dawson Little**
*Toy* shirt, 1987
Pigment on silk poplin
29 x 40 inches

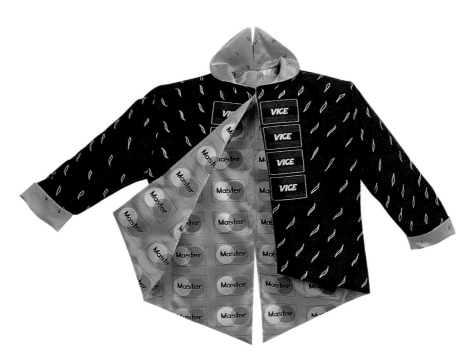

**Patrick Siler**
*Big Brother* shirt, 1987
Pigment on beige silk
poplin
31 x 40 inches

**Phoebe Adams**
*Vice Master* jacket, 1987
Pigment on silk
duppioni; lining:
pigment on silk satin
25 x 50 inches

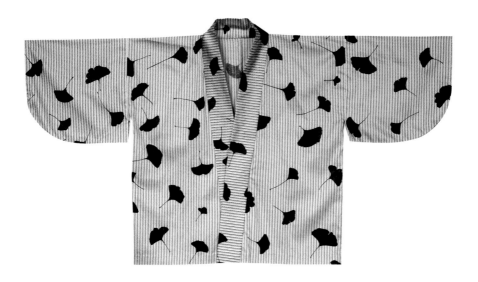

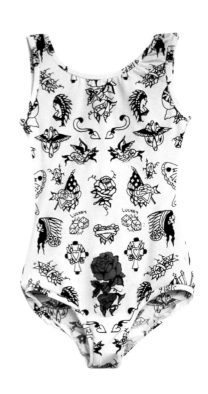

**Diane Itter**
*Ginkgo* kimono, 1978
Pigment on Swiss
pima cotton with
woven stripe
(black colorway)
24 x 40 inches

**Claire Zeisler**
*Swimsuit* with *Tattoo*
yardage, 1980
Pigment on nylon and
Lycra spandex
22½ x 11 inches

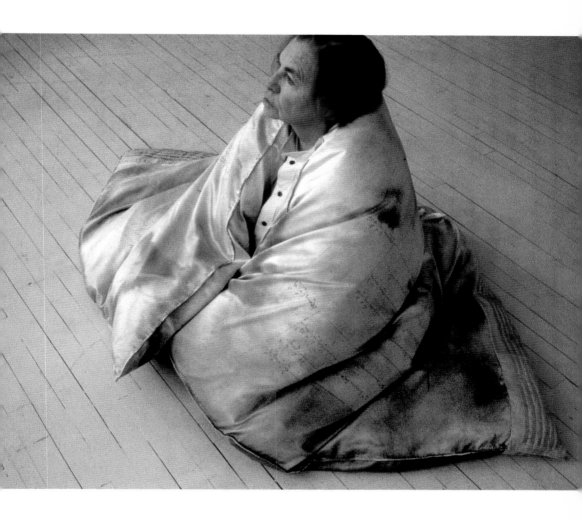

**Lenore Tawney**
*Cloud Garment,* 1982
Pigment on silk satin
and silk pongee,
stuffed with goose
down
50 x 76 inches
Worn by the artist

Moe Brooker (left)
checks screens with
master printer Robert
Smith, 1985.

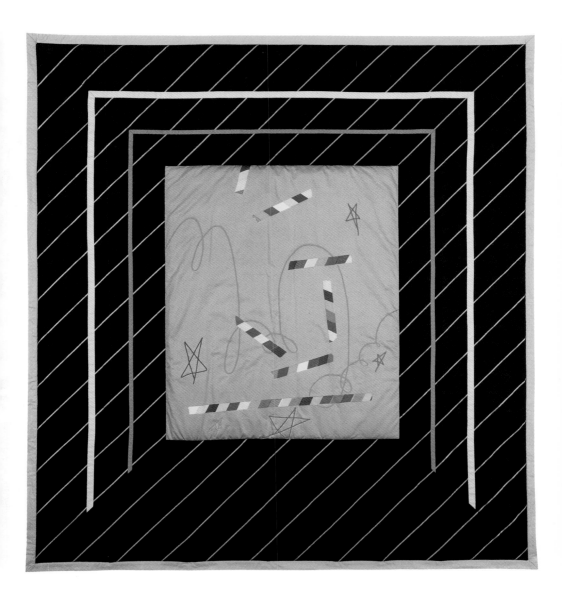

**Moe Brooker**
*Moché* quilt, 1985
Pigment and fiber-
reactive dyes on cotton
sateen with appliqué
and industrial
embroidery
100 x 88 inches

**Susan Chrysler White**
Untitled quilt
Pigment on rayon
antique satin
87 x 87 inches

**John Ferris**
*Black Landscape* quilt,
1983
Pigment on Amish
cotton, quilted with
multicolored silk
thread and cotton
batting
100 x 72 inches
Quilted by Bob Douglas,
Berkeley Springs

**Yoshiko Wada**
*Shadow Figure,* 1983
Indigo dye and
Japanese rice paste
resist on cotton sateen
82 x 52½ inches

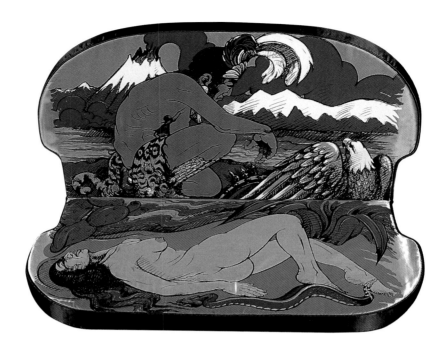

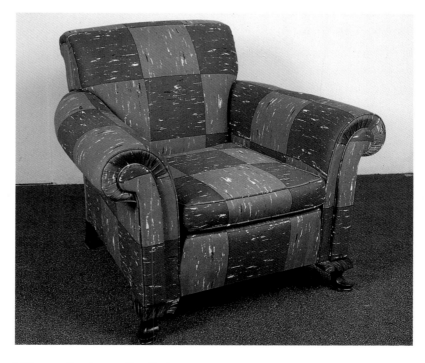

**Luis Jimenez**
*Low Rider Backseat,*
1983
The back seat of a
Volkswagen, the top of
which is an Indian
chief, the bottom an
Indian maiden; printed
in pigment on pink
satin, with cotton

batting, muslin, ply-
wood, and foam.
34⅛ x 59¼ x 29 inches

**Tony Costanzo**
*Linoleum,* 1980
Pigment on cotton
sateen (green color-
way), found chair
designed by Marie
Keller
Collection of Marie
Keller

**Andrea Gill**
*Holding It All Together*
scarf, 1989
Acid dyes on silk
42 x 42 inches

**Richard DeVore**
*From Kuba* scarf, 1980
Fiber-reactive dyes on
natural silk pongee
38 x 39 inches

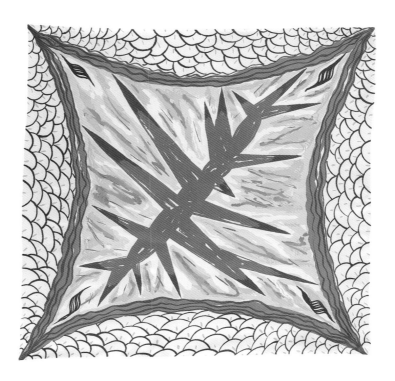

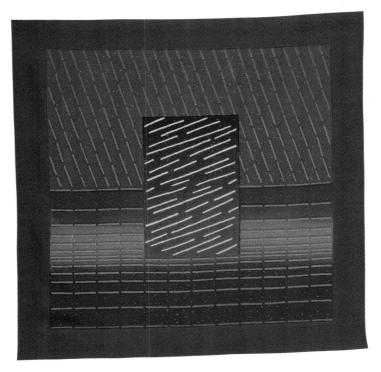

**Gregory Amenoff**
*Espina* scarf, 1990
Acid dyes on silk
charmeuse (red
colorway)
43 x 43 inches

**Phillip Warner**
Untitled scarf, 1979
Acid dyes on natural
silk broadcloth
28 x 28 inches

138

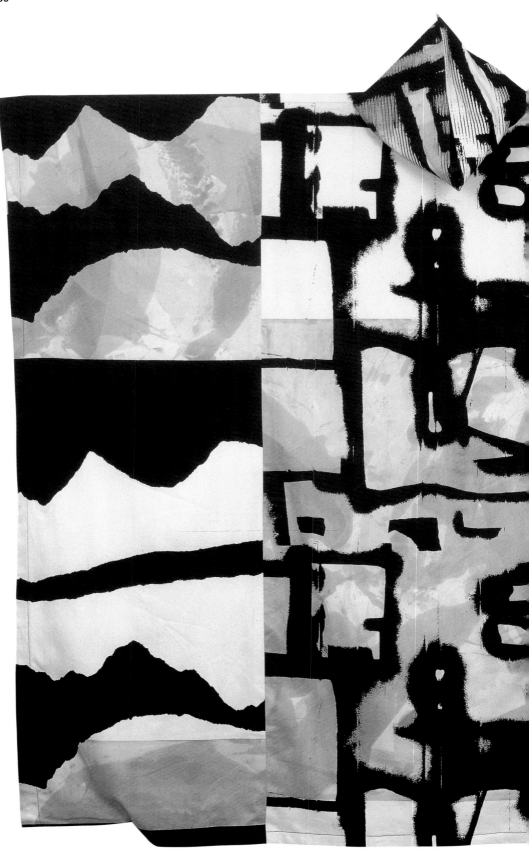

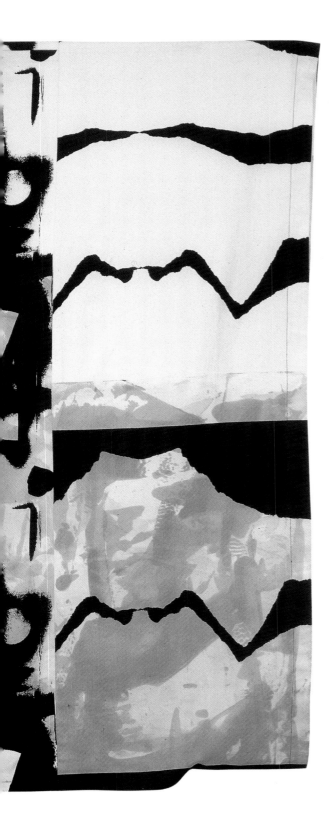

# Performance
Marian A. Godfrey

Some of the most challenging and gratifying work of the past thirty years has been created by visual artists working within the medium of live performance and by collaborations between visual and performing artists. Fabric is a versatile medium for the creation of performance environments as well as costumes, and The Fabric Workshop has worked with a number of artists to explore its use in performance.

Nancy Graves has designed costumes whose subtlety of texture complements the fluidity of Trisha Brown's choreography (p. 201). Louise Nevelson has applied her vision to operatic scale in designing costumes and settings for *Orfeo ed Euridice*. Robert Whitman, a pioneer in the development of multimedia performance, beginning with the Happenings of the early 1960s, has created in *Black Dirt* a performance environment that highlights the use of clothing for set pieces. Joseph Nechvatal has imagined a visual environment for *XS, The Opera*, a collaboration with composer Rhys Chatham, that displays slide projections on a textured fabric surface.

The Fabric Workshop's collaborations with these gifted artists have yielded a rich and diverse array of work that integrates visual and performance elements.

**Louise Nevelson**
*Opera Costume*, 1985
Pigment on cotton twill
Three designs pieced together with open-screen marbled background
67 x 69 inches
Edition of forty
Printed at The Fabric Workshop, New York
Commissioned by the Opera Theater of St. Louis's production of *Orfeo ed Euridice*

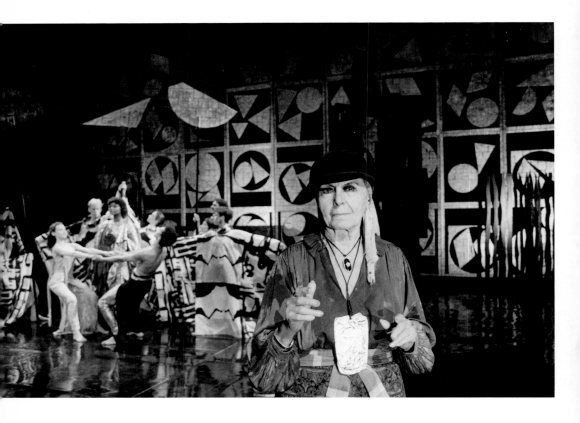

Louise Nevelson and
dancers wear the cos-
tumes—printed at The
Fabric Workshop—that
she designed for the
Opera Theater of St.
Louis's 1984 production
of *Orfeo ed Euridice.*

A performance of
*Orfeo ed Euridice,* 1984.

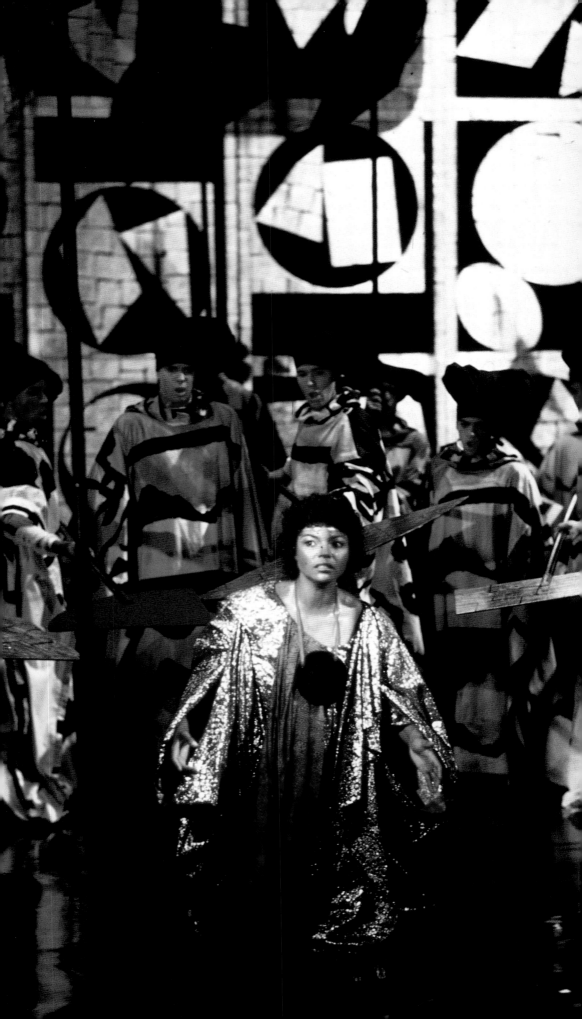

**Joseph Nechvatal**
*Night Train,* 1985
Pigment on canvas
and cotton batiste with
handpainting, from an
enlargement of an
original graphite
drawing by the artist,
stretched over frame
48 x 52 inches

Joseph Nechvatal's
performance of the
opera *XS* at the
Solomon R.
Guggenheim Museum,
New York, 1985.

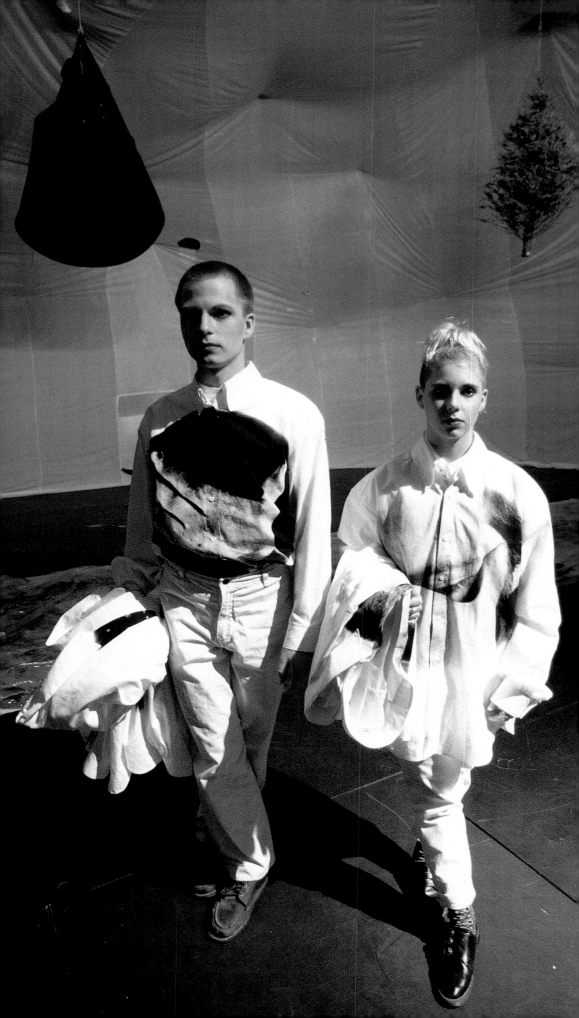

Robert Whitman (left)
at a 1990 performance
of *Black Dirt* at M.I.T.'s
List Visual Arts Center,
Boston.
This piece was also
performed at The
Kitchen, in New York
City; the Painted Bride
Art Center, in Phila-
delphia; and the
Walker Art Center, in
Minneapolis.
Since the days of
Happenings in the
early 1960s, Whitman
has been a pioneer in
the development of
theater rooted in
psychologically
charged images and
poetic restructuring of
time and space in lieu
of more traditional
elements of narrative
and character.

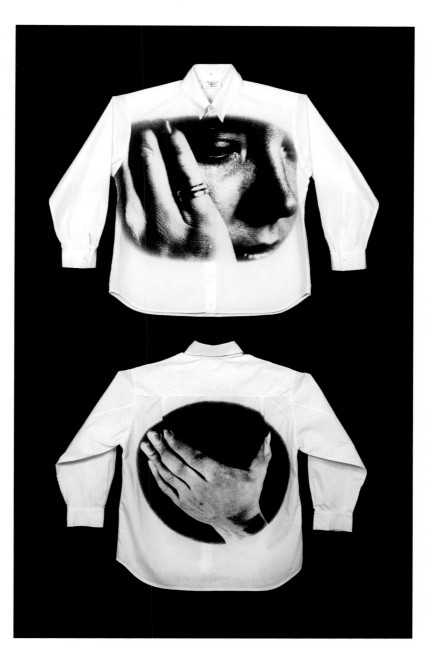

**Robert Whitman**
*Black Dirt* costumes,
1990
Pigment on cotton
broadcloth
Edition of four sets
of eight shirts in
graduated sizes.

Four of the eight
shirts are for a male
performer, four for
a female performer.
The screen printed
halftone simulates a
photo projection.

## Installation
Alanna Heiss

A curator approaching an installation-style exhibition will find several constants among the many variables:

*One must work directly with the artist; no dealer, collector, or studio assistant can make the ultimate artistic decision, and the very nature of the experience precludes any normal curatorial role beyond the choice of the artist.*

*One becomes more actively involved with the production dimension, whether one is locating and transporting bones, boats, or boulders.*

*One can rarely predict the exact result of the experience.*

*When it's over, it's over.*

The very definition of The Fabric Workshop implies its willingness to not only invite but actively work and assist in the production of an unknown "thing," to experiment with intangibles, and to risk failure. Most important, the mounting of any installation involves mutual trust between artist and organizer. It is no surprise that the Workshop, with such a long track record of devotion to the individual artist, has such an important place in the development of this unwieldy form of exhibition-making.

**Phillip Maberry**
*Mao Wow* installation, 1987, for The Fabric Workshop *Decade of Pattern* exhibition at the Graduate School of Fine Arts, University of Pennsylvania, Philadelphia. Pigment and acrylic with handpainting on silk, cotton flannel, canvas, and cotton sateen; also, hand-painted ceramics and furniture by the artist and two paper prints of *Mao* by Andy Warhol 180 x 144 x 30 inches

148

**Ned Smyth**
Installation at the
Grey Art Gallery,
in New York, a portion
of which is now a
permanent part of the
Ludwig Collection,
Cologne, Germany;
1978. The installation
combines Smyth's
concrete sculpture and
print editions in cotton,
silk, tweed, and satin.

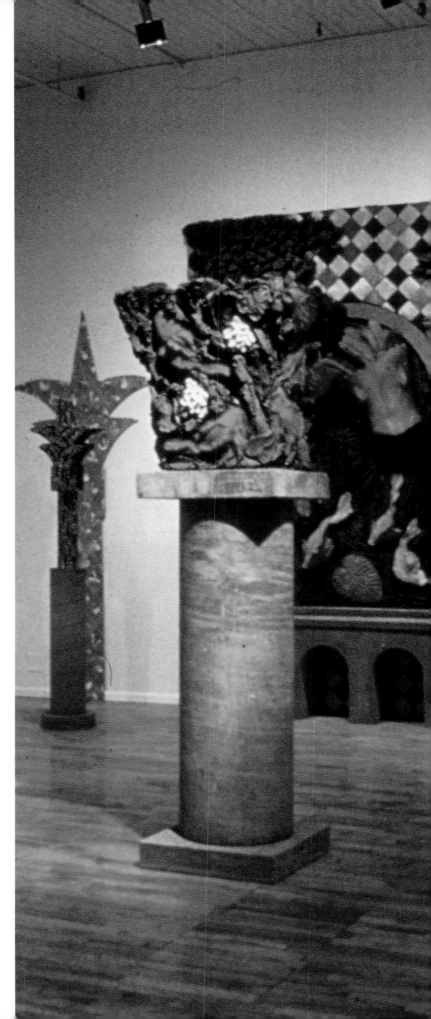

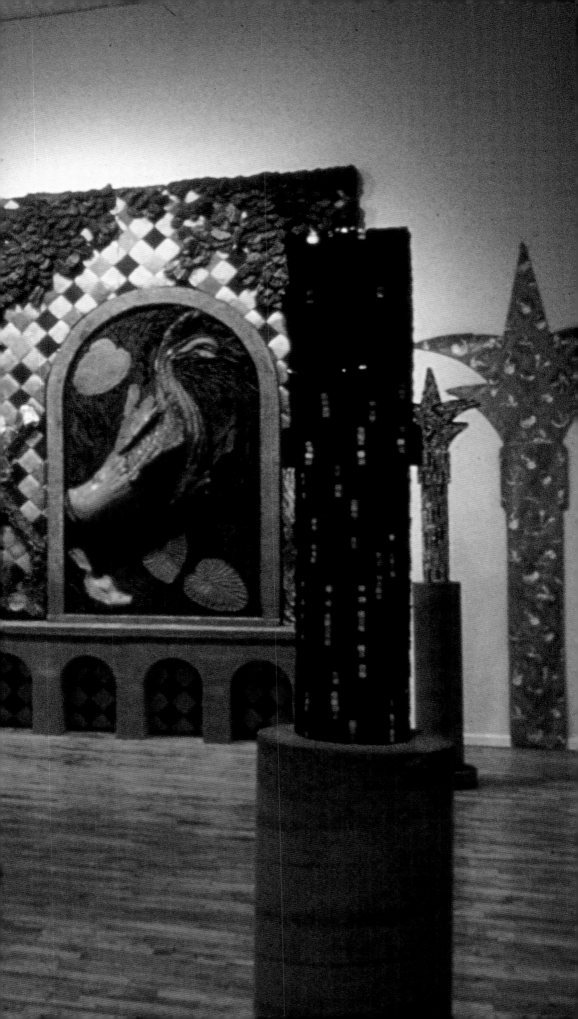

**Anita Thacher**
*All through the House*
installation, 1985, at
The Fabric Workshop's
New York gallery at
205 Mulberry Street.
Pigment on industrial
felt and polyester
sheer with television,
chair, rug

*Thacher's* All through
the House *reached
through time and
traditions to mediation
on the beauty of
domestic life, fusing
various genres in a
new hybrid form. . . .*
—Anne Sargent
Wooster, *Art in America,*
December 1985

following pages:
**Red Grooms and
Lysiane Luong**
*Tut's Fever* installation,
1985, with *Rita
Hayworth Meets
Nefertiti* chaircovers—
seating for Grooms's
"Ruckus Shorts"
theater at the Penn-
sylvania Academy of

the Fine Arts (part
of the permanent
collection of Brooklyn's
Theater of the Moving
Image).
Pigment on cotton
sateen with
handpainting
30 x 19 x 16½ inches

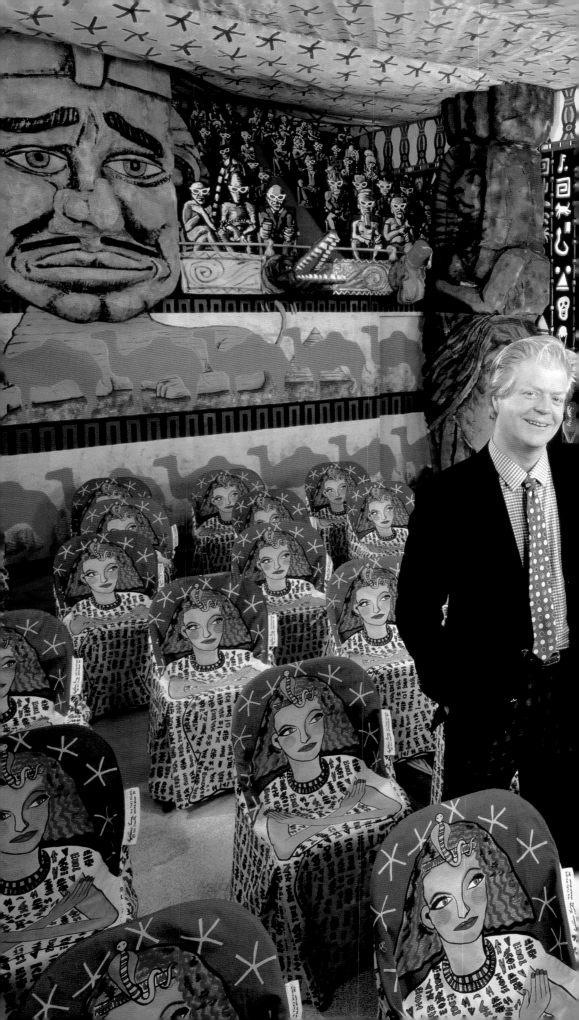

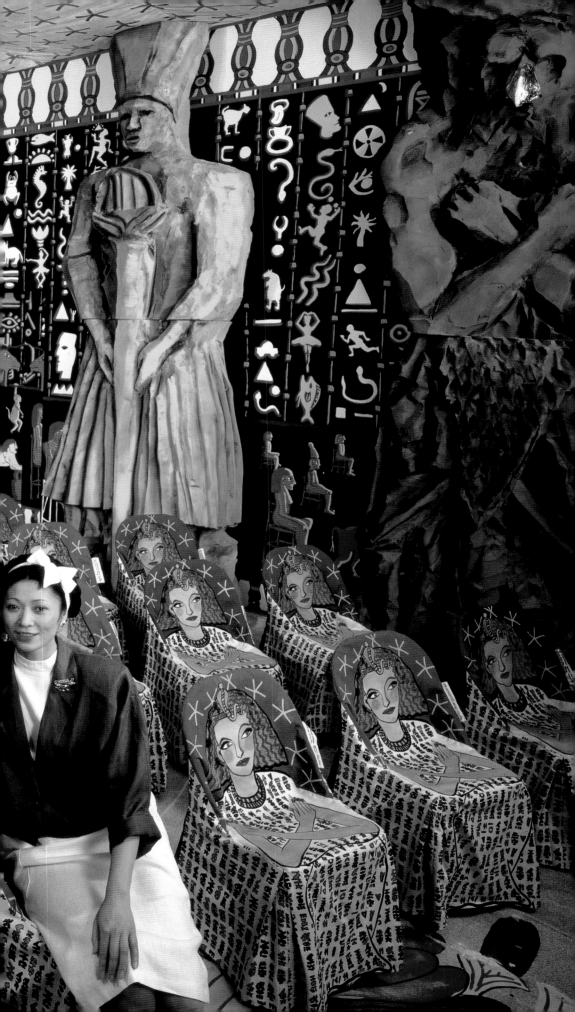

**Houston Conwill**
*Second Lining* street
umbrella, 1987
Gold metallic pigment
printed with ten
handpainted colors on
cotton canvas, with
gold fringe
Height: 80 inches
Diameter: 108 inches
Edition of ten

Houston Conwill's
*Second Lining,* an
outdoor installation at
Philbrook Museum,
Tulsa, Oklahoma, 1987.

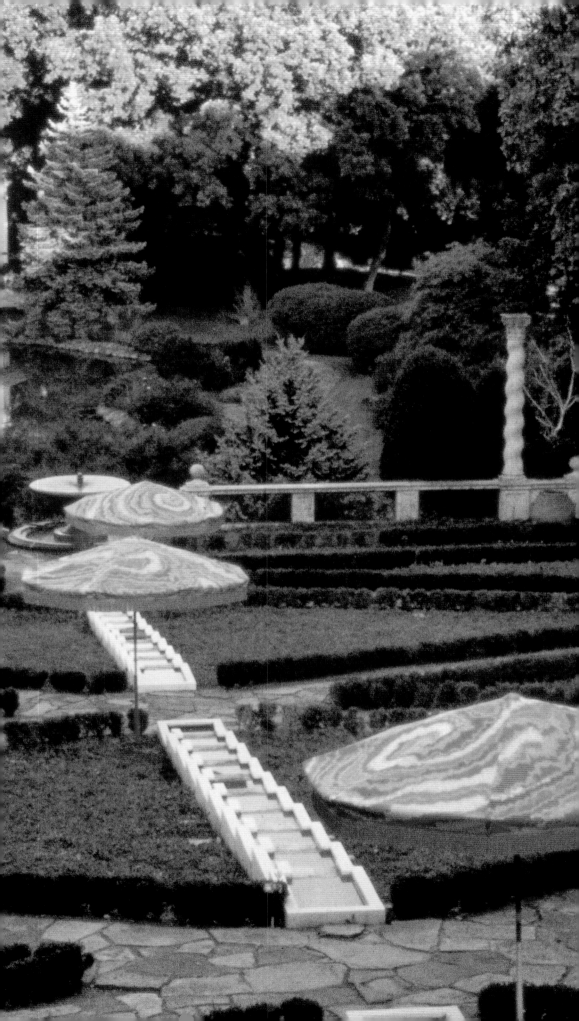

**Robin Winters**
*Fressen Zum Denken:
Bonaparte's Party*
tablecloth and table,
1988, installation at
The Fabric Workshop
Forty-eight untitled
monoprints
Pigment on cotton
Monoprints:
44 x 33 inches
Tablecloth:
44 x 537 inches
The exhibition was
originally presented at
the Bonnefante
Museum, Maastricht,
Holland, in 1984.

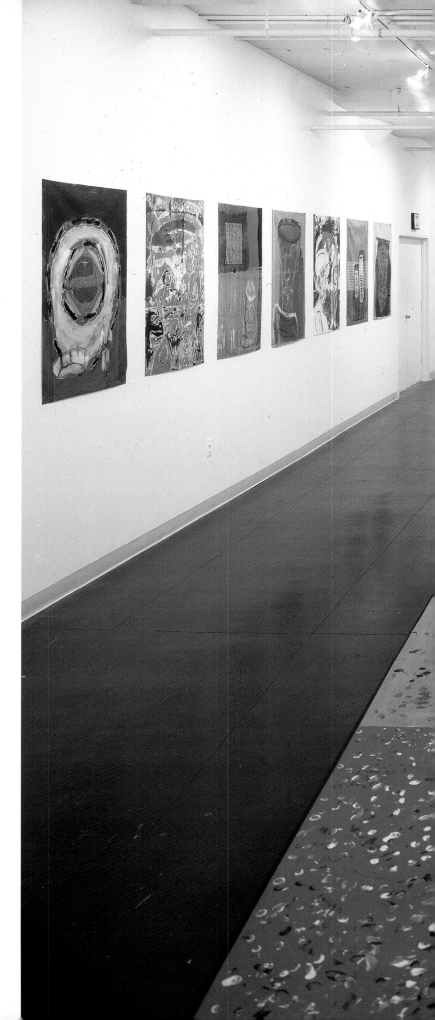

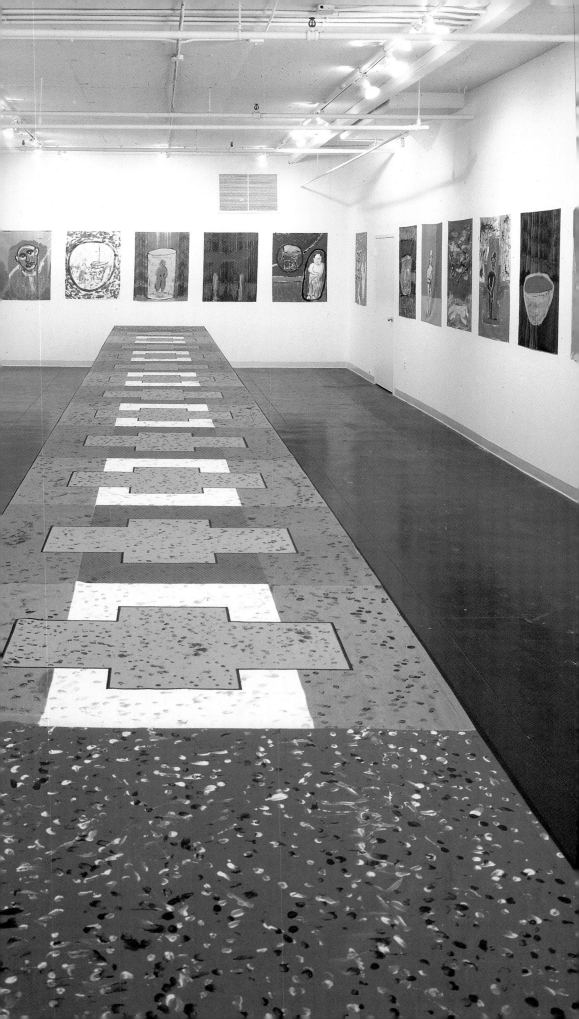

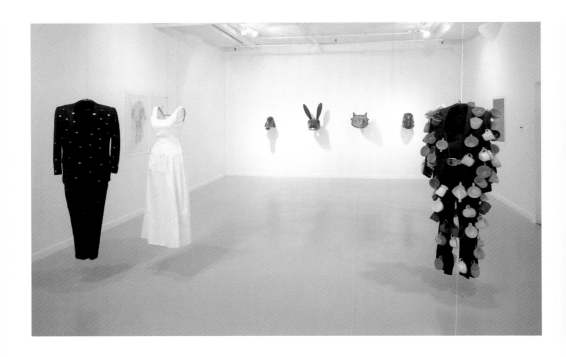

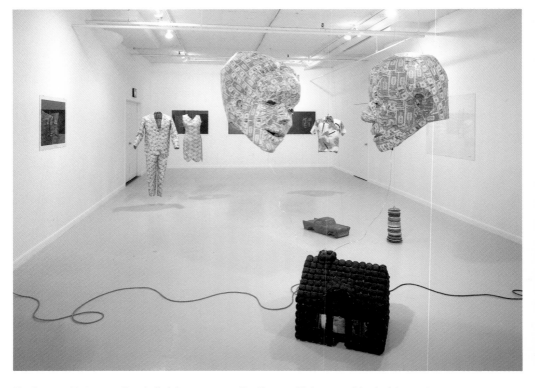

**Ken Dawson Little** *Elements of Progress* installation (partial view), 1989, at The Fabric Workshop. From left: *Rose and Bud,* evening gown and tuxedo with buttonholes and buttons, respectively. *Drawing for Buck and Doe,* India ink on vellum. *Bronze masks,* swan, rabbit, horned toad, gorilla. *Blossom,* man's dark pinstripe suit with plastic cups attached, used in performances between 1986 and 1988.

**Ken Dawson Little,** *Elements of Progress* installation (partial view), 1989, at The Fabric Workshop. Erased charcoal drawings, 22 x 30 inches, on rag paper, 1988. *House Made of Charcoal Briquettes,* with television and tape recorder. Wires inside the house lead from the chimney to the speakers in *Mom and Pop* masks, suspended by a stack of thirteen Gideon Bibles, thirty Fiesta-ware plates, and a 1957 Chevrolet.

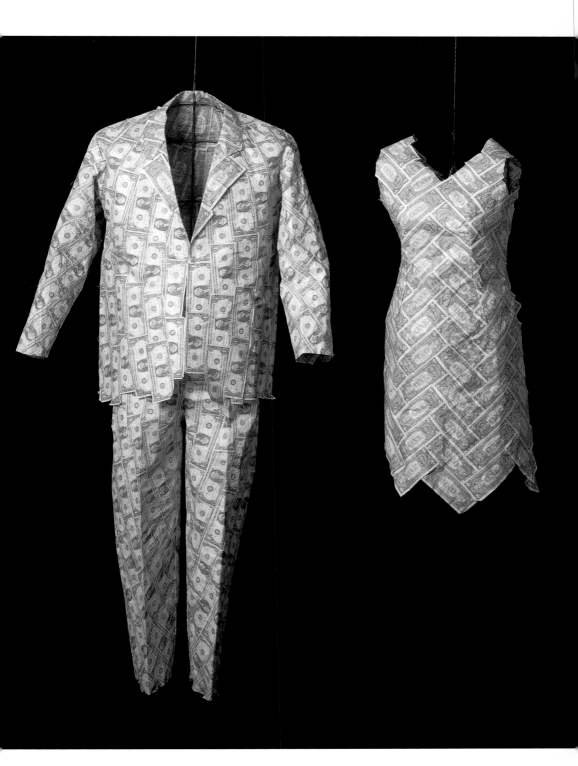

**Ken Dawson Little**
*Bread Couple, Buck and Doe* suit and dress, 1988
Constructed entirely of 450 U.S. one-dollar bills
*Buck* (left):
62 x 23 x 12 inches
*Doe:* 34 x 18 x 12 inches

**David Ireland**
*Pan of Clues,* 1989
Red fiber-reactive dye
in metal container, hot
plate, steam kettle,
cotton wick

**David Ireland**
*Chunk in the Cabinet,
Chunk out of the
Cabinet, with Doors
Permanently Ajar*, 1989
Metal cabinet,
concrete, electrical
wiring and bulb, canvas
duck, wood

**David Ireland**
*Table and Bolt,* 1989
Concrete, iron and
metal, electric light, silk

*I call myself a non-media installation artist. I prefer to explore without any end or purpose in sight, an active inquiry on an architectural scale. I just live my life and my art occurs in the process.*
—David Ireland at The Fabric Workshop, January 1989

following pages:
**David Ireland**
*Camp* installation
(interior view), 1989, at
The Fabric Workshop.
Muslin tent and studio
materials (concrete,
metal, fabric)
144 x 216 x 120 inches

*Dumb Bookends* (in
process) in foreground,
with *Dumb Ball* (left)
and other objects.

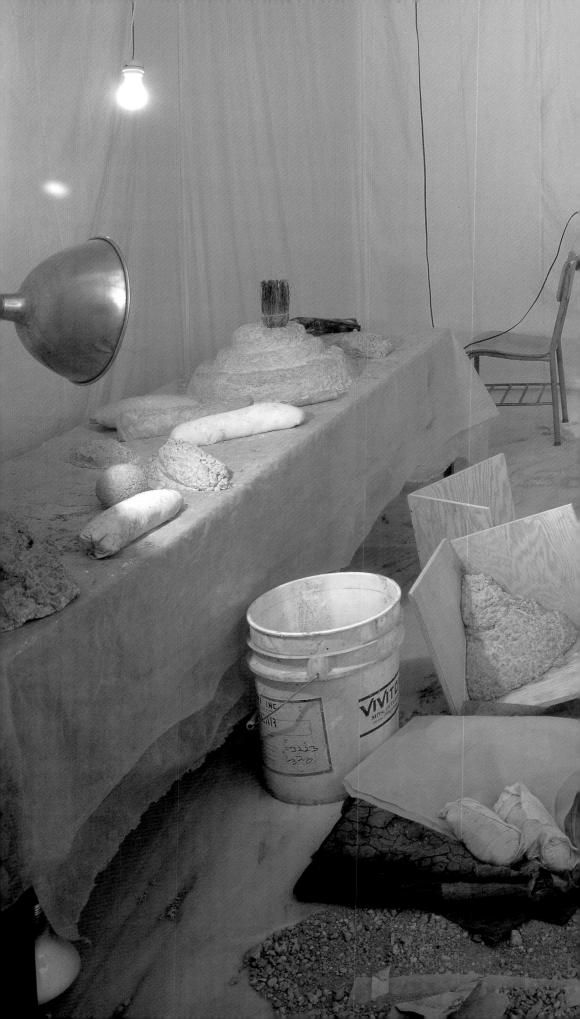

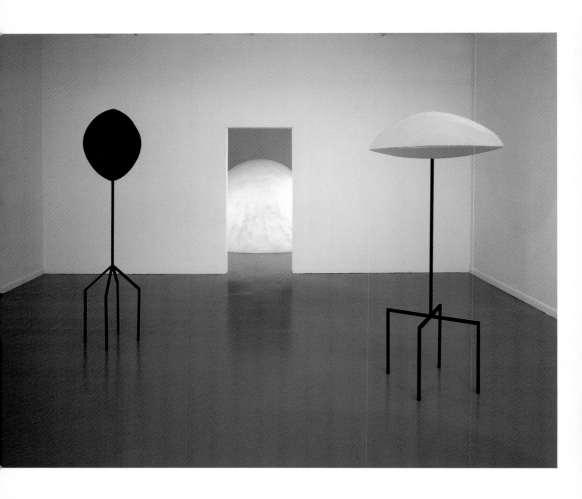

**Jene Highstein**
Two *Anti-Lamps,* 1989
Iridescent handwoven
Indian and French
silks, handsewn and
stretched over painted
and welded metal
armatures

Orange: 75 x 34 x 18
inches
Black: 78 x 16 x 16
inches
Two of nine silk-and-
steel sculptures
produced in collabo-
ration with The Fabric
Workshop, 1988–89;
view of *Great Manis*
through doorway.

Eight people worked
for more than three
hundred hours with a
cement mixer and
ninety-seven bags of
concrete to produce
*Great Manis.* A ply-
wood armature was
covered with layers of
galvanized chicken
wire that were then
stapled to the armature

along with wood
lathing. The form was
then covered with
three to four inches of
ferro cement—mixed
from three-parts yellow
bar sand and one-part
gray Portland cement—
placed with a hand-
troweled finish. It was
strong enough to walk
on.

**Jene Highstein**
*Great Manis*
installation, 1989, at
The Fabric Workshop
Ninety-seven bags of
ferro cement with eigh
to fifteen layers of woo
and wire armature
67 x 120 x 348 inches

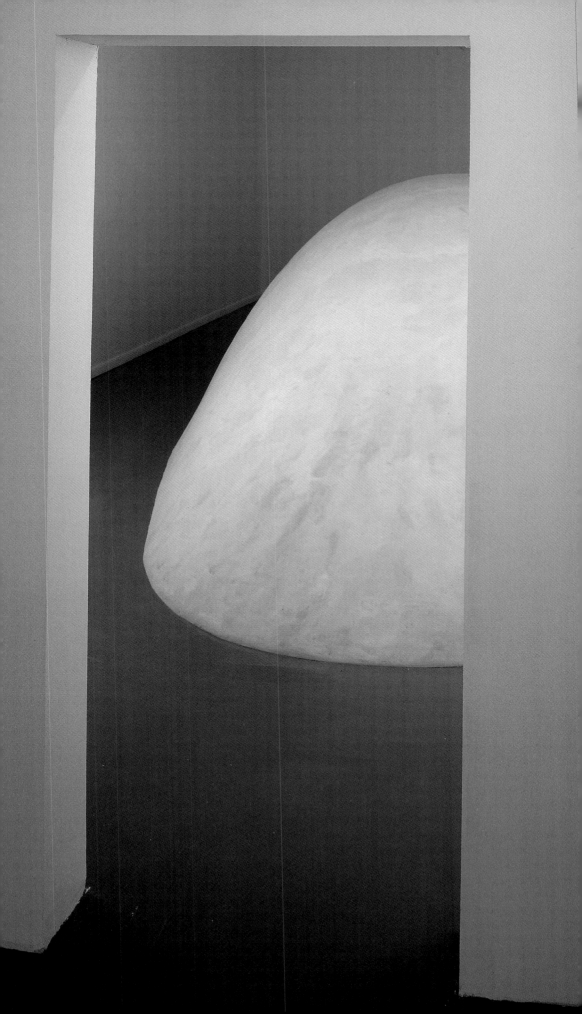

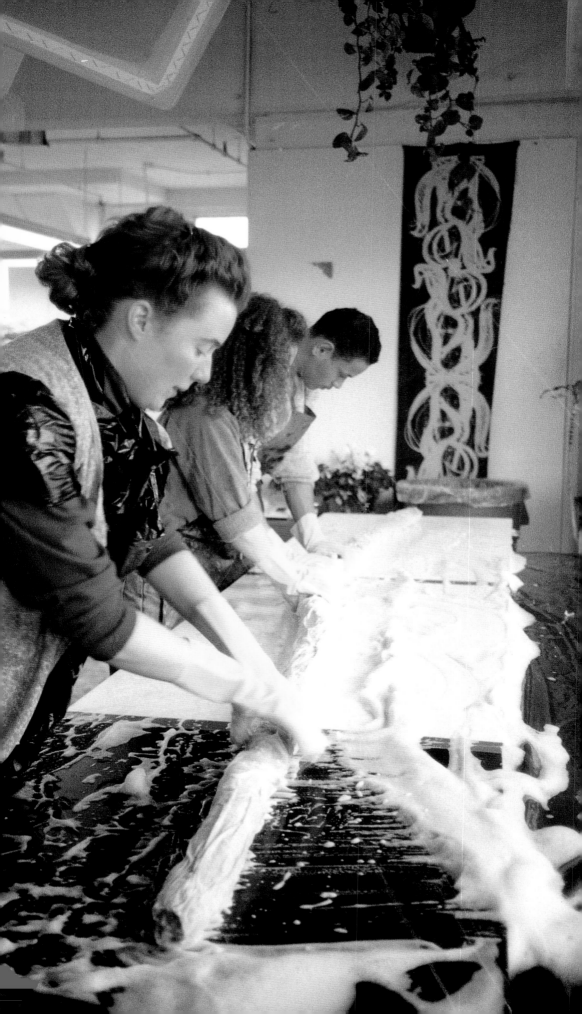

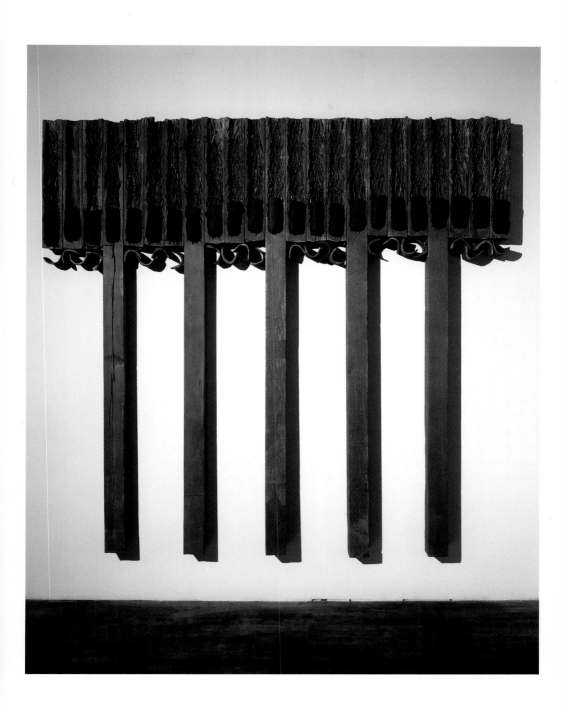

Master printer Christina Roberts (foreground) and apprentices make felt elements for Ursula von Rydingsvärd's *Silver Queen.*

**Ursula Von Rydingsvärd**
*Felt Cup Board,* 1989
Handmade wool felt, handcarved cedar
80 x 82 x 60 inches

*My original vision in working with The Fabric Workshop was for us to make enormous sheets of handmade felt and stack them very high. This image was refined by making more specific, almost objectlike, pieces out of felt. Watching the process of the raw, airy wool being kneaded into felt until it was hard and solid was exciting; it seemed quick and natural, with a lot of repetition. As is typical of the way in which I make my sculpture, I had these handmade felt chunks visually accessible in the studio for almost a year until I found a situation in cedar appropriate for them.*
—Ursula von Rydingsvärd

preceding pages:
**Gregory Amenoff**
*Good Friday* vestments,
1990
Acid dyes on silk
charmeuse with rayon
lining
51 x 63 inches
Worn by Father
Mennekes (center) and
two deacons at Saint
Peter's Church, Cologne,
Germany, with paint-
ings by the artist

**Donald Lipski**
*Black by Popular
Demand,* 1990, at The
Corcoran Gallery of
Art, Washington, D.C.
Silk organza
25 x 25 x 21 feet
Made for the artist by
The Fabric Workshop
staff, *Black by Popular
Demand* is now part
of the Corcoran's
permanent collection.

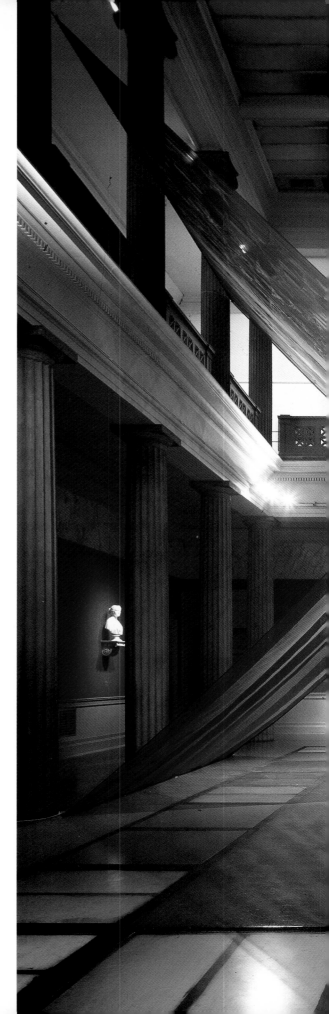

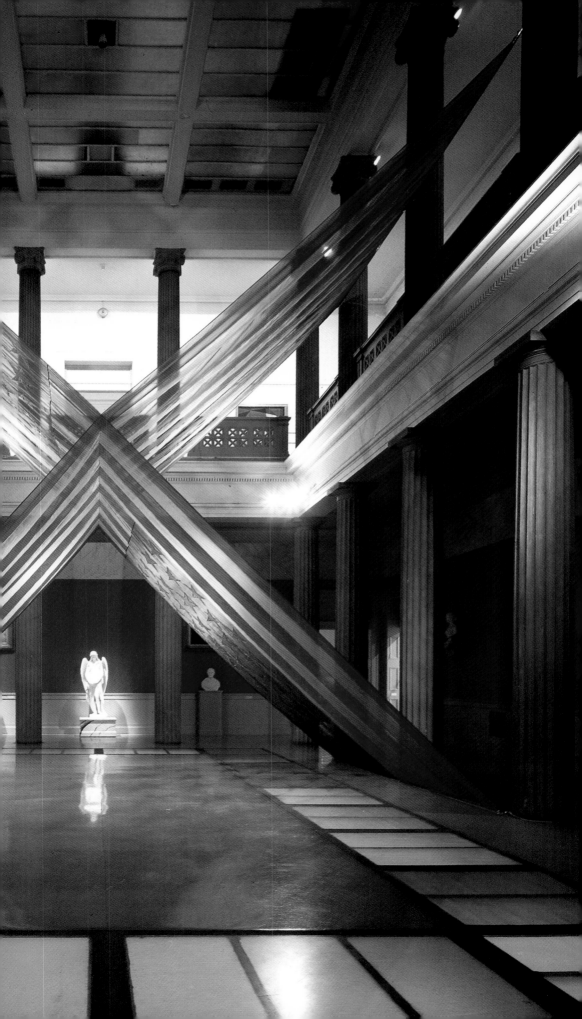

**Cassandra Lozano**
*Vanity in Industry*
exhibition, 1991, at The
Fabric Workshop.
Wood, encaustic,
punched aluminum,
papier-mâché,
handprinted fabric,
beadwork, electric
lights, fan

*Lozano's work is
directly inspired by
tales of mythology,
saintly legends, and
the images of popular
culture. Apparently
diverse, these themes
have in common a
central element of
transformation. . . .
Lozano explores the
way symbols function
as counterparts for
emotions, spiritual
states, and forms of
behavior.*
—Judy Sheperdson

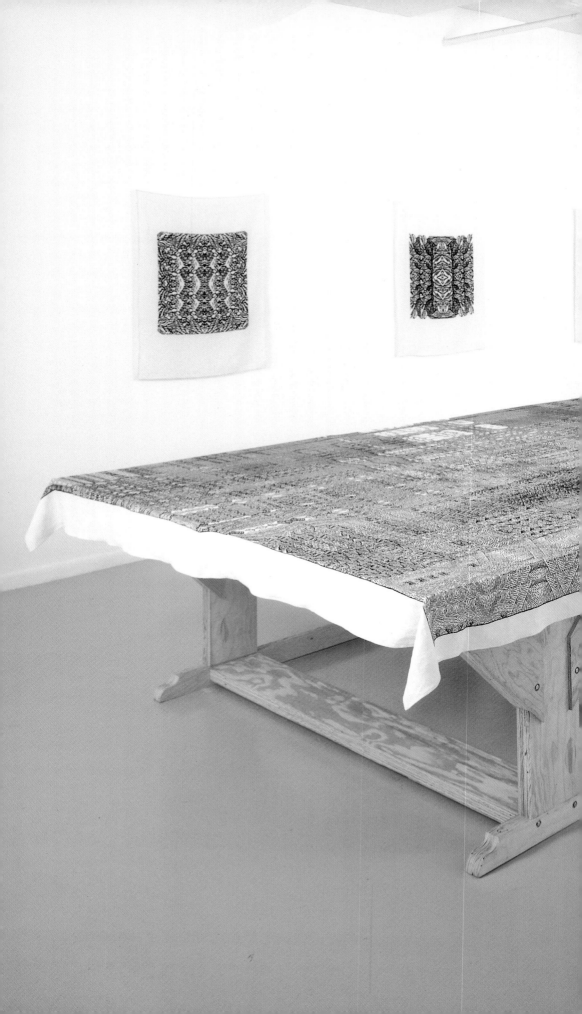

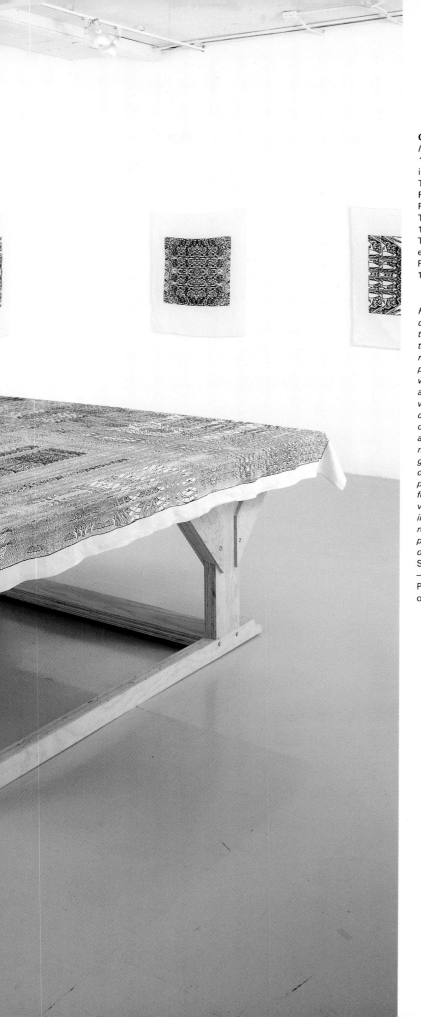

**Carl Fudge**
*Images from Durer's "The Last Supper"* installation, 1991, at The Fabric Workshop. Fiber-reactive dyes on Polish linen
Tablecloth:
136 x 94 inches
Twelve panels:
each 31 x 40 inches
Plywood table:
120 x 78 x 34 inches

*Fudge's installation . . . consisted of a wood table covered with a tablecloth and surrounded by twelve prints silkscreened with images appropriated from Durer's 1523 woodcut. Fudge photocopied a reproduction of this work, cut it up, and reassembled the master's precise graphic designs to create abstract allover patterns. . . . Durer's formal, rational universe was transformed into sensual, irrational, repetitive designs that persistently register in our minds as* The Last Supper.
—John Ittmann,
Philadelphia Museum of Art

**Jesse Amado**
*to circumscribe,* 1991
Wool felt, brass zippers
Height: 22 inches
Diameter: 19 inches

**Steven Beyer**
*Oxalis,* 1990
Bronze
26 x 18 x 8 inches

*Peony,* 1990
Bronze, embroidered
cotton batiste
20 x 10 x 7 inches

# Ruminating on the Changing Character of Art

Mark Rosenthal

**Tony Costanzo**
*Linoleum* banner, 1980
Pigment on natural
cotton sateen (green
colorway)
Width: 44 inches

Throughout the modern period, there has been a great deal of theoretical debate about the nature and definition of art, sometimes at a cost to the potential value of art in society at large. Early in this century, the abstract painter Wassily Kandinsky put forth the view that a central concept is "the spiritual in art." That notion is based on the idea that a transcendent condition is present in the world. Like medieval artist-monks, some contemporary artists have undertaken the task of conveying this immaterial sense, employing the new vehicle of abstraction. In the ever-shifting vision of art, such efforts have represented an attempt to deal with felt sensations. An opposing view, however, might proclaim that physical matter is the preexistent *something* that must take precedence, and that art is in fact "a treating of the commonplace with the feeling of the sublime" (J. F. Millet). In this approach, the power of art lies in its capacity to observe and render a field of heightened perceptions based on an explicit image of the world.

Before the modern period, with all of its competing and somewhat conflicting aesthetic theories, societies generally had little problem determining the meaning of art. For example, throughout most of history, artists have often been engaged to carry out decorative schemes, including those for tombs and public and private buildings. These commissions had specific conditions that were usually based upon function. Hence, Phidias was required to conform his narrative of the Lapiths and Centaurs to the shape of the Parthenon pediment. This was also true during the Renaissance and baroque periods, for artists routinely worked in many media and at many tasks. Therefore, we can understand how a competition in Florence for the commission to sculpt the Baptistry doors easily commanded the attention of the most accomplished sculptors and architects of the day. Some artists of the time were visionaries in a certain conceptual sense: Michelangelo created paintings, sculpture, and architecture; Bernini was a "designer" of buildings, city squares, fountains, and sculpture; and Rubens painted as well as designed tapestries, gardens, and public spectacles. Regardless of their fame, artists of earlier times served society, whether educating people in the mysteries of religion or embellishing surfaces for the delectation of the eye.

It is only in the modern period that artists routinely claim the absolute aesthetic freedom to determine the physical dimensions of the work of art and its subject matter. The result of this claim has been that gradually an exaggerated point of view has crept into the thinking of the period, at times dominating all debate. One kind of art has been considered to be overly concerned with functional necessity, whereas "authentic art" has been understood to be free of all external preconditions. But even while the concept of the fully independent artwork has maintained a strong position, there have been quite successful attempts to redress the dichotomy and create a more synthesized view, similar, ironically, to that which held sway throughout much of earlier history. Instead of acting as sensors of the nature of the world, artists could physically manipulate its objective manifestations. This vision initially required co-opting the traditional place of the artisan; and such an effort was made by the Arts and Crafts movement in nineteenth-century England, and was continued throughout the various manifestations of art nouveau at the turn of the century. Subsequently, some painters and sculptors were attracted by an outlook in which the arts were merged. In the 1920s, the De Stijl movement, in Holland, and the Bauhaus, in Germany, attempted

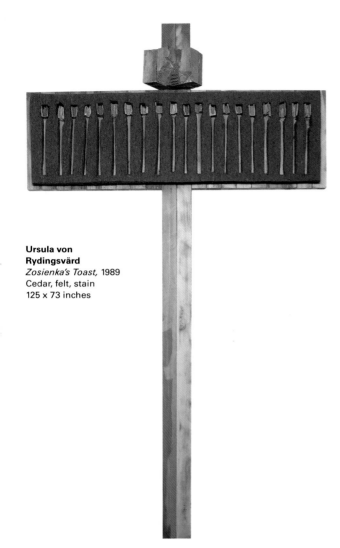

**Ursula von Rydingsvärd**
*Zosienka's Toast,* 1989
Cedar, felt, stain
125 x 73 inches

to project a holistic view of an art-filled world. (Even Kandinsky designed a cup and saucer during his stint at the Bauhaus.) A typical result of this joining of the arts was the admiration that many early-twentieth-century painters and sculptors had for the practice of architecture, believing that the process of constructing expressed a sublime level of ambition to which even completely abstract artists might aspire.

If one steps back from the debate on what constitutes the truly worthy efforts of an artist and simply observes the activities of the painter, sculptor, printmaker, architect, and/or craftsman, a crucial point can be made. All work with their hands to manipulate materials of every description and coax these substances into new states; that is a basic fact. Indeed, all must accept the functional conditions of their chosen media and a vocabulary of form that is essentially universal to every visual phenomenon. Furthermore, these individuals are involved in a process of play. In this creative activity, conventional ideas of hand skill, whether considered as art or craft, are essential. Notwithstanding theoretical positions on the nature of art, most artists must be concerned with concrete, earthly objects. Materialism as a philosophical outlook is impossible to avoid since individuals must start with an activity in the physical world.

Increasingly in the sphere of contemporary art, artists have seized on the possibilities of exploiting the apparent and preconceived contrasts between "art" and "craft," as well as between function and autonomy, in order to move away from conventional notions and distinctions about the nature of high art. This phenomenon is particularly present in the United States: consider Claes Oldenburg's many monuments, such as the *Clothespin* (1976), where the traditional notion of a monument and

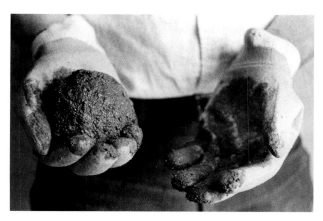

**David Ireland**
*Dumb Ball,* 1988 (in process)
Hand-thrown cement
Diameter: 4 inches

contemporary irony are mixed, or the work of his sometime colleague, the California architect Frank Gehry. Gehry is well known for mingling high art with the everyday vernacular of street life, and allowing the latter, even in its least attractive forms, to inhabit the former. The sculptor Donald Judd makes furniture; the painter Jody Pinto designs bridges as well as shirts (*Hair Shirt,* 1978, The Fabric Workshop) (p. 124); Scott Burton created furniture and window curtains (*Window Curtains,* 1978, The Fabric Workshop) (pp. 44–45); Tony Costanzo produces linoleum patterns (*Linoleum,* 1980, The Fabric Workshop) (p. 178); Jean Tinguely constructs fountains; Siah Armajani designs everything from picnic benches to dictionary stands; Tim Rollins + K.O.S. produced dress shirts (*Scarlet Letter,* 1989, The Fabric Workshop) and T-shirts (*By Any Means Necessary,* 1989, The Fabric Workshop) (pp. 88–89); and the painter-sculptor Neil Jenney hopes his design for a baseball cap will be accepted by the New York Mets. Artists' attention to materials regarded as prosaic—as, for example, Ursula von Rydingsvärd's use of felt (*Zosienka's Toast,* 1989, The Fabric Workshop) (p. 180), David Ireland's manipulation of concrete (*Table with Bolt* and *Camp,* 1989, The Fabric Workshop) (pp. 160–63), as well as Jene Highstein's use of ferrocement (*Great Manis,* 1989, The Fabric Workshop) (pp. 164–65)—further indicates an embrace of daily life.

These kinds of projects suggest that in a society that values the bottom line and pragmatism, the only way to sustain Kandinsky's dream of art affecting the general population is with a revamped understanding of the spiritual in art. A declaration by Armajani could represent the intentions of many of the aforementioned individuals: "I am interested in the nobility of usefulness." Thus, instead of painting Christ carrying the Cross or an abstract composition filled with some palpable presence, the revisionist hopes to touch humanity by enhancing everyday life. In other words, some artists are thoroughly integrating their works with the material world in the knowledge that it dominates contemporary thinking, and only by starting there can something elevated beyond the material world emerge.

At The Fabric Workshop, one observes this truly contemporary vision in action. If one were to imagine a Workshop household, one would envision a situation in which most, if not all, things were made in a more imaginative and beautiful way than in quotidian life. The artist who participates in the Workshop joins in the desire to perfect the organism of everyday living, to make a physical object more joyful, fascinating, or playful, to focus on and amplify the commonplace. A sense of abundance exists, the world is full of delight, and a ubiquitous joy exudes from the appurtenances of daily life. Instead of assuming that art must only exist in a museum where it can, with true and appropriate solemnity, uplift our ponderous souls, these artists imbue us with a heightened sense of the physical world around us.

*I am grateful to Joseph Rishel and George Marcus for their helpful suggestions during the preparation of this essay.*—MR

# The Fabric Workshop: Approaching a New Century
## Parallels between 1890 and 1990
David A. Hanks with Mary Dellin

**Frank Faulkner**
*Pea Pods* banner, 1981
Pigment on cotton
sateen with
handpainting (gray
colorway)
Width: 52 inches

From our vantage point in the final decade of the twentieth century, it may be timely to consider the history of handcrafted textiles as an important aesthetic alternative to mass production. Today, through creative experiments at The Fabric Workshop, artists and craftspeople collaborate in the invention of handprinted-textile techniques offering rich possibilities for the new millennium. But what historical perspective can shed light on this current, vital Fabric Workshop undertaking? Although there are several precursors,[1] no exact prototypes for The Fabric Workshop exists. However, William Morris's revival of handprinted-textile techniques in late-nineteenth-century England provides some surprising parallels. In fact, comparisons in general between society in 1890 and 1990 offer many striking similarities.

Americans and Europeans at the end of the nineteenth century experienced a duality of optimism and fear at the prospect of the future. Their viewpoint is surprisingly similar to our own as we face the coming century. One hundred years ago a great dichotomy existed within society itself, with extremes of wealth and poverty, education and ignorance. Similar contrasts were evident in the decorative arts. While monied classes preferred elaborate furniture and objects, reform artisans attempted to bring art to everyday life. Paradoxically, mass-production techniques encouraged both the proliferation of elaborate ornament and the manufacture of simple furniture.[2] Eventually, the Industrial Revolution's promise of benefits to society, such as cheaper goods for the masses, became clouded by its accompanying ills. Urban congestion, poverty, pollution, and shoddy merchandise seemed the terrible price of industrial progress. Nostalgia for the simplicity of an earlier age became widespread.

Against this backdrop such theorists as the British historian John Ruskin suggested a direction for the future. Maintaining that the proper moral relationship between art and society had existed in medieval guilds—where workers, skilled in every aspect of their craft, could exercise freedom of expression—Ruskin accused the Industrial Revolution of stifling man and society through the compartmentalization of labor:

*And the great cry that rises from all our manufacturing cities, louder than their furnace blast, is in all in very [sic] deed for this—that we manufacture everything there except men; we blanch cotton, strengthen steel, and refine sugar, and shape pottery; but to brighten, to strengthen, to refine or to form a single living spirit never enters into our estimate of advantages.[3]*

Ruskin's solution was the rejection of the machine and an advocacy of handcrafted goods. His crusading theories had a profound influence on the British textile designer William Morris and his circle, the acknowledged leaders of the Arts and Crafts movement. In their quest to elevate textile art to its highest aesthetic potential, in their zeal for recreating and improving handprinting techniques, and in their desire to use design for the betterment of humanity, Morris & Company provides the most direct parallel to the aims and activities of The Fabric Workshop.

William Morris's credo was "art made by the people and for the people," and he set about producing household textiles that would improve the daily life of the common man. As a socialist who championed the nobility of labor, Morris held a dim view of capitalism, mechanization, and debased mid-Victorian design. As a designer profoundly influenced by the art of the Middle Ages, Morris greatly valued the poetic irregularities of objects wrought by hand. Ironically, his avoidance of the machine resulted in products too expensive for the

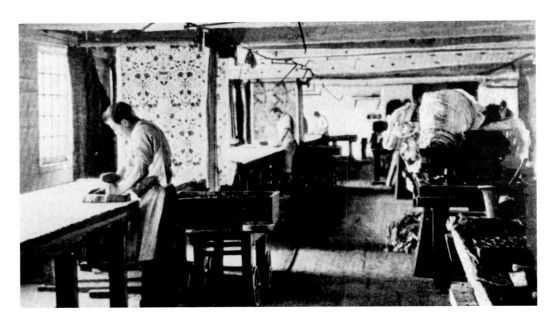

Worker prints cotton at Merton Abbey Works, in England.

masses he wished to serve. Since its inception, The Fabric Workshop has also understood the additional expense of art produced by hand, but it has succeeded in sharing the resulting art with the community through exhibitions, catalogs, and educational programs.

Energized by his political idealism and assisted by a collaborative team of artists,[4] experienced craftspeople, and young apprentices, William Morris applied his artistic genius to extraordinary embroidery, textile, wallpaper, carpet, and tapestry designs for more than thirty years. Inspired by an intimate observation of nature and the study of historical patterns in various cultures, Morris's designs were further enhanced by the application of ancient dyeing, printing, and weaving techniques. After preliminary experimentation in the 1860s and 1870s, Morris led his craftspeople in outstanding textile manufacture, which began at Merton Abbey in 1881 and continued into the next decade.

Among his aesthetic innovations—which often were courageous revivals of forgotten crafts—Morris began experiments as early as 1872 in the production of natural plant and animal dyestuffs. Elsewhere, these dyes had been commercially abandoned for cheaper and more facile chemical aniline dyes. Morris's objection to the garish colors and rapid fading of anilines[5] was eloquently expressed in his 1889 Arts and Crafts lecture "Of Dyeing as an Art":

*It must be enough to say that their discovery while conferring the greatest honour on the abstract science of chemistry, and while doing a great service to capitalists in their hunt after profits has terribly injured the art of dyeing, and for the general public has nearly destroyed it as an art. Henceforward, there is an absolute divorce between the* commercial process *and the* art *of dyeing. Anyone wanting to produce dyed textiles with any artistic quality in them must entirely forego the modern and commercial methods in favour of those which are at least as old as Pliny, who speaks of them as being old in his time.*[6]

In any age, the printing of textiles by hand is a labor-intensive process. Certainly, Morris's revival of the technique of surface block printing at Merton Abbey was considered unusual in late-nineteenth-century England, where mechanized roller printing had become the dominant method. To achieve the greater aesthetic results of handprinting, a

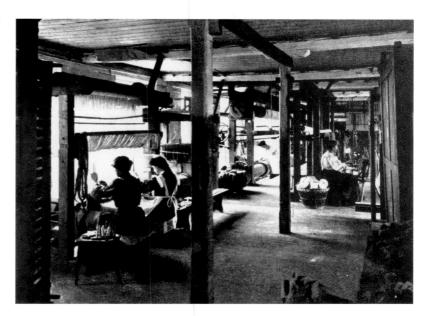

The tapestry looms at Merton Abbey Works, 1881.

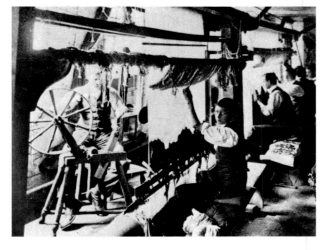

Boys weaving on loom at Merton Abbey.

As with Morris & Company a century ago, today's Fabric Workshop is a collaborative creative enterprise, bringing together artists, craftspeople, and apprentices in a common artistic endeavor. Since its inception, The Fabric Workshop has shared Morris's dedication to producing the highest quality textiles, and has supported the additional expense of art produced by hand.

The advanced chemistry and scientific testing of the modern age provide the twentieth-century craftsperson with a greater variety of pigment and dye options. Although these improvements have reduced the dependency on natural dyes, artists at The Fabric Workshop often favor the greater color receptivity and fine tactile character of natural cottons and wools—the only fabrics available to Morris & Company in its day. With a wider choice of fabrics available today, however, manmade synthetic materials are selected when they can best achieve a desired effect.

Of particular significance, the aesthetic goals of each artist at The Fabric Workshop can be realized without focusing on issues of cost or marketing. Sometimes, traditional techniques are employed—such as the occasional use of discharge printing, as in Morris's day—with updated chemicals and improved ventilation. Other techniques have

series of woodblocks was required, each block intricately carved for printing a different color of the design.[7] Registration was accomplished by pins projecting from the blocks that printed tiny dots of color. Cloth stretched out on tables ran the length of the shop. A "printer" loaded dye onto his block from a dye pad resting on a mobile trolley, and impressed it onto the cloth by rapping it with a mallet (known as a mall). This process was repeated, color by color, until the length of cloth was complete. To control the drying time, the shop was kept moist and warm—sometimes by boiling teakettles.[8]

Master printer
Elizabeth McIlvaine
(right) and Margo
Schriber print
Schriber's design. Left
background: Former
Workshop director
Emily Wallace (1987–
89) gives a tour to a
group of senior citizens.

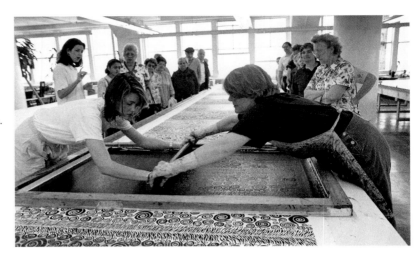

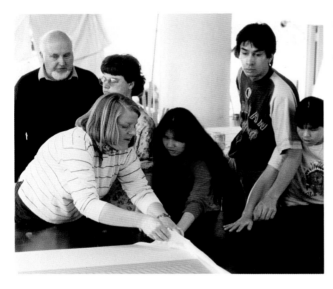

Registrar Elizabeth
McIlvaine explains
photo process printing
to a group from the
Overbrook International
School for the Blind.

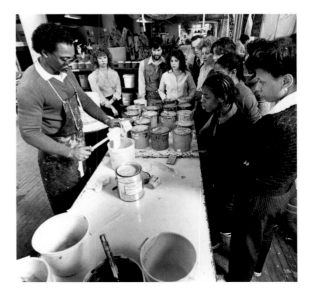

Master printer Robert
Smith (left) demon-
strates color mixing to
a high school tour.

existed for decades, such as photo silkscreening of handpainted images; but many entail considerable experimentation and invention, and these receive vital support for development. Recent Fabric Workshop innovations that have produced spectacular aesthetic results include the utilization of the paper-printing process of four-color separation for printing on silk charmeuse; the application of sprinkled dirt to screened adhesive (p. 66); and the technique of open-screened marbling.[9] One can imagine that Morris and his craftspeople would be sympathetic to (and perhaps a little envious of) these contemporary creative possibilities.

Topical issues of health and the environment provide some interesting comparisons between then and now. Perhaps unaware of environmental ramifications, Merton Abbey's textiles were often cleared of dye by washing in the waters of the adjacent river Wandle. More commendable was the use of wind and solar energy in the drying of textiles, accomplished outdoors in warm weather, in the meadow behind the workshops. In contrast, The Fabric Workshop employs only water-based inks. Its refuse is never dumped into the water system but is instead disposed of in sealed buckets. Improved indoor ventilation is made possible at the Workshop by a system of fans that runs along the sides of the worktables.

Many of Morris's artistic intentions can now be witnessed a century later in the mission and activities of The Fabric Workshop. Even a reflection of Morris's social commitment can be observed in the Workshop's educational purpose: Tours are available to the community, and special programs exist for minority apprenticeships. The Workshop is an important avenue for artistic expression and invention, aspiring to the highest aesthetic achievement. Here, as in Morris's Merton Abbey, the tradition of handprinted textiles as a collaborative endeavor and its potential as an art form are being preserved and expanded for the coming generation.

## Notes

1. See Sarah McFadden, "Fabric in Art: An Historical Perspective," in *Art Materialized, Selections from The Fabric Workshop* (New York: Independent Curators Incorporated, 1982).

2. From "Approaching a New Century: American Decorative Arts 1890–1900," exhibition proposal by Marilynn Johnson and David Hanks, 1989.

3. From John Ruskin, "On the Nature of Gothic," in *Stones of Venice* (1853), quoted in *William Morris by Himself, Designs and Writings,* edited by Gillian Naylor (Boston: Little, Brown & Company, 1988), 10.

4. Morris was assisted by several Arts and Crafts artists, such as the painter Edward Burne-Jones, in furniture design, and the architect Philip Webb, in embroidery design.

5. On occasion, Morris did resort to using aniline dyes when they achieved a particular color that he desired—such as the yellow in his last chintz, *Daffodil.* Although natural dyes exposed to light also faded, Morris felt that they faded into lovely, muted versions of the original color. His objection to anilines was that, in fading, they either disappeared or changed color entirely.

6. Quoted by Linda Parry, in *Textiles of the Arts and Crafts Movement* (London: Thames and Hudson, 1988), 39.

7. The cutting of the woodblocks was not done in-house but was contracted to Alfred and James Barrett, London.

8. In his commitment to reviving the technique of indigo-discharge printing, in which cloth is dyed and the pattern "removed" by block printing with bleaching agents, Morris's hands became permanently stained blue—a testament to his devotion to the perfection of process. See Linda Parry's excellent description in *Textiles of the Arts and Crafts Movement,* 36–57.

9. In open-screened marbling, two or more colors are splattered onto the screen. They are printed by drawing small squeegees or spatulas across the image area until all areas are covered with ink. A full-size blade with unpigmented base is then drawn across the screen to clear any residue of color that may cause the colors to blend and become muddy in the next print. Using this technique, each print is unique, and various effects can be achieved.

*We are grateful to Betsy Damos for her helpful technical information in the preparation of this essay.*

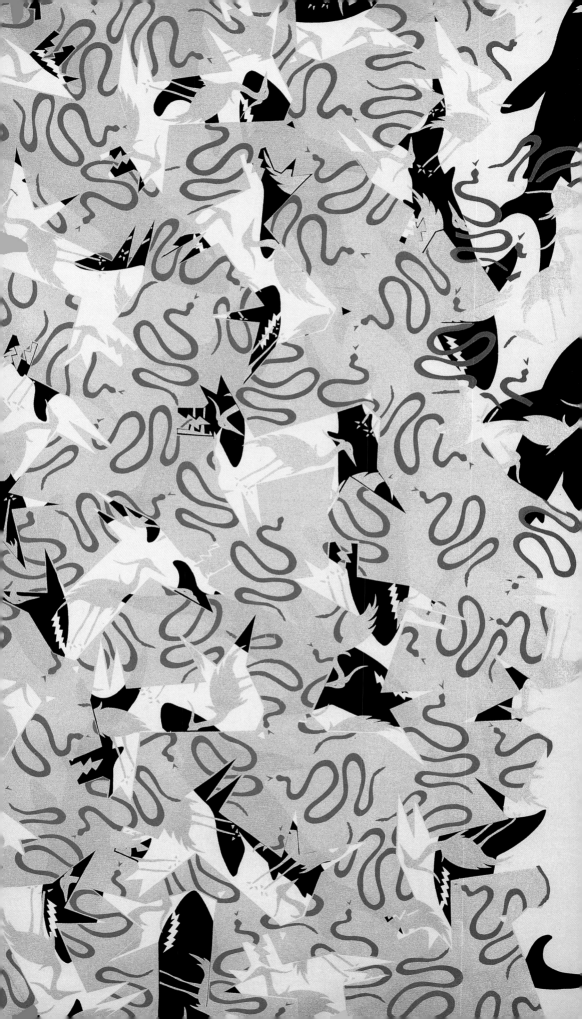

# Making History

A conversation with Marion Boulton Stroud, Anne d'Harnoncourt, and Patterson Sims.

Tina Girouard
*Animals* banner, 1984
Pigment on cotton sateen (peach colorway)
Width: 50 inches
Originally commissioned for ARC International, New York

**Patterson Sims**: When did you start The Fabric Workshop?

**Marion Boulton Stroud**: We began thinking about it in 1976. In the summer of 1977, we had our first painter and performance artist, Robert Kushner, from New York, and our first ceramic artist, Richard DeVore, from Colorado, as well as Sam Gilliam, the painter, from Washington, D.C. By 1978, twenty-two artists had come from around the country, and The Fabric Workshop was under way!

We signed a two-year lease at 1133 Arch Street (p. 191). We had five thousand square feet on the fifth floor of an industrial building, a one-hundred-foot print table, as large a washout sink as could fit in our twelve-foot freight elevator, a sales and office area, a pigment mixing area, and a small studio in the rear for the artists-in-residence. The entire west wall of windows let in beautiful light from the sunsets. The space was formerly Fox Slacks and Trousers, and we were able to take advantage of its industrial furniture, masses of metal shelving, and sewing equipment. In 1977, rent was a dollar fifty per square foot. Since we were directly across from the Reading Terminal Market and the train station, we didn't have to put on a jacket to run across the street. This central location, close to public transportation, benefited the apprentices, artists, and visitors.

Early advice and encouragement came from both of you, Patterson and Anne. You were wonderfully helpful with suggestions for visiting artists, just as Helen Drutt English suggested craftsmen. David Hanks waxed eloquent in our first grant application to the National Endowment for the Arts. Word of the Workshop got around through an opening reception and a benefit, with a hundred patrons eating dinner on our print table, followed by a fashion show with members of the Pennsylvania Ballet as models for emcee-announcer Scott Burton, which was also performed on the print table

(p. 197). Our much-admired mentor, the late Lallie Lloyd, was our first benefit chairman.

**PS**: What were your initial thoughts?

**MBS**: Will it work? Can we educate experienced artists, who know nothing about the process, and inexperienced apprentices, who are eager to help them? We were systematizing an idea through a great deal of trial and error. That first year was both terrifying and exciting.

**Anne d'Harnoncourt**: How did you get the idea? You worked with Prints in Progress [nonprofit community workshops in the inner city, sponsored by the Philadelphia Print Club], but give us a sense of the day it occurred to you that this might be a wonderful thing to do.

**MBS**: When I was artistic director of Prints in Progress, Letty Lou Eisenhauer applied for the executive directorship. After she saw our community art workshop's three-yard fabric printing table, she said, "I've helped make sewn pieces for Claes Oldenburg's store and Roy Lichtenstein's banners, and I know artists would love to do this!" Letty had also worked for the New York State Arts Council and offered to help us by writing our first grant. Letty, Carolyn Ray, Carol Fertig, Mark Thompson, and I began to gather data on how to make it happen. I often dreamt of naming the Workshop "Whole Cloth," because it felt like a story made up out of thin air—a fabrication! Others felt that was too esoteric, and so we all decided on the more straightforward name, The Fabric Workshop.

**PS**: Did you have any models or ideas as you launched the Workshop?

**MBS**: Having done graduate work in art history at the University of

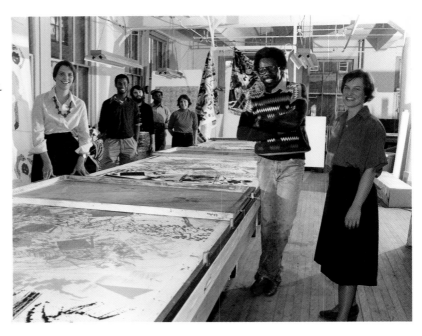

Pennsylvania, I knew of many traditions from which to derive inspiration: William Morris, the Bauhaus, print workshops such as Gemini G.E.L., in Los Angeles; Tamarind, in Albuquerque; ULAE, on Long Island; Ken Tyler, in Bedford, New York; and Crown Point Press, in San Francisco. In the beginning, though, we only thought of how to make it work as a professional print workshop, an industrial process, and an educational resource for young, primarily minority, apprentices. I had had close to eight years of experience with etching, silkscreen, litho, and woodcut printing processes, as well as having helped to form the community print workshop systems for Prints in Progress.

**PS**: Had you been to Gemini? Tamarind? Had you ever been to Scandinavia?

**MBS**: Yes, but we thought about them more intensely once The Fabric Workshop was under way. I went to Key West Fabrics, in Florida, and Marimekko, in Finland, to find out about fabric printed as an industrial process. Later, my friend and first master printer, Lucile Michels, and I went to visit Ken Tyler, one of the founders of Gemini G.E.L., who came east to begin Tyler Graphics print studio in Bedford, New York.

**PS**: What did he tell you?

**MBS**: "You just have to get in there and do it!" Both Gemini and Ken Tyler's studios had continually added new equipment, or even new rooms, to accommodate the suggestions of their artists—Oldenburg, Kelly, Lichtenstein, Stella, Johns, among others. It helped us both to listen more openly to the artists' new ideas.

**PS**: What were your aspirations? You expected it to be a place where artists would come, but what did you imagine they would do when they got there?

**MBS**: Four-way repeat yardage, as the industry requires it. We hadn't anticipated that because they saw a seventy-five-foot table, they'd immediately begin to make large prints. We didn't expect them to use our fabrics in their next exhibition. It was, and still is, extraordinarily gratifying to see what artists can do, and how many simultaneous lives they can give to a piece of cloth.

**Ad'H**: Why do artists occasionally surprise you by having problems with repeat yardage? Is it because they tend to think of their work as individual objects?

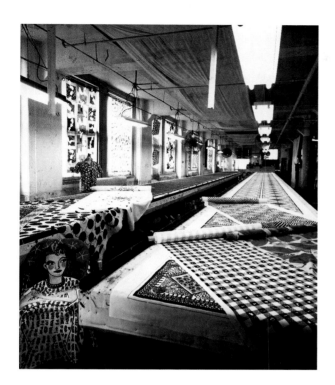

The Fabric Workshop's 1977–88 location at 1133 Arch Street, in Philadelphia.

**PS**: The Fabric Workshop started at a time when pattern and decoration was a dominant movement. It continued into a period when making functional works was a high priority for many artists. Now, the Workshop seems to be entering another phase as it becomes a vehicle for more personal, narrative work. One assumes it will continue to be a viable studio for whatever kind of art is being made at any given time. Who were some of the artists who were best suited to the Workshop experience?

**MBS**: That's a difficult question; some of the most interesting ideas were the farthest afield, coming from artists you'd perceive as the least suitable to the Workshop's facilities and equipment. Initially, you might think you'd want nothing but pattern painters or sculptors, but someone like Richard DeVore, a ceramic artist from Fort Collins, Colorado, who had done contained vessels symbolizing the cosmos, worked very successfully in the Workshop environment. He had the wonderful idea of dipping a sweater in ink and printing the results (p. 41). And Robert Morris thought of rolling a medical school skeleton on fabric (pp. 60, 198)—an idea that might not have occurred to a pattern painter or someone in the textile industry.

Morris's skeleton certainly may have been the first, but it was followed by a number of seemingly unconventional but aesthetically effective pieces. Kim MacConnel used Mexican house-painting rollers embossed with rubber die cuts to create a gold wheat pattern (p. 42). Ken Dawson Little made a suit and dress out of 450 real dollar bills (pp. 22, 158–59). David Ireland used the contents of an old textile factory, along with hand-cast concrete, to create his installation (pp. 160–63, 192); Jene Highstein departed from his usual dense materials, like wood and stone, to create sculpture from luminous, iridescent silks (p. 164); and filmmaker Anita Thacher created an eight-foot-high patterned felt

**MBS**: Yes. Repeat yardage is an industrial process that's new to them. Most of the artists are beginners in the medium, and it takes imagination to predict what something you envisioned as a single image will look like when it's multiplied. Repetition adds meaning and intensity to an image that, by itself, might appear fairly ordinary.

**PS**: Didn't some of the first artists who worked with repeat fabric decide right away to experiment, and weren't some of them very particular about the way the fabric was used?

**MBS**: Yes. Because they spend a lifetime developing their philosophy and style, most artists want to control their work and the context in which it's seen. Therefore, many saw their Workshop efforts as print multiples that could be presented and considered as art. The pattern painters were extremely successful at that, and eager to do it.

The contents of this former textile factory served as the raw material for David Ireland's 1988 installation *Camp*.

David Ireland in *Camp*, his 1988 installation at The Fabric Workshop. The Mangels—Debbie, Susan, and Larry— look through the tent window.

house, and used its windows to project shadow images on the gallery walls (pp. 150–51). Donald Lipski used the American flag in every way possible (pp. 102–3, 170–71, 193); he said he was decorating, not desecrating it. That, too, seems like an appropriate idea for an artist to have at this time.

**PS:** You are highly visible in the creative process but absolutely invisible in trying to direct it.

**MBS:** The artists, printers, and I continually discuss what's possible, given what we've got to offer and what the artist wants to make.

**PS:** Do the best artists make the best prints?

**MBS:** Yes. Established artists who have previous printmaking experience have used silkscreen to their own purposes faster than the younger artists. Although they may have had prior experience with intaglio and relief printing, instead of silkscreen printing, if the artists have been to another print workshop, they generally have a better idea of what the print staff expects of them. For instance, color fall-ons and registration are also common aspects of paper and fabric printing. Prior knowledge or experience helps them feel more confident the first time they come into our studio; however, their ideas may *not* be the freshest.

**PS:** Are there artists you dream of having work here who haven't yet participated?

**MBS:** Oh, yes, the list changes every year—for that matter, every day. Surprisingly, though, artists you expect to say no often say yes. The type of artist that wants to come also changes. The imagery being produced and the issues being explored now are very different from when we first began—or are they? They may have come full circle; who knows?

**Ad'H:** There is no profile of the ideal Fabric Workshop artist. The point is that you can't predict ahead of time

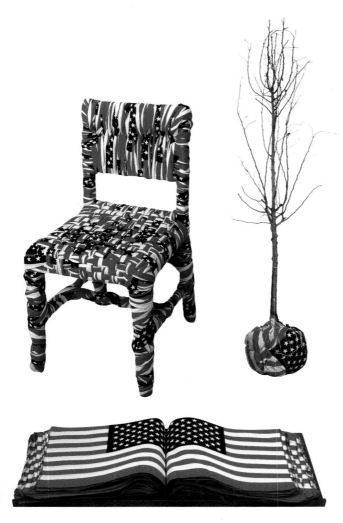

who will do something wonderful, or who will do something that arises from a great idea but isn't as successful in actuality, or who will do something that no one thought would work and yet turns out to be terrific.

**MBS**: We've been extremely misunderstood in that sense; we're never what any one person perceives us to be. The minute they think we're working with conceptual artists, we're involved with a pattern painter. The minute they think we're working with a pattern painter, we're dealing with a ceramist. Then we're off with a photographer or an architect. It's this variety that results in such a range of products.

**PS**: What role has Philadelphia, and your location in it, played in The Fabric Workshop?

**MBS**: A major and formative influence in my life was the architect Louis Kahn. He taught a master class at the University of Pennsylvania's Graduate School of Fine Arts. Kahn liked to ask, "What does a building want to be?" Since then, I've tossed that question around, admired it, responded to it, lived with it. We've said to the artists and apprentices when they come to the Workshop, "Why do you want to make a fabric? What does it want to be? What are your reasons for making the cloth? What's it going to be—a gallery piece, a chair, a pillow, a dress, an umbrella? If an umbrella, then it must function as an umbrella." We try to use what the Workshop offers artists—both a finished object and an industrial process.

Philadelphia offers a great deal to visiting artists: the Philadelphia Museum of Art, the Pennsylvania Academy of the Fine Arts, the Barnes Foundation, and many other arts institutions. We spent eleven years next door to the Reading Terminal Market, which always fascinated our visitors. For many artists, coming to the Workshop gives them a chance to concentrate without interruptions. The artists find that with the help of the staff and apprentices, many hands make light work.

**Donald Lipski**
*Who's Afraid of Red, White & Blue? #13,*
1990
Muslin flags wrapped over chair
33½ x 16½ x 17½ inches

*Who's Afraid of Red, White & Blue? #30,*
1990
Pear tree, cotton flags
132 x 36 x 36 inches

*Who's Afraid of Red, White & Blue? #25,*
1990
Ring binder with muslin flags
34 x 14 x 2½ inches

*Lipski's imaginative reconstructions of the flag were partly motivated by his response to recent attempts to legislate its usage. A strong advocate of artistic freedom of expression, Lipski asserts that "you can make art out of anything in the world." His flag series was also a natural outgrowth of his longtime interest in subjecting found objects to a playful series of structural permutations that expand their metaphorical resonance and interpretive possibilities. It is from the application of a cool, essentially formalist methodology to the presentation of a highly charged image that this work derives its power.*
—Paula Marincola

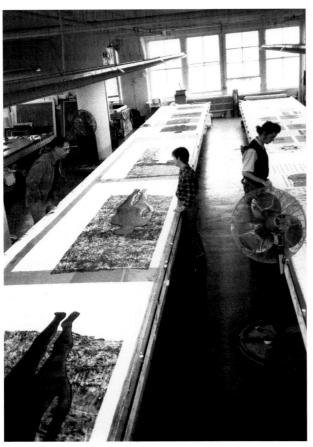

Alan Stone and master printer Betsy Damos work on his project at the Workshop, 1987.

**MBS**: It was an integral part of our origin, since community arts and printmaking with inner-city youth had been my background. Will Stokes, Jr., who began as an apprentice and is now a resident artist, has enjoyed popular and artistic success (pp. 10, 52–53, 123, 216). We've had many other apprentices, from all over North America as well as Europe, Asia, and Africa (p. 9).

When young artists finish school, it's often hard for them to resolve the philosophies in their own work. This has been a place for apprentice printers to learn from mature artists, to see what the struggle takes, and to evolve an artistic philosophy. For instance, a young woman who had been a seamstress at the Workshop recently visited from England. She's now making conceptual clothing. It was gratifying to see how her work had developed and to hear her say that her inspiration first came from making a jumpsuit here for Scott Burton. That is a strong and rewarding part of the program.

**Ad'H**: I'm intrigued by artists who use fabric to imitate substances like linoleum or brick or old-fashioned black-and-white school notebooks. Does that spring out of an individual artist's method?

**MBS**: It was in the air. Trompe l'oeil was just one way of experimenting. Scott Burton's *Window Curtains*, in 1978, was our first (pp. 44–45).

**Ad'H**: It wasn't one type of artist who had that approach?

**MBS**: Not at all. Tony Costanzo, a ceramic artist from the Bay area, did linoleum floor tiles (pp. 135, 178). Robert Venturi's *Notebook* fabric is the product of an architect's vision (pp. 29–31).

**PS**: Does the interest in trompe l'oeil reflect a particular sensibility that occurs at the Workshop?

**MBS**: No, many more artists did *not* do trompe l'oeil; it was only one aspect of a Workshop residency. Just as many made print multiples: Mike Kelley (p. 92), William Anastasi (p. 11), Lynda Benglis (p. 64), Robert

The Workshop gives Philadelphia's curators and collectors a chance to meet our artists-in-residence and to see work that might otherwise be inaccessible to them. We also have tours coming from places other than Philadelphia, such as the Museum of Modern Art, the Whitney Museum of American Art, the Seattle Art Museum, the Denver Art Museum. The Workshop's been a great American meeting place.

**Ad'H**: To see Philadelphia artists intermingling with their counterparts from around the country and overseas is impressive. The Philadelphians, both apprentices and artists, have made a strong contribution to the accomplishments of the Workshop. The apprentice program has no equivalent at Gemini or other large-scale artists' ventures; presumably, it came out of the Workshop's origin as an inner-city, job training program.

Examining a swatch
test to determine color
accuracy before
printing the lining for
Luis Cruz Azaceta's
*Acid Rain* coat.

**MBS**: Yes. Picasso said he always
wanted to see as if through the eyes
of a child, because children see with-
out preconceptions, biases, or theo-
ries. Our goal is to work with artists
who bring few preconceptions to the
medium. We try to understand their
existing work, and then determine
how we can best express it for them.

**Ad'H**: The Workshop has been a
great adventure. Everyone has
stretched themselves to accommo-
date the artists' inspirations.

**MBS**: There have been difficult
technical projects: Chuck Fahlen
tried to print on a large needlepoint
grid; Michael Singer printed with
glue instead of ink and flocked it
with New York dirt (pp. 66–67);
Jene Highstein stretched fabric over
a steel armature like a lampshade
(p. 164); Robert Blackburn skillfully
made silkscreen look like a litho
process; and Luis Cruz Azaceta's
coat lining used the rainbowing
technique with fluorescent pigments
(pp. 86–87).

**PS**: If an artist has a technical prob-
lem, how does he or she deal with it?

Morris (pp. 60–61, 198), Roy
DeForest (pp. 72–73, 122), Tina
Girouard (p. 43), Roy Lichtenstein
(pp. 50–51), Louise Nevelson (pp.
138–39), Robin Winters (pp. 76–
77), Ned Smyth (pp. 48–49), Faith
Ringgold (p. 84), Tim Rollins +
K.O.S. (p. 88), Red Grooms (pp.
152–53), and Pat Steir (p. 70),
among others. There are many who
created luxurious print yardage, like
Frank Faulkner (p. 182), Matt Mulli-
can (p. 91), Michael Kessler (p. 94),
Kim MacConnel (p. 42), John Moore
(p. 112), or Robert Kushner (p. 36).
Trompe l'oeil is just one direction
that the medium was able to take.

**PS**: How free are you to let artists
explore?

**MBS**: As free as our time, talents,
and financial backing allow. We're
eager to solve new problems and try
new techniques and new materials.

**PS**: Is that openness one of the
hallmarks of the Workshop?

**MBS**: We work problems out by
talking, testing, and trying other
solutions. For Nancy Graves we
researched suitcases (p. 121); for
Miriam Schapiro and Alan Stone,
window shades (pp. 55, 194); for
Ursula von Rydingsvärd, felt; for
Robert Venturi, umbrellas (pp. 166–
67, 180, 210); for Ecke Bonk (pp.
96–97) and Luis Cruz Azaceta, how
to waterproof and vinylize their
raincoats. Now, we've started print-
ing wallpaper, and we use umbrella
and necktie manufacturers. What-
ever we need to do, someone has
already done, so we do a great deal
of networking and research to find
out who they are. Also, the printers
spend many hours *being* the artist.
They help by fixing the acetates,
adjusting the screens, suggesting a
change here or there, but always
asking permission, always making
sure that it works within the context
of the artist's work and, often, a
number of proofs are produced in
order to arrive at the best solution.

**PS**: There must also be cases where someone hadn't done it before, someone hadn't printed on that kind of fabric in quite that way.

**MBS**: Rarely is any artist's work a straightforward, commercially viable piece. Tina Girouard, for example, printed on preprinted and metallic fabrics rather than fabrics that had been prepared for printing (pfp) (p. 43), and Chuck Fahlen used commercial puff inks on industrial felt (p. 46). In order to get exact background fabric colors for the Alan Stone window shades, we table-dyed the white fabric. We've also revived techniques no longer used in this country such as discharge and Japanese paste resist. Robert Whitman, in his *Black Dirt* performance piece, used an extremely fine photo detail and a 230-threads-per-inch mesh screen pieced together in a shirt to form a seamless image (pp. 144–45). And Christopher Wool used stencils on oversize silk. In the early days, we gave a lot of thought to how we could print fabric as well as the industry had, as well as what it could become after printing. Only now are we realizing—as with the Robert Venturi pieces—that often we can print it even better than some of the commercial places we've used. We use industrial techniques, such as the stop-and-rail system for printing yardage, and we utilize back grays when necessary. We have setups similar to the commercial places, but we spend more time achieving the desired results.

**Ad'H**: Is there anything you wish an artist would try?

**MBS**: Of course, but we listen to the artists' ideas and try to make them happen, rather than forcing the artist into the Workshop's system. We have the staff—seamstresses, artist, and printers—interacting throughout the whole process.

**Ad'H**: I was thinking of a secret, unexpressed desire, not something you had actually suggested. My question may have to wait to be answered in the work of the next artist who walks in.

It interests me that the Workshop has flourished at a time when artists of all kinds are dealing with the useful, the everyday, the inexpensive. One of the things I take pleasure in is the possibility of something being made that's not expensive—a thing people can use, sit on, or wipe their mouths with after a great spaghetti dinner, then toss in the washing machine. The artists who've worked here and done some of the particularly useful things get a great kick out of thinking that what they've designed and made is in the world in a way that a painting, piece of sculpture, or unique object cannot be, because only one person or one institution can have it at a time. For example, Italo Scanga's napkins or Robert Venturi's umbrellas.

There's a populist feeling to the Workshop that's very appealing. Did the artists initiate the idea of doing useful objects? Did they come to the Workshop wanting to make something utilitarian, or did it occur to them while they were here?

**MBS**: Both. Craftsmen in particular had no inhibitions about their work being useful. Jun Kaneko and Betty Woodman, for example, were very willing to do things like canvas bags and tablecloths they'd use every day. Some painters and sculptors were apprehensive that their birthright might be stolen if they made something useful, that it wouldn't possess the mystique of an art object a museum might wish to acquire. It was much harder for them to do a common object; it took great courage.

**PS**: Your selection of artists has evolved in an interesting way. At first, you worked with artists who didn't really have an association with the functional or craft, and then you moved on to those designated as craft artists. Now, you've broadened to include architects. Was it a conscious decision to try to relate the things you produce to the functional world?

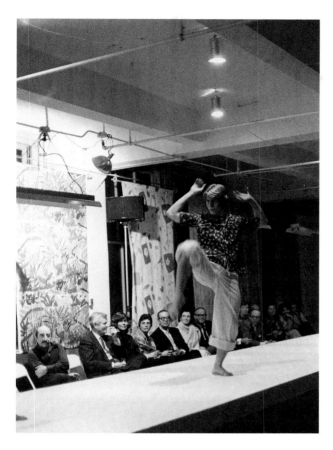

Jeffrey Gribler, of the Pennsylvania Ballet, performs in a shirt designed by Richard Tuttle at the first Fabric Workshop benefit, 1979.

**PS**: You've been producing a good deal of a fabric created in 1983 by Robert Venturi, called *Grandmother* (p. 24), for which you've had many requests. Even as I speak you look anxious, because so much time is required to produce it. But isn't that what you want?

**MBS**: Yes and no. We're happy with the demand for the fabric, but we'd like to have it produced by rotary screen printing. Bob Venturi has given a tentative yes, and recently we've been looking at this process with a commercial printer. But roller printing doesn't reproduce the subtle nuances and the color changes in those pastel rosebuds that reminded Venturi of his grandmother. Commercial houses can't get the colors the way we can; only Venturi's color mixer or our own print staff seem to be able to produce it with the right color intensity. With handprinting, we're able to preserve the bloom, which is a beautiful characteristic of the handprinting process. It's a real dilemma; we're thrilled whenever we can use mass-production processes, but we also have to keep very close tabs on work done out-of-house. The commercial houses aren't always as demanding in their quality control, and they often let the colors or materials vary without telling us.

**MBS**: All of our textiles are commercially viable and set up as an industrial process so that they can be repeated. Just as the world can own that number seven Shaker rocker, Fabric Workshop textiles are produced for sale.

**PS**: One of the interesting dilemmas of the Workshop is that while it allows for the production of functional materials, it's hard for those functional materials to find their way into the world—or it's taken a long time to figure out how to get them out there. Is that a concern of yours, or a concern expressed by artists?

**MBS**: Oh, yes. As Bob Kushner said, "Anything worth doing is worth doing poorly." Our ability to mass-produce has been poor. We tend to produce limited amounts of yardage because we're immediately on to the next project. At present, we don't have the resources to focus on both aspects at once.

**PS**: At the Workshop, there's always been that push-pull of how to keep the yardage in the inventory moving and, at the same time, keep the artists' new projects going. It's a fairly ingenious—

**Ad'H**: Not to say desperate—

**PS**: Yes, desperate enterprise. But I've always thought that your heart was in the new—in what's coming next rather than the successes of the past.

**MBS**: I don't think you can give yourself too much time to reflect; you have to live in the present. We try to do the best possible work with the artists who are here now so they can experience the Workshop to the fullest. Production often takes time away from that.

The human skeleton that was used to print Robert Morris's *Restless Sleeper* dries in the washout sink, 1981.

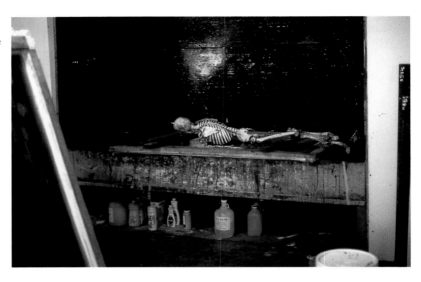

Production is very much a part of the Workshop process, but to the staff it's one of its strongest educational tools. Some of the freshness of our designs is based on the fact that they aren't the most commercially viable. For instance, we would never force an artist to produce a fabric that has a multi-directional pattern layout if it was not compatible with the intended concept. Artists do want to see their work in production, however, and the best way we can do that is by selling it in art museum shops, where it's seen by a receptive audience that may not be able to afford the artist's paintings or sculpture but can purchase a big umbrella, T-shirt, necktie, napkin, or silk scarf (pp. 2–3, 114–37). An industrial production house wouldn't touch some of these pieces because they demand too much work, too much time, and the repeats are too big and, of course, the quality of production is much too expensive to recover any profit. We've never forced the artists here to work within the confines of what a rotary screen machine can do, which on the Stork machines at New London are twenty-five and one-quarter, twenty-eight and one-half, thirty-two, or thirty-six-inch modules. Someone called to note that Venturi's fabric can't be made into wallpaper because it doesn't line up on the selvages. We were sorry to hear that, and we could certainly put it into repeat for him if we had the time or money, but we're already on to our next project.

**PS**: Has the industry changed in terms of what can be printed and how?

**MBS**: Very much so. And we also see a number of the designs that we know were created here being recycled commercially.

**Ad'H**: One of the fascinating things about the Workshop is the way it affects artists. Have you watched them expand or shift gears because of working here?

**MBS**: We see that happen not only during their residency at the Workshop but in the progression of their careers. After working here, Bob Morris began to use a good deal of silkscreen. The colors in Joseph Nechvatal's new paintings are quite similar to the dyes he used when he handpainted the background for his fabrics (pp. 142–43). Richard De-Vore did pattern textures on his ceramic pieces when, to the best of my knowledge, he hadn't used pattern in his ceramics prior to his Workshop residency. These are only a few examples. There's a continuing dialogue in the subsequent work of all the artists who've worked here.

Partially printed
*Restless Sleeper*
by Robert Morris.

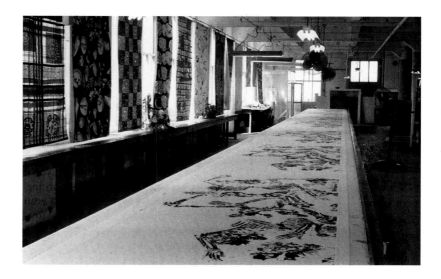

**Ad'H**: Have you ever been skeptical about an artist's ability?

**MBS**: Who would've thought of Bob Morris for textiles?

**PS**: Except that he's a very good artist who takes a creative approach to whatever material he turns his hand to.

**MBS**: Yes, but there are many other artists you'd think of first because their art has the look of a textile.

**PS**: Has the Workshop lived up to your initial concept, and how would you like to see it grow and evolve?

**MBS**: Certainly, as any teacher says about her students, the artists and the apprentices have made things happen that we didn't think possible. I've been amazed at how far an artist can take something intended only to be a repeat image. This multiplicity started that first year when Robert Kushner (pp. 18, 32, 36–37), Ned Smyth (pp. 20, 48–49, 148–49), Joyce Kozloff (p. 54), Miriam Schapiro (p. 55), Kim MacConnel (pp. cover, 14, 42), and Tina Girouard (pp. 11, 12, 43, 188) all did repeat yardage, which then became print multiples and also sculpture. Ned Smyth's *Philadelphia Pattern Palm* (pp. 148–49) was shown at the Grey Art Gallery and then was quickly bought by the

Ludwig Collection, in Germany. Sam Gilliam did nineteen screens, in 1977, for *Philadelphia Soft* (pp. 34–35). Every second brought a change, a new artist, a new idea.

**PS**: Initially, you saw that fabric could be used as an experimental medium by artists, and that it could have an effect not just on the artist who made that fabric but on the people who assisted in realizing the idea. The Workshop manifests a political impulse as well as an aesthetic one.

**Ad'H**: More precisely, a social impulse.

**MBS**: As a museum curator, what do *you* perceive as the most interesting aspects of the Workshop?

**PS**: For me, it's the range of what's been achieved. Also, the notion that very frequently you're asking artists to be creative in ways that are new to them.

**Ad'H**: I'm struck, too, by the broad range of the Workshop's production. There are Jun Kaneko's bags, which are very popular; Italo Scanga's scarf (pp. 78–79) and napkins, which are forever functional; the wonderful *Gridley* bag, by California artist Roy DeForest (p. 122), large enough for him to put his own dog in; Kim MacConnel's playful *Polka Dot*

umbrella; Red Grooms's *Mummy Bag,* inspired by his trip down the Nile (p. 118); and Betye Saar's delicate and mysterious duvet cover (pp. 74–75). Anyone can use these objects, but they are unlike anything they've ever seen before. Then there are Robert Morris's terrifying nuclear disaster sheets (pp. 61, 199), from 1981, which really transcend functionality. These works are at opposite ends of the scale, yet they're produced by the same place and, oddly enough, the artists' intentions, in some ways, were probably not so far apart.

I can envision all kinds of artists who'd find themselves challenged by standing in the Workshop with you and the printers, the vast printing table stretched out before them, confronted by the reality that they have to do something: small, large, repeat, unique—*something.*

**MBS**: Professionals in their own field, suddenly they're beginners, students in another. It makes them both nervous and eager to try the unknown.

**PS**: What gave you the notion that artists would be excited to try something new?

**MBS**: When I first started printing fabric myself, I enjoyed the process so much, I assumed they would, too. I also found out that textiles played a part in my family background. In 1899, Alphonse Mucha had his work printed on silk by Stroud and Hines, of London. One of the partners was probably a relative of mine. So, you could say that the Workshop is both revival and survival. It may be genetic but repeat textiles fascinate me, and working with artists is uniquely gratifying.

**PS**: You've said that every person is a textile curator.

**Ad'H**: Did you mean in just the way one buys clothes or furnishes a house?

**PS**: Look around the table and see how many fabrics we've each brought to this conversation. We were talking about the appeal of the objects in the Workshop and how quickly people relate to them, unlike the way they may relate to other kinds of contemporary art. Every single person is his or her own curator when it comes to textiles.

**MBS**: You hold opinions on textiles that you may be slightly more reluctant to express about paintings or prints. You know fabric and use it yourself; you curate your wardrobe every morning when you get dressed and select your necktie, silk scarf, whatever. You are aware of the tactile characteristics or qualities of fabrics although you might not describe them using the more professional term "hand." Fabric comes under much more critical surveillance because it must serve a daily function.

**PS**: Have you ever encountered a Workshop fabric in some very unexpected context?

**MBS**: All the time. You walk around a corner in a museum and see our fabrics on the walls or come across them in the museum shop. You see our work on the street; in the Museum of Modern Art; in Madame Duchamp's home, in Fontainebleau; in a prison art show; and in interior photographs in magazines like *House & Garden, Metropolis,* and *Contemporanea;* you name it. There could be an entire exhibition devoted to Fabric Workshop scraps that were given away to artists, weavers, their children, whomever, and ultimately made into something else.

**PS**: What do you feel when you have one of those encounters?

**MBS**: Very happy that our art is being used and appreciated. The Venturi fabric has found its way everywhere.

**Ad'H**: What about the other uses of fabric—such as being part of a performance or as props? Some artists have used the Workshop's capabilities to do something on a large scale.

Trisha Brown (left) with dancers from the Trisha Brown Company in costumes designed by Nancy Graves (second from left), at the Workshop, 1983.

Shirt: pearlescent white pigment on Swiss cotton
36 x 41 inches
Pants: pearlescent white pigment on Belgian handkerchief linen
43 x 20 inches

**MBS:** Louise Nevelson had wanted to design costumes for an opera since 1930, but when she had presented the designs we eventually did for her, no one would make them. Finally, we printed and constructed about forty opera costumes designed by Louise for the Opera Company of St. Louis's production of *Orfeo ed Euridice* (pp. 138–41), and she was very pleased. She took the scraps and made them into a coat for herself as well, which she wore at her honorary doctorate ceremony at Harvard. Other artists have also used the Workshop for performance or theater, such as Red Grooms and Lysiane Luong's *Tut's Fever* movie theater (pp. 118–19, 152–53). Robert Whitman's *Black Dirt* performances used photowork images of hands, faces, and fingers; he then repeated these images in films and projections. And Nancy Graves's costumes were part of a Trisha Brown Company dance performance.

**PS:** Do you think the Workshop can sustain its level of involvement into the future?

**MBS:** The Workshop has certainly grown with our relocation to a new space. We've expanded the changing exhibitions, added installations, and also developed more experimental uses of new materials while incorporating more techniques such as handmade felt. We also increased printing with dye, which expands the Workshop's capabilities; the retensionable screens provide more technical ability; and the color matching booth (Macbeth box) provides an excellent metameric color match. We've also initiated a visiting curator's program, as well as a museum sales shop and traveling exhibitions. Some examples of our installations have been: David Ireland's *Camp* (pp. 160–63, 192); Ken Dawson Little's "Elements of Progress" (pp. 158–59); Phillip Maberry's *Mao Wow* (pp. 146–47); the touring exhibition "Rain of Talent: Umbrella Art" (pp. 106–11); Gregory Amenoff's priest and deacon vestments for Easter Sunday, Good Friday, and everyday (pp. 98–99, 168–69); and Donald Lipski's "Who's Afraid of Red, White & Blue?" (pp. 102–3, 170–71, 193).

**PS:** In the early days of the Workshop, when you frequently came to New York, I was always startled; it seemed like every two weeks you had a new artist in Philadelphia and had attained a very high level of productivity. It may be exactly the same now, but something about those early years always struck me as very heroic and amazingly energetic. Has becoming more of an institution affected your capacity to work at the level of energy and imagination that you did in those first years?

Director Richard
Siegesmund (left) and
visiting curator Ruth E.
Fine prepare a slide
lecture for *Let's Play
House* at The Fabric
Workshop, 1990.

Textile conservator
Margaret Fikiorius
(left) and Megan
Granda give a cleaning
demonstration.

Registrar Megan
Granda (foreground)
demonstrates proper
archival storage
techniques for an
apprentice.

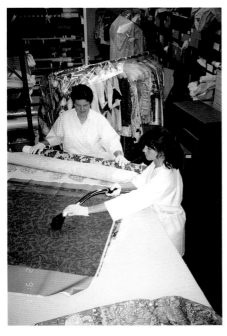

Master printer Mary Anne Friel tests pigments in the Textile Conservation Laboratory during her residency at the Smithsonian Institution, which was sponsored by the Mid Atlantic Arts Foundation.

**PS**: If you compare the last five years of the Workshop's production to the first five, you see more narrative and figurative content. Today, the artists are making pictures as opposed to repeating patterns.

**MBS**: Artists want more philosophical, content-oriented statements. They are also more interested in large-scale projects. They want a whole room for their installations. These installations use more space and incorporate new materials, such as those in Gregory Amenoff's wall mural or David Ireland's *Camp*. For Jene Highstein's *Great Manis* sculpture installation, we used ninety-seven bags of concrete! Then there's Donald Lipski's eight-foot American-flag ball and proposed twenty-five-by-twenty-five-by-twenty-one-foot pair of silk organza red, blue, and brown flags for the entryway of the Corcoran Gallery of Art (pp. 170–71).

**MBS**: Yes, because we now have more than one mission. We're not just sitting down to print with artists for the first time—we're also a museum, a gallery, an archive, and an educational force in the city. We sometimes wish, though, that we could lock ourselves in a room, forget the past, and get a fresh start, with no phones ringing, no interruptions, just pure concentration on the creative process.

**Ad'H**: It's really the problem of a continuing avant-garde. At a certain point, you realize that no matter how adventurous you have been, the next phase of the adventure will have a different base.

**PS**: Are you still as involved in the actual production of fabric?

**MBS**: Of course; even more so. It's a complicated situation we can't do without; we feel that the young generation of apprentices, printers, and artists should be allowed to have those fresh experiences and develop from them. Production printing is very much a part of the apprentice training program.

**Ad'H**: Yet, I have the feeling that many artists now working in an abstract way could still make strong repeat patterns. It's not an idea that's run dry. Harry Anderson's repeated images of small objects of various kinds in *Harry's Hunt* (pp. 2–3) work beautifully, and even if they have a narrative or sentimental or affectionate content, they're also fairly abstract.

**PS**: Given the strength of the Workshop's concept, what's keeping its products from being acquired by museums?

**MBS**: Even today, textiles are not as accepted by the museum world as much as we would like them to be. Perhaps that's because we're so many things; we've brought so many different artists together that museum curators may think that the work belongs to some area other than their particular field. Textiles are also difficult to sell as art because of their impermanence.

**Ad'H**: It may also reflect an ambivalence on the part of the artists as to where the work belongs. Is it part of their next gallery show? Is it part of the next show in a museum? Or is it a private creative experiment?

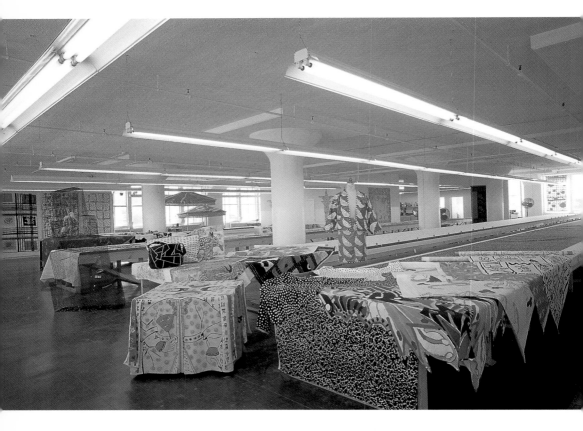

The Workshop's location at 1100 Vine Street, Philadelphia, March 1988.

**PS:** But you've had a lot of acceptance for museum exhibitions.

**MBS:** Some museums have purchased fabric or objects for their collections—the Philadelphia Museum of Art, Montreal Museum of Decorative Arts, Art Institute of Chicago, to name a few. The umbrella show will have traveled to at least nine museums, the first of which was New York's American Craft Museum (p. 111). The United States Information Agency has asked us to organize an exhibition that will travel to Africa. The Museum of Modern Art included Rebecca Howland's *Toxicological Table* (p. 120) in its "Committed to Print" show. We've also had shows that traveled to Wales, Italy, France, and Germany, and we regularly loan individual pieces to artists for their exhibitions at galleries and museums internationally. Yes, we are happy to see the work get out in the world.

**Ad'H:** As a museum director, I covet what the Workshop produces. It's easy for me to think of acquiring them. Once they're in a museum collection, though, there will always be an ambiguity about where they belong; the textile curators believe they are textiles, while the print curators consider them prints. And if they're unique objects, the curators will want them in the department of twentieth-century art.

**PS:** No matter when they're made, or by whom, textiles and costumes are often the stepchildren of museum collections. It seems to be harder to get funding for the research and conservation needed in those sectors. For instance, the Wadsworth Atheneum's costume collection may be as great as its Old Masters. But we know more about its Old Masters.

**Ad'H:** It works both ways. The Metropolitan has a costume institute whose openings and shows have been better attended than some of its great exhibitions of baroque paintings.

**PS**: The Workshop's prints may be in many museums, but they're in the museum store as opposed to the galleries or storage vaults.

**MBS**: Or in the closet. But not in a frame or Plexiglas box on the wall. We've responded by becoming our own museum, complete with archives, and organizing our own traveling exhibitions.

**Ad'H**: The question is, where do you want to be? Workshop productions are as likely to be seen being worn by the man or woman waiting behind a counter, or as napkins on the restaurant table, as hanging on a gallery wall. These display possibilities work in your favor.

**MBS**: We want to keep on being as creative as we can and let others worry about where the objects will fit into history.

**PS**: But one of your central concerns has been in keeping the right kind of repository and record of your products. For instance, have you kept all the screens you've used over the years?

**MBS**: We've kept the acetates and we have all the fabric samples stored on acid-free tubes with tissue paper and muslin (p. 202). We're doing everything we can to preserve the Workshop's pieces and keep a comprehensive archive.

By 1984, we knew we were producing a major body of work that needed to be cared for, just as any museum would. Our collection, moreover, was not limited merely to textiles. Ceramists had donated complete dinner sets to be exhibited with their tablecloths and napkins. We had artists' glass works and drawings. Scott Burton selected a specific double-hung window with panes, the identical size of the trompe l'oeil panes in his fabric design for curtains. Ken Dawson Little produced plaster body casts of himself and his wife for the production of the suits and dresses in "Elements of Progress." And with each new artist the collection grows.

The Workshop has sought out conservators from the Philadelphia Museum of Art, the Smithsonian, and Winterthur to advise on the best procedures for handling such an eclectic and open-ended collection (p. 202). We now have archival files for the acetates and Mylars, which are the primary record of an artist's time at the Workshop. We've built a special movable roller-rack system for storing bolts of fabric. And we've also designed a computer data base for cataloging the collection.

**PS**: As you said, you are your own museum while you're also functioning as a workshop and gallery.

**MBS**: Definitely. But I still don't think printing on textiles is widely accepted as an art form. When Tamarind started a lithography workshop in this country, it wasn't easily accepted. We're in that position today.

**PS**: It presents an interesting curatorial problem. Do you hang a wonderfully printed T-shirt next to a print? The challenge is for the curators who like Workshop things, yet don't quite know how to categorize them, to determine the answer. The Workshop may or may not like what the curators decide to do, but the options are wide open.

As you look down this room, what memories come back to you?

**MBS**: My memories are mostly of the visiting artists—encouraging them to do the project, meeting them at the train or the plane or the bus, making them feel at home, trying to introduce them to the Workshop experience, and, above all, learning from them. It's those moments of learning about and coming to understand their work that have been so vital to all of us here. There's always an exciting sense of renewal when the next new artist walks in the door!

# Glossary
Betsy Damos

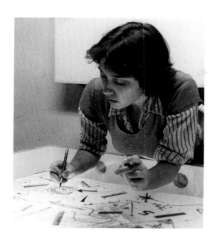

**Judy Rifka**
*Museum Wallpaper*
banner, 1983
Pigment on cotton
canvas; also printed
on unbleached cotton
muslin
Width: 52 inches

Master printer Lucile
Michels works on
frosted acetate (film
positive) with India ink.

**acetates** (Mylars, Melinex, film positives) Clear or frosted plastic films containing the image to be transferred to a photoscreen. The image is either opaque or of red film (Rubylith), each of which will block the light from the photo emulsion coating on the screen. Acetates can be produced photographically, by handpainting, by cutting red film from a clear backing (p. 209), or by adhering found objects or other opaque, flat material to the film. Handpainting is often done on Mylar (manufacturer's name in the United States; Melinex in England), since it remains very stable when exposed to humidity and temperature changes.

**aniline dyes** Early synthetic dyes for which the chemical base was aniline. Aniline was first obtained from indigo; later, from coal tar. These dyes are now becoming obsolete.

**art deco architecture** *Art deco* is a term coined in the 1960s to describe the style that originally was called art décoratif. This name was taken from the international exhibition held in Paris in 1925, the Exposition Internationale des Arts Décoratifs et Industriels Modernes. Characterized by a hard edge and angular composition, it was applied to forms of architecture and object design, primarily during the 1920s and 1930s. Among the artists working in this style were Jacques-Emile Ruhlmann and Jean Puiforcat, in France, and Donald Deskey, in the United States.

**art nouveau** A design style of the late nineteenth and early twentieth centuries characterized by elaborate, flowing lines and ornament derived from nature. Some of the artists contributing to the art nouveau movement were Louis Comfort Tiffany, in the United States; Hector Guimard and Emile Galle, in France; and Alphonse Mucha, in Czechoslovakia.

**Arts and Crafts movement** Beginning in England in the mid-nineteenth century and continuing into the early years of this century, the movement was motivated by social, moral, and aesthetic values. Its early participants, which included **William Morris** (see **William Morris** for other early English proponents), stressed handcraftsmanship to allow freedom of creative expression, to produce useful objects of quality, and to improve the quality of life. Some later contributors to the movement were Charles Robert Ashbee and C. F. A. Voysey, in England, and Gustave Stickley, in the United States.

**back gray** A plain, absorbent fabric (usually cotton) placed on the printing surface when necessary to absorb excess dye or to protect the printing surface from dye. Historically, in the textile industry, this was **gray goods**; hence, its name.

**Bauhaus** An influential art and design school established in 1919 at Weimar, Germany. It moved successively to Dessau in 1925 and Berlin in 1932 before being closed by the Nazis in 1933. Numerous accomplished artists worked and taught at the Bauhaus, including the director, architect Walter Gropius; architect Marcel Breuer; and painters Wassily Kandinsky, László Moholy-Nagy, and Josef Albers. Artists working at the Bauhaus weaving workshop, among them Gunta Stölzl, the technical master and form director at the Dessau location, and Anni Albers, developed influential designs for industry. They emphasized economy

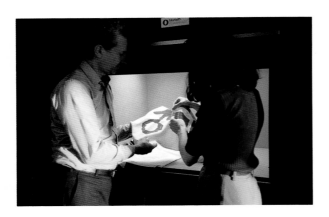

Sculptor Tom Marioni and master printer Mary Anne Friel demonstrate the use of the color-matching booth, in which new dye and pigment color matches can be evaluated under specified light sources.

in the use of materials, moderation in color range, and the relationship of design to the technical process of weaving.

**block printing** (of textiles) Early hand method of printing textiles using a woodblock. The image was raised while the surrounding area was carved away. Large areas were often outlined in wood and filled with felt to absorb color evenly for improved printing. Fine lines were achieved with strips of copper or brass imbedded in the block, creating a narrow, raised printing surface.

**bloom** A desirable, lively quality of the colors in a handprinted fabric, usually lost in **roller printing** due to the crushing of the surface during the printing step.

**color matching booth** (Macbeth Spectralight: trade name) A cabinet in which control samples and new match samples can be compared in various selected light sources (p. 208). This provides a consistent light source situation and identifies **metamerism**.

**colorway** One of a group of alternative combinations in which a given pattern is printed.

**direct blockout** A method of applying an image to a printing screen by painting directly onto the screen mesh with a substance that will block the mesh (p. 209). This produces a negative image in the resulting print. Substances not soluble in

the print paste can be used in this one-step process. For instance, glue can be used with solvent-based paste and lacquer or shellac with water-based paste.

To produce a positive printed image, a fugitive substance is used for painting on the **silkscreen** mesh. A permanent material is then **squeegeed** over to fill the remaining screen openings. Finally, the fugitive substance is removed, leaving open mesh in the painted or drawn areas. Combinations of glue and shellac, glue and lacquer, tusche and glue, litho crayon and glue, and rubber cement and glue can be used in this multistep process. There are also other commercially prepared blockout products available.

**direct photo emulsion technique** A versatile method of applying the stencillike image to the screen. The emulsion coating applied to the screen develops and becomes hard when exposed to light. Emulsion blocked from the light washes away, leaving open areas in the screen mesh (p. 213). When exposing the emulsion to light, a light-blocking film positive is placed between the light source and the screen. The light-sensitive chemical in the photo emulsion is usually ammonium bichromate (a light-sensitive salt) or a diazo compound.

Images on the film can consist of painted ink, pencil, litho crayon, red film (Rubylith), opaque paper, or flat, opaque objects such as leaves, ribbon, lace, etc. Film positives can also be produced photographically; these appear as full-size, reversed negatives.

**discharge printing** A method in which a chemical is printed onto a previously dyed fabric, destroying the color in the printed area. Selected **dyes** from specific dye classes must be used for the dyed grounds in this process. This produces a white image on a colored ground.

Some dye colors from other dye classes can be added to this same print paste to act as replacement, or peg, colors. This produces a colored, or illuminated, discharge print. The removal of the ground and the fixation of the new color take place

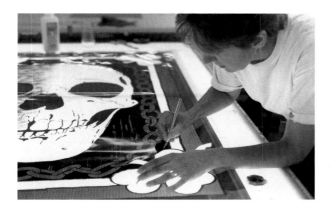

Betsy Damos cuts a film positive from Rubylith film.

A high school apprentice applies a thin coating of photo emulsion directly to the screen to block unintended pinhole openings prior to printing.

the plate is inked, wiped clean on the surface, and printed from the recessed areas. Traditionally thought of as a paper printing technique, etched copper rollers were the basis for **roller printing** of fabric. Engraved copper plates were used in the eighteenth and nineteenth centuries and occasionally in the twentieth century for fabric printing.

**fall-on** (overlay) An area in a print where two or more colors overlap to create an additional, different color. Infinite combinations are possible. A simple example would be printing a yellow screen over a blue screen to achieve green.

**Fortuny** (Mariano Fortuny, 1871–1949) Born in Spain, he spent much of his life in Italy. An innovative fabric and fashion designer as well as painter, engraver, and stage-lighting and theater designer, he is known for a variety of work, including uniquely dyed, printed, and pleated textiles and clothing. Fortuny was influenced by a wide range of sources, from Venetian Renaissance designs to those of the Middle East.

**four-color separation** A technique commonly used in offset **lithography** and other color printing on paper. The colors in the image are separated into four components: magenta, cyan, yellow, and black. This separation takes place by means of photographic filters or laser scanning. A **halftone film** is produced for each of the colors. Each color is printed separately, creating all intermediate colors (orange, green, purple, brown, etc.) as they overlap in different quantity mixes. Although traditionally a paper-printing technique, four-color process printing has also been used for fabric printing. See Italo Scanga's scarf, *Cubist* (p. 79).

**Frank Furness** (1839–1912) A major figure in post–Civil War architecture in Philadelphia, the city in which he was born. In an era of European influence on American architecture, Furness's buildings were enriched with an eclectic mix of style, colors, textural materials, and exuberant,

after printing in the subsequent steaming process.

**dyes** Colorants that are usually water soluble as opposed to **pigments** that are not. They are mixed with water, a thickening agent, and chemicals to form a paste for printing. Dyes become fast during the fixation—usually a steaming process in which the dye enters and chemically bonds with the fiber. Auxiliary chemicals and thickeners are removed in an afterwash step. The appropriate dye and chemicals must be used on each fiber choice since not all dyes will chemically bond with all fibers. The dye classes most commonly used for printing today are reactive, acid, vat, disperse, and direct.

**etching** An **intaglio printing** technique in which a metal plate is coated with an acid-resistant ground, then drawn upon (incised), exposing the metal. The plate is placed in an acid bath that eats away at the exposed metal. During the printing,

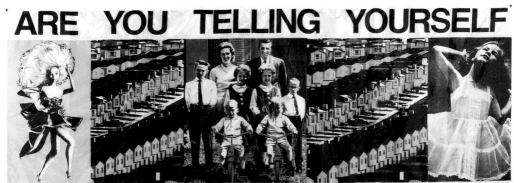

# ARE YOU TELLING YOURSELF A LITTLE WHITE LIE?

**S. A. Bachman**
*Are You Telling Yourself a Little White Lie?*
street banner, 1988
Halftone photographic silkscreen pigment on nylon
60 x 144 inches

Shelley Bachman's banner for public places uses photographic images that were converted to halftone film positive and printed on nylon for use out-of-doors. It has been grommeted at the four corners with reinforced wind-resistant eyelets.

Master printer Christina Roberts rolls and forms handmade felt for Ursula Von Rydingsvärd's sculpture project *Silver Queen.*

detailed ornamentation. Notable among his many fine buildings are the Pennsylvania Academy of the Fine Arts (1871–76), the Provident Life and Trust Company Building (1876–79), and the Library (1887–91; now the Furness Building) at the University of Pennsylvania.

**gray goods** (greige goods) A fabric in the state immediately after construction (weaving, knitting), containing impurities that can be removed later by such processes as desizing, scouring, and bleaching, among others.

**halftone film** A photographically produced film positive containing

the conversion of a continuous image to a dot pattern (p. 210). In a black-and-white image, the dots will be largest in the black areas, gradually becoming smaller in the various gray areas, and nonexistent in the white areas. When printed by a screen in black, this dot pattern will create an illusion of black and shades of gray. In a color image, the film positives for each of the **four-color separations** will contain dots of different sizes controlling the quantity of that color applied in various areas of the print. When magenta, cyan, yellow, and black overlap in various combinations throughout the print, they produce all of the colors in the original image.

**hand** The way a fabric feels to the touch.

**handmade felt** A formed fiber construction rather than a woven or knitted construction. The process consists of bonding or matting loose fibers together using heat, moisture, and pressure (pp. 166, 210). The fiber most commonly used is wool, but other fibers can be combined with wool.

**Industrial Revolution** Covering a broad span of years, approximately 1770 to 1900, it was a period of rapidly increasing economic growth, mechanization, and mass production. For example, the engraved copper **roller printing** machine for fabric printing was developed in the 1780s. It remained the primary mass-

Workshop assistant Maria Rodriquez paints a film positive, showing an irregular jog line.

production machine well into this century, until the **rotary screen** printing machine began replacing it in the late 1960s and early 1970s.

**intaglio print** One in which color is transferred to the print from the recessed areas of the inked printing surface as in an etching. From the Italian, *itagliare*, meaning to engrave, carve, or cut.

**Japanese paste resist** A rice paste that is applied to the fabric, by either printing or painting, to act as a physical barrier between an overdyed or overprinted color and the fabric. The color will not take to the fabric where the paste resist has been applied (pp. 134, 211).

**Yoshiko Wada**
*Shadow Figure,* 1983
Indigo dye and
Japanese rice paste
resist on cotton sateen
82 x 52½ inches

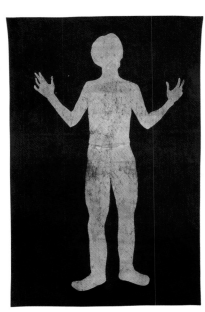

**jog line** A dividing line or break in the **selvage**-to-selvage direction through a pattern intended for a continuously repeating fabric. This guideline is not transferred to either the screen or the fabric. This jog line, however, is necessary when printing continuous yardage with a flat screen; it enables the repeating images to fit together inconspicuously as one printing position abuts the next (p. 211).

The jog line is determined while the images are being put into mechanical repeat, usually on paper, before being put onto the screens. All images between the jog line's first appearance and the location in the print where it repeats again (in the lengthwise direction of the fabric print) are transferred to the screen. In the case of a small repeat, multiples of this area can be placed on the screen. Ideally, the jog line is placed between whole shapes and through the unprinted areas of the pattern. Since each screen for a multicolor print reproduces different shapes from the pattern, jog lines may vary for each color and can pass through areas of the other colors.

**litho (lithography)** Printing method dependent upon the mutual resistance of grease and water. A greasy image is drawn upon the stone or metal plate with grease pencils, lithographic crayon, or liquid tusche. A film of water adheres to the non-image areas. When inked, the greasy areas attract the ink and the wet areas repel it. The inked image is transferred to paper or fabric with pressure.

**metamerism** The effect of a color appearing differently under different lighting conditions. When this results in a good match under one light source but not another, it is known as a metameric match.

**William Morris** (1834–1896) Morris was a major force in the nineteenth century as a designer, poet, and political philosopher. During a period of increased mass production, he sought to restore preindustrial patterns of life in England, based on the use of handcraftsmanship. He

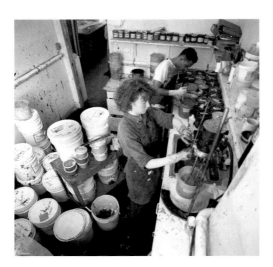

In the pigment room, Christina Roberts and workshop assistant Louis Williams mix colors in a homogenizer for the Kim MacConnel *Polka Dot* umbrella.

strived for a balanced and nurturing relationship between art and labor.

In 1861, with the painters Dante Gabriel Rossetti, Edward Burne-Jones, and Ford Madox Brown, architect Philip Webb, mathematician Charles Faulkner, and engineer Peter Paul Marshall, Morris formed a group enterprise, Morris, Marshall, Faulkner and Company, to produce handcrafted furniture, stained glass, embroidery, tiles, and fabrics. The firm in its collaborative form dissolved in 1875, to be reorganized under Morris's sole management as Morris & Company.

In the years that followed, Morris was a prolific designer of printed wallpaper and fabrics and woven tapestries and rugs. His interest in weaving, dyeing, and cotton printing led to the establishment of workshops at Merton Abbey in 1881, where he experimented with fabric **dyes** and **discharge printing** for the firm's large production of cotton prints.

He is strongly identified with the **Arts and Crafts movement.**

**multidirectional pattern layout** Repeating fabric prints in which equal numbers of like images face approximately in the upward, downward, left, and right directions. This is a layout from which it is economical to cut pattern pieces for use in constructing such functional items as clothing, upholstery, and draperies.

**muslin** A plain weave fabric, of carded but not combed cotton, in a wide range of thread counts (up to 140 threads per square inch). In the heavier sheeting weights, it is available either bleached or natural and in a variety of widths (p. 8).

**natural dyes** Dye colors derived from plants, minerals, and animals. Examples include: dark blue from indigo, orange and green-gold from onion skins, buff from iron, and sepia from squid.

**open-screen marbling** Printing method used to create a marblelike appearance on the fabric. Two or more colors are smeared or splattered into the screen. Small **squeegees** are used to force these areas of color onto the fabric (p. 20). The **squeegees** are usually moved in a variety of directions. The entire screen is then printed with colorless print paste to clear it of color before moving to the next printing position.

**pattern and decoration** Art movement flourishing in the 1970s. It emphasized repetition, ornament, and color. Pattern and decoration artists include Brad Davis, Frank Faulkner, Valerie Jaudon, Joyce Kozloff, Robert Kushner, Kim MacConnel, Miriam Schapiro, Ned Smyth, and Robert Zakanitch.

**pfp (prepared for printing)** Fabrics that have been processed to remove substances present in the **gray goods** state that may interfere with the fabric's receptivity to dye or **pigment**, or that have been physically altered to improve printing. These processes may include singeing, desizing, scouring, bleaching, and mercerizing. Pfp fabric often results in prints with an improved mark (impression), higher color yield, and better fastness qualities.

**photo silkscreen** Printing a photographic image using screenprinting. The **stencil** is transferred to the screen by either the **direct photo emulsion technique** or the indirect film technique.

Christina Roberts
washes photo emulsion
from the silk screen
after exposing Mike
Kelley's *Peat Spade.*

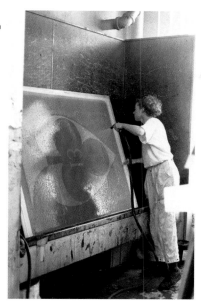

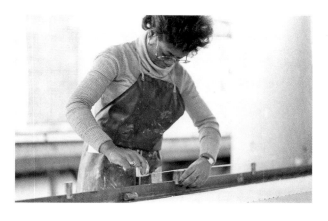

An apprentice positions
and sets the stops
along the print table
rail to register printed
images.

**proofs** The first test prints provided to an artist for approval or modification. When printing continuously repeating images on fabric, the industrial term for this test print is "strike-off." The strike-off is used to evaluate print quality and to approve colors.

**rainbowing** (rainbow roll, blend printing, split fountain, split font) Printing multicolored striped areas of color, each color softly blending with the adjacent color area (pp. 86–87, 195). This is accomplished with one screen, one **squeegee**, and various print paste colors adjacent to one another. A few preliminary **squeegee** passes are necessary to begin the gradual blend of colors.

**registration** The precise fitting of the edges of one printing of the screen's image with its adjacent printing in a continuously repeating fabric. This is accomplished with a stop-and-rail system. A length of angle iron runs lengthwise along one edge of the print table. Metal **stops**, or markers, are positioned along this rail at regular, predetermined intervals (the distance at which the image on the screen should repeat) (p. 213). A metal angle brace attached to the flat, top surface of the screen projects over the rail. This brace is placed against the **stops** as the printing progresses along the table. Every other stop position is printed sequentially in hand screen-printing; the intervening stops are printed when the first set of impressions are dry.

Registration also refers to the correct alignment of numerous colors in a multicolor print. A screen for each color is printed separately and must be positioned precisely. Initially, small cross marks (registration marks) are placed in the same places on each color's film, with the films superimposed in alignment. Correct registration is further controlled by the placement of the image on the screen, the stop-and-rail system, and by two screw eyes attached to the rail side of the screen frame.

**pigment** Finely ground white or colored particles that are not soluble in water. Suspended in a thickened paste to facilitate printing, they are fixed to the fabric after printing with heat, using a thermosetting resinous substance in the paste. Pigment printing is a surface phenomenon—the color bonding to the surface of the fiber, not combining chemically within the fiber as in dye printing (pp. 2–3, 212).

**pop art** Developed most fully in the 1960s, it utilized images from popular mass-culture and commonplace objects. Pop artists include Roy Lichtenstein, Claes Oldenburg, and Andy Warhol.

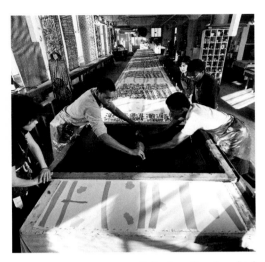

Apprentices supervised by Mary Anne Friel (left) pass a squeegee across the silk screen as they print continuous repeat yardage for Judy Rifka's *Museum Wallpaper*.

**relief print** One in which color is transferred to the print from the raised areas of the inked printing surface, as in a woodcut.

**repeat yardage** Continuously printed fabric, the images repeating in the lengthwise direction of the fabric and, in most cases, also in the **selvage**-to-selvage direction. Repeating units merge inconspicuously (p. 91).

**retensionable screens** Aluminum screen frames constructed with a mechanical ratchet device with which to control a precisely measured screen tension. As the screen mesh is cleared and reused for new images, tension can be increased until it reaches maximum tautness. This high degree of tautness is useful in the printing of a multicolor image requiring tight **registration** of color against color.

**roller printing** Mechanized method of fabric printing, patented by a Scotsman, Thomas Bell, in 1783, and believed to have been used commercially in 1785. The pattern is engraved into copper rollers, and color is transferred from the recessed-image areas when the rollers rotate against the fabric. A roller is utilized for each color printed. This method is appropriate for high-volume production as setup costs are expensive. Today's quickly changing fashion market requires smaller

print runs. For this and other reasons, **rotary screen** printing, with its lower setup costs, has been replacing roller printing.

**rotary screen** (roller screen) Mechanized textile printing method using cylindrical metal screens. The cylinders contain open perforations in the image areas. A **squeegee** within the screen forces color onto the fabric as the cylinder turns in contact with the fabric. This method has been used in this country since the mid-1960s.

**selvage** (selvedge) The two side edges of a fabric running in the warp or lengthwise direction. In a woven fabric, they are usually visible as narrow strips composed of stronger yarns or a stronger, tighter weave. The Workshop prints identifying information (The Fabric Workshop, artist's name, title of print) and the copyright information along the selvage edge. This information is referred to as the legend.

**silk charmeuse** Fabric with a lustrous satin-weave construction on the face and a duller back. Other characteristics are a soft **hand** and excellent drape.

**silkscreen** A printing tool consisting of fabric mesh tautly stretched across a wooden or metal frame and attached to the frame with staples or adhesives, respectively. Some areas of the mesh are blocked; others are open, as in a **stencil**. Print paste is forced through the open areas of the screen mesh with a **squeegee**, producing an image on the material under the screen. Today, this print method is usually called "screen-printing," since polyester and nylon mesh are often stretched on the screen frame instead of silk. Originally used for commercial paper printing in the first part of this century, screenprinting began to be used in the United States in the 1930s to produce printed textiles.

Visiting artist Jill Bonovitz (center) and Mary Anne Friel position a film positive and emulsion-coated screen on the glass surface of a vacuum frame.

**squeegee** In screenprinting, a tool used to force color through a screen (p. 216). It consists of a wide wooden or metal handle, longer than the image to be printed, with a blade of rubber, plastic, or other material affixed to the bottom edge. As the squeegee is passed across the screen, the blade forces an even application of color through the open areas onto the fabric beneath. Squeegee blades of different types (chiseled, square, or round) apply different amounts of print paste with one pass. Dull or unevenly worn blades can be sharpened and leveled.

**stencils** Centuries-old printing tools consisting of a flat material from which the desired image is cut. Color is dabbed through the openings onto a surface beneath. Paper, plastic, or other materials that are impervious to the print paste are used today. The stencil is the forerunner of the **silkscreen**.

**stops** Cylindrical (occasionally square) metal devices approximately one inch in diameter and two inches high. They are slotted on the bottom and fitted with a set screw that can be loosened and tightened with an Allen wrench for moving and positioning on the rail. The stops guide the printers in placing screens for correct **registration** of the print (p. 213).

**table dyeing** Applying continuous color along a length of fabric by **squeegee**ing lengthwise down the fabric on the print table without using a screen. Referred to as table dyeing, although this can be accomplished with either dye or **pigment** paste.

**trap** A slight overlapping of adjacent colors in a print, it is created to avoid a white space. When printing with opaque ink or paste, this overlap usually is not visible; with transparent ink, it may appear as a third color outline.

**trompe l'oeil** From the French, meaning "fool the eye." An extremely realistically painted image, it makes a surface look like something other than what it is (pp. 45, 112, 178).

**vacuum frame** Device used for exposing **direct photo emulsion** screens to light in order to transfer the image to the screen. It consists of a light table with a hinged lid (p. 217). The film positive is placed on the glass surface of the light table and the screen placed on top, mesh side down. The lid is closed and a pump activated to create a vacuum within the frame. This draws the film positive into tight contact with the emulsion-coated screen mesh. The lights beneath the glass are lit for a carefully timed exposure, developing the photo emulsion where the light shines through the clear areas of the film positive. After exposure, the undeveloped emulsion is washed from the screen, leaving open areas through which to print.

**woodcut printing** An ancient paper printing method first used in China and developed in Europe by the fourteenth century. The image is transferred to the print from the surface of a block of wood. The areas not to be printed are cut away or gouged out of the wood. Woodcuts are traditionally cut from the plank side (grain side) of the wood. Prints cut from the end grain surface, popular in the eighteenth century, are referred to as "wood engravings." (See **block printing** for textile printing with a woodblock.)

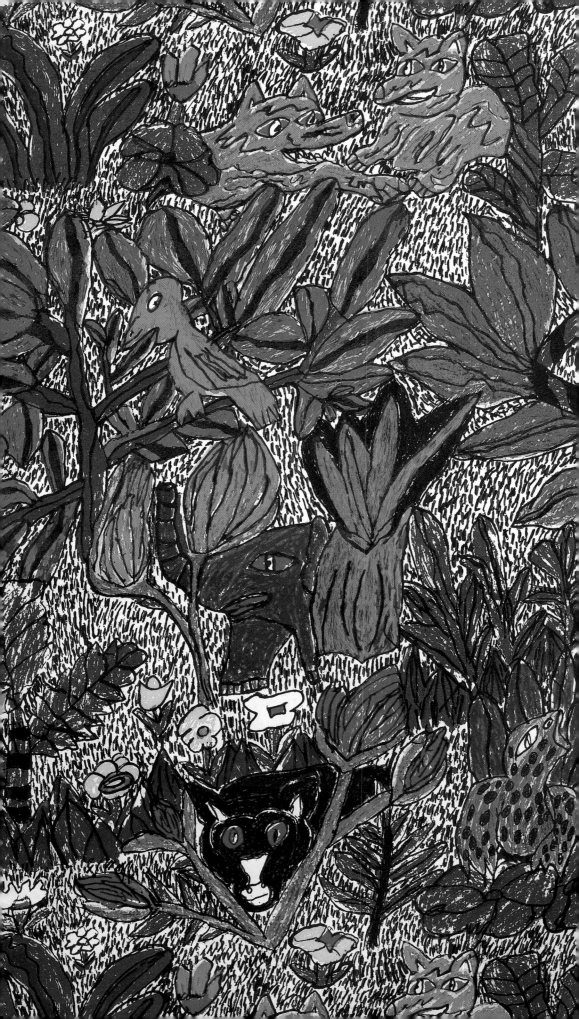

**Will Stokes, Jr.**
*Hidden* banner, 1980
Pigment on cotton
sateen
Width: 50 inches

**Vito Acconci**
Sculptor
b. 1940, Bronx, New York
Lives in Brooklyn, New York

**Phoebe Adams**
Sculptor
b. 1953, Greenwich, Connecticut
Lives in Philadelphia, Pennsylvania

**Adela Akers**
Fiber artist
b. 1933, Santiago de Compostela,
Spain
Lives in Philadelphia, Pennsylvania

**Anni Albers**
Weaver
b. 1899, Berlin, Germany
Lives in Orange, Connecticut

**Jesse Amado**
Sculptor
b. 1949, San Antonio, Texas
Lives in San Antonio, Texas

**Gregory Amenoff**
Painter
b. 1948, St. Charles, Illinois
Lives in New York, New York

**William Anastasi**
Painter/Conceptual artist
b. 1933, Philadelphia, Pennsylvania
Lives in New York, New York

**Harry Anderson**
Glass artist
b. 1943, Highland Park, Illinois
Lives in Philadelphia, Pennsylvania

**Edna Andrade**
Painter
b. 1917, Portsmouth, Virginia
Lives in Philadelphia, Pennsylvania

**Luis Cruz Azaceta**
Painter
b. 1942, Havana, Cuba
Lives in Ridgewood, New York

**S. A. Bachman**
Photographer
b. 1957, Columbus, Ohio
Lives in Collegeville, Pennsylvania

**Ed Baynard**
Painter
b. 1940, Washington, D.C.
Lives in Shokan, New York

**Lynda Benglis**
Sculptor
b. 1941, Lake Charles, Louisiana
Lives in New York, New York

**Steven Beyer**
Sculptor
b. 1951, Minneapolis, Minnesota
Lives in Philadelphia, Pennsylvania

**Bob Bingham**
Installation artist
b. 1953, La Crosse, Wisconsin
Lives in Brooklyn, New York, and
Pittsburgh, Pennsylvania

**Robert Blackburn**
Printmaker
b. 1920, Summit, New Jersey
Lives in New York, New York

**Ecke Bonk**
Draftsman
b. 1953, Frankfurt, West Germany
Lives in Düsseldorf, Germany

**Jill Bonovitz**
Ceramist
b. 1940, Philadelphia, Pennsylvania
Lives in Philadelphia, Pennsylvania

**Richard Bosman**
Printmaker/Painter
b. 1944, Madras, India
Lives in New York, New York

**Louise Bourgeois**
Sculptor
b. 1911, Paris, France
Lives in New York, New York

**Gary Bower**
Painter
b. 1940, Dayton, Ohio
Lives in Charlotteville, New York

**Moe Brooker**
Painter/Printmaker
b. 1940, Philadelphia, Pennsylvania
Lives in Philadelphia, Pennsylvania

**Scott Burton**
Sculptor/Performance artist
1939–1989
Born Greensboro, Alabama
Lived in New York, New York

**Mark Campbell**
Sculptor
b. 1952, Philadelphia, Pennsylvania
Lives in San Francisco, California

**Cynthia Carlson**
Painter
b. 1942, Chicago, Illinois
Lives in New York, New York

**James Carpenter**
Sculptor
b. 1949, Washington, D.C.
Lives in New York, New York

**Rosemarie Castoro**
Sculptor
b. 1939, Brooklyn, New York
Lives in New York, New York

**Dale Chihuly**
Glass artist
b. 1941, Tacoma, Washington
Lives in Seattle, Washington

**William Christenberry**
Photographer/Sculptor
b. 1936, Tuscaloosa, Alabama
Lives in Washington, D.C.

**Peter Coan**
Architect
b. 1946, New York, New York
Lives in New York State

**Robert Colescott**
Painter
b. 1925, Oakland, California
Lives in Tucson, Arizona

**Lillian Concordia**
Printmaker
b. 1945, Philadelphia, Pennsylvania
Lives in Brooklyn, New York

**Houston Conwill**
Painter
b. 1947, Louisville, Kentucky
Lives in New York, New York

**Louise Todd Cope**
Weaver
b. 1930, Ventnor, New Jersey
Lives in Penland, North Carolina

**Tony Costanzo**
Ceramist
b. 1948, Schenectady, New York
Lives in Oakland, California

**Brad Davis**
Painter
b. 1942, Duluth, Minnesota
Lives in Carbondale, Colorado

**Roy DeForest**
Painter/Sculptor
b. 1930, North Platte, Nebraska
Lives in Port Costa, California

**Agnes Denes**
Environmental sculptor/
Graphic artist
b. Budapest, Hungary
Lives in New York, New York

**Richard DeVore**
Ceramist
b. 1933, Toledo, Ohio
Lives in Fort Collins, Colorado

**Mark diSuvero**
Sculptor
b. 1933, Shanghai, China
Lives in Long Island City, New York,
and Paris, France

**Allan Edmunds**
Printmaker
b. 1949, Philadelphia, Pennsylvania
Lives in Philadelphia, Pennsylvania

**Chuck Fahlen**
Sculptor
b. 1939, San Francisco, California
Lives in Philadelphia, Pennsylvania

**Eiko Fan**
Sculptor/Performance artist
b. 1952, Tokyo, Japan
Lives in Philadelphia, Pennsylvania

**Frank Faulkner**
Painter
b. 1946, Sumter, South Carolina
Lives in New York, New York

**Zhou Xiu Fen**
Printmaker
b. 1942
Lives in Tianjin, China

**Rafael Ferrer**
Painter/Sculptor
b. 1933, Santurce, Puerto Rico
Lives in Philadelphia, Pennsylvania

**John Ferris**
Painter
b. 1952, Stamford, Connecticut
Lives in Philadelphia, Pennsylvania

**Carol Fertig**
Creative director
b. 1946, New York, New York
Lives in New York, New York

**Howard Finster**
Artist
b. 1916, Valley Head, Georgia
Lives in Summerville, Georgia

**Richard Francisco**
Painter/Sculptor
b. 1942, St. Helena, California
Lives in New York, New York

**Helen Frederick**
Paper- and Printmaker
b. 1945, Pottstown, Pennsylvania
Lives in Washington, D.C.

**Viola Frey**
Ceramist
b. 1933, Lodi, California
Lives in Oakland, California

**Carl Fudge**
Conceptual artist
b. 1962, London, England
Lives in New York, New York, and
Philadelphia, Pennsylvania

**James Gadson**
Printmaker
b. 1937, Allendale, South Carolina
Lives in Chapel Hill, North Carolina

**Phillip Galgiani**
Artist
b. 1951, San Francisco, California
Lives in New York, New York, and
Amsterdam, Netherlands

**David Gilhooly**
Ceramist
b. 1943, Auburn, California
Lives in Dayton, Oregon

**Andrea Gill**
Ceramist
b. 1948, Newark, New Jersey
Lives in Alfred, New York

**Sam Gilliam**
Painter
b. 1933, Tupelo, Mississippi
Lives in Washington, D.C.

**Tina Girouard**
Painter/Sculptor/Performance artist
b. 1946, De Quincy, Louisiana
Lives in Cecilia, Louisiana

**Sidney Goodman**
Painter
b. 1936, Philadelphia, Pennsylvania
Lives in Philadelphia, Pennsylvania

**Nancy Graves**
Sculptor/Painter
b. 1940, Pittsfield, Massachusetts
Lives in New York, New York

**Red Grooms**
Painter/Mixed-media artist
b. 1937, Nashville, Tennessee
Lives in New York, New York

**Richard Haas**
Painter
b. 1936, Spring Green, Wisconsin
Lives in Yonkers, New York

**Dorothy Hafner**
Ceramist
b. 1952, Woodbridge, Connecticut
Lives in New York, New York

**Ann Hamilton**
Installation artist
b. 1956, Lima, Ohio
Lives in Columbus, Ohio

**Gaylen Hansen**
Painter
b. 1921, Garland, Utah
Lives in Pullman, Washington

**Suzanne Helmuth**
Photographer/Installation artist
b. 1947, New Haven, Connecticut
Lives in Andover, Massachusetts

**Marcy Hermansader**
Painter
b. 1951, Glen Cove, New York
Lives in Putney, Vermont

**Linda Herritt**
Sculptor
b. 1950, Columbus, Ohio
Lives in Boulder, Colorado

**Jene Highstein**
Sculptor
b. 1942, Baltimore, Maryland
Lives in New York, New York,
and Salem, New York

**Howard Hodgkin**
Painter
b. 1932, London, England
Lives in London, England

**Rebecca Howland**
Ceramist
b. 1951, Niagara Falls, New York
Lives in New York, New York

**Eleanor Hubbard**
Printmaker
b. 1943, Waterbury, Connecticut
Lives in Philadelphia, Pennsylvania

**Margo Humphrey**
Printmaker
b. 1942, Oakland, California
Lives in Oakland, California

**Lydia Hunn**
Sculptor/Performance artist
b. 1946, Philadelphia, Pennsylvania
Lives in Philadelphia, Pennsylvania

**David Ireland**
Installation artist
b. 1930, Bellingham, Washington
Lives in San Francisco, California

**Diane Itter**
Fiber artist
1946–1989
Born Summit, New Jersey
Lived in Bloomington, Indiana

**Luis Jimenez**
Sculptor
b. 1940, El Paso, Texas
Lives in El Paso, Texas

**Fumi Kaneko**
Fiber and mixed-media artist
b. 1942, San Joaquin, California
Lives in Omaha, Nebraska

**Jun Kaneko**
Ceramist
b. 1942, Nagoya, Japan
Lives in Omaha, Nebraska

**Steve Keister**
Sculptor
b. 1949, Lancaster, Pennsylvania
Lives in New York, New York

**Mike Kelley**
Artist
b. 1954, Detroit, Michigan
Lives in Los Angeles, California

**Maurie Kerrigan**
Sculptor/Painter
b. 1951, Jersey City, New Jersey
Lives in Philadelphia, Pennsylvania

**Michael Kessler**
Painter
b. 1954, Hanover, Pennsylvania
Lives in Kutztown, Pennsylvania

**Alexa Kleinbard**
Painter/Sculptor
b. 1952, Abington, Pennsylvania
Lives in Tallahassee, Florida

**Joyce Kozloff**
Painter
b. 1942, Somerville, New Jersey
Lives in New York, New York

**Robert Kushner**
Painter/Performance artist
b. 1949, Pasadena, California
Lives in New York, New York

**Eva Kwong**
Ceramist
b. 1954, Hong Kong
Lives in Mercer, Pennsylvania,
and Kent, Ohio

**Seaver Leslie**
Painter
b. 1946, Boston, Massachusetts
Lives in Wiscassett, Maine

**Roy Lichtenstein**
Painter/Sculptor
b. 1923, New York, New York
Lives in Southampton, New York

**Donald Lipski**
Sculptor
b. 1947, Chicago, Illinois
Lives in Brooklyn, New York

**Ken Dawson Little**
Sculptor
b. 1947, Canyon, Texas
Lives in San Antonio, Texas

**Susan Lowry**
Painter
b. 1953, Philadelphia, Pennsylvania
Lives in Philadelphia, Pennsylvania

**Cassandra Lozano**
Sculptor
b. 1959, San Antonio, Texas
Lives in New York, New York

**Lysiane Luong**
Mixed-media artist
b. 1951, Paris, France
Lives in New York, New York

**Phillip Maberry**
Ceramist
b. 1951, Stamford, Texas
Lives in Highland, New York

**Kim MacConnel**
Painter
b. 1946, Oklahoma City, Oklahoma
Lives in Encinitas, California

**Martha Madigan**
Photographer
b. 1950, Milwaukee, Wisconsin
Lives in Philadelphia, Pennsylvania

**Andrew Magdanz**
Glass artist
b. 1951, River Falls, Wisconsin
Lives in Cambridge, Massachusetts

**Lynn Mandelbaum**
Printmaker/Bookmaker/Painter
b. 1950, New York, New York
Lives in Morrisville, Pennsylvania

**Kirk Mangus**
Ceramist
b. 1952, Greenville, Pennsylvania
Lives in Mercer, Pennsylvania

**Margo Margolis**
Painter
b. 1947, Lawrence, Massachusetts
Lives in New York, New York

**Tom Marioni**
Sculptor
b. 1937, Cincinnati, Ohio
Lives in Berkeley, California

**Graham Marks**
Ceramist
b. 1951, New York, New York
Lives in Bloomfield Hills, Michigan,
and Scottsville, New York

**John McQueen**
Fiber artist
b. 1943, Oakland, Illinois
Lives in Alfred Station, New York

**James Melchert**
Ceramist
b. 1930, New Bremen, Ohio
Lives in Oakland, California

**Miralda**
Sculptor
b. 1942, Barcelona, Spain
Lives in New York, New York

**Juanita Jimenez Mizuno**
Ceramist
b. 1943, Los Angeles, California
Lives in Los Angeles, California

**Mineo Mizuno**
Ceramist
b. 1944, Gifu Prefecture, Japan
Lives in Los Angeles, California

**Jacqueline Matisse Monnier**
Sculptor/Performance artist
b. 1931, Neuilly-sur-Seine, France
Lives in La Chapelle-la-Reine, France

**John Moore**
Painter
b. 1941, St. Louis, Missouri
Lives in Boston, Massachusetts

**Toshiko Mori**
Architect
b. 1951, Kobe, Japan
Lives in New York, New York

**Robert Morris**
Sculptor
b. 1931, Kansas City, Missouri
Lives in Gardiner, New York

**Matt Mullican**
Multimedia artist
b. 1951, Santa Monica, California
Lives in New York, New York

**Robert Murray**
Sculptor
b. 1938, Vancouver, British
Columbia, Canada
Lives in Coatesville, Pennsylvania

**Joseph Nechvatal**
Painter
b. 1953, Chicago, Illinois
Lives in New York, New York

**Louise Nevelson**
Sculptor
1899–1988
Born Kiev, Ukraine, U.S.S.R.
Lived in New York, New York

**Gladys Nilsson**
Painter
b. 1940, Chicago, Illinois
Lives in Wilmette, Illinois

**Pat Oleszko**
Performance and visual artist
b. 1947, Detroit, Michigan
Lives in New York, New York

**Michael Olijnyk**
Sculptor
b. 1956, Pittsburgh, Pennsylvania
Lives in Pittsburgh, Pennsylvania

**Michael Olszewski**
Fiber artist
b. 1950, Baltimore, Maryland
Lives in Philadelphia, Pennsylvania

**Bill Omwake**
Painter
b. 1946, New Rochelle, New York
Lives in Chadds Ford, Pennsylvania

**Izhar Patkin**
Painter/Sculptor
b. 1955, Haifa, Israel
Lives in New York, New York

**Judy Pfaff**
Sculptor
b. 1946, London, England
Lives in New York, New York

**Jody Pinto**
Sculptor
b. 1942, New York, New York
Lives in New York, New York

**Jock Reynolds**
Photographer/Installation artist
b. 1947, New Brunswick, New Jersey
Lives in Andover, Massachusetts

**Jacquie Rice**
Ceramist
b. 1941, Orange, California
Lives in Providence, Rhode Island

**Judy Rifka**
Painter
b. 1945, New York, New York
Lives in New York, New York

**Faith Ringgold**
Painter/Sculptor
b. 1930, New York, New York
Lives in New York, New York,
and La Jolla, California

**Warren Rohrer**
Painter
b. 1927, Lancaster, Pennsylvania
Lives in Philadelphia, Pennsylvania

**Tim Rollins + K.O.S.**
Painter
b. 1955, Pittsfield, Maine
Lives in New York, New York

**Annabeth Rosen**
Ceramist
b. 1957, Brooklyn, New York
Lives in Philadelphia, Pennsylvania

**Alison Saar**
Mixed-media artist
b. 1956, Los Angeles, California
Lives in New York, New York

**Betye Saar**
Mixed-media artist
b. 1926, Los Angeles, California
Lives in Hollywood, California

**Alan Saret**
Sculptor
b. 1944, New York, New York
Lives in Brooklyn, New York

**Wade Saunders**
Sculptor
b. 1949, Berkeley, California
Lives in Brooklyn, New York

**Italo Scanga**
Sculptor
b. 1932, Lago, Italy
Lives in San Diego, California

**Miriam Schapiro**
Painter
b. 1923, Montreal, Quebec, Canada
Lives in New York, New York

**Barbara Schwartz**
Sculptor
b. 1948, Philadelphia, Pennsylvania
Lives in New York, New York

**Denise Scott Brown**
Architect
b. 1931, Nkana, Zambia
Lives in Philadelphia, Pennsylvania

**Warren Seelig**
Fiber artist
b. 1946, Abington, Pennsylvania
Lives in Elkins Park, Pennsylvania

**Judith Shea**
Sculptor
b. 1948, Philadelphia, Pennsylvania
Lives in New York, New York

**Patrick Siler**
Ceramist
b. 1939, Spokane, Washington
Lives in Pullman, Washington

**Michael Singer**
Sculptor
b. 1945, Guadalajara, Jalisco, Mexico
Lives in Wilmington, Vermont

**Kiki Smith**
Sculptor
b. 1954, Nuremberg, West Germany
Lives in New York, New York

**Ned Smyth**
Sculptor
b. 1948, New York, New York
Lives in New York, New York

**Katherine Sokolnikoff**
Sculptor/Ceramist
b. 1949, Los Angeles, California
Lives in Yonkers, New York

**Rudolf Staffel**
Ceramist
b. 1911, San Antonio, Texas
Lives in Philadelphia, Pennsylvania

**Pat Steir**
Painter
b. 1940, Newark, New Jersey
Lives in New York, New York

**Lizbeth Stewart**
Ceramist
b. 1948, Philadelphia, Pennsylvania
Lives in Philadelphia, Pennsylvania

**Will Stokes, Jr.**
Artist
b. 1955, Philadelphia, Pennsylvania
Lives in Philadelphia, Pennsylvania

**Alan Stone**
Sculptor
b. 1943, Fort Smith, Arkansas
Lives in Washington, D.C.

**Marjorie Strider**
Sculptor
b. 1935, Guthrie, Oklahoma
Lives in New York, New York

**Paula Sweet**
Artist
b. Chicago, Illinois
Lives in New York, New York

**Toshiko Takaezu**
Ceramist
b. 1922, Pepeekeo, Hawaii
Lives in Quakertown, New Jersey

**Lenore Tawney**
Fiber artist
b. 1925, Lorain, Ohio
Lives in New York, New York

**Anita Thacher**
Filmmaker
b. New York, New York
Lives in New York, New York

**Rena Thompson**
Fiber artist
b. 1950, New York, New York
Lives in Chalfont, Pennsylvania

**Robert Turner**
Ceramist
b. 1913, Port Washington, New York
Lives in Alfred Station, New York

**Richard Tuttle**
Sculptor
b. 1941, Rahway, New Jersey
Lives in New York, New York,
and Galisteo, New Mexico

**Pamela Vander Zwan**
Photographer
b. 1960, Belleville, New Jersey
Lives in Belleville, New Jersey

**Robert Venturi**
Architect
b. 1925, Philadelphia, Pennsylvania
Lives in Philadelphia, Pennsylvania

**Ursula von Rydingsvärd**
Sculptor
b. 1942, Deensen, Germany
Lives in New York, New York

**Yoshiko Wada**
Fiber artist
b. 1943, Kyoto, Japan
Lives in New York, New York

**Clara Wainwright**
Fiber artist
b. 1936, Boston, Massachusetts
Lives in Arlington, Massachusetts

**Bill Walton**
Sculptor
b. 1935, Camden, New Jersey
Lives in Philadelphia, Pennsylvania

**Phillip Warner**
Textile designer/Painter
1947–1987
Born Clovis, California
Lived in New York, New York

**Jeff Way**
Painter/Performance artist
b. 1942, Waverly, Ohio
Lives in New York, New York

**Carrie Mae Weems**
Photographer
b. 1953, Portland, Oregon
Lives in Northampton, Massachusetts

**Yann Weymouth**
Architect
b. 1941, Coronado, California
Lives in London, England

**Susan Chrysler White**
Painter
b. 1954, Chico, California
Lives in New York, New York

**Robert Whitman**
Theater artist
b. 1935, New York, New York
Lives in Warwick, New York

**James Wines**
Architect/Designer
b. 1932, Oak Park, Illinois
Lives in Rye, New York

**Robin Winters**
Painter
b. 1950, Benicia, California
Lives in New York, New York

**Karl Wirsum**
Painter/Sculptor
b. 1939, Chicago, Illinois
Lives in Chicago, Illinois

**Betty Woodman**
Ceramist
b. 1930, Norwalk, Connecticut
Lives in New York, New York;
Boulder, Colorado; and Florence,
Italy

**Christopher Wool**
Painter
b. 1955, Boston, Massachusetts
Lives in New York, New York

**Lily Yeh**
Painter/Sculptor
b. 1941, Kueizhou, China
Lives in Philadelphia, Pennsylvania

**Isaiah Zagar**
Painter/Sculptor
b. 1939, Philadelphia, Pennsylvania
Lives in Philadelphia, Pennsylvania

**Claire Zeisler**
Fiber artist
b. 1903, Cincinnati, Ohio
Lives in Chicago, Illinois

**Marty Zelt**
Painter/Printmaker
b. 1930, Washington, Pennsylvania
Lives in Roswell, New Mexico

**Barbara Zucker**
Sculptor
b. 1940, Philadelphia, Pennsylvania
Lives in Burlington, Vermont

**Artists participating in the
"Rain of Talent:
Umbrella Art" exhibition**

Luis Cruz Azaceta
Roger Brown
Jeffrey Chapp
Robert Colescott
Warrington Colescott
Houston Conwill
Roy DeForest
Lisa Englander
Dennis Evans
Richard Francisco
Viola Frey
Dan Friedman
Rodney Alan Greenblat
Richard Haas
Edward Henderson
Robert Kushner
Charmaine Locke
Michael Lucero
Phillip Maberry
Kim MacConnel
Miralda
Jeffry Mitchell
Don Nakamura
Gladys Nilsson
Jim Nutt
Ed Paschke
Martin Puryear
Vicki Scuri
Alan Shields
Buster Simpson
Jean Stamsta
Will Stokes, Jr.
Anita Thacher
Robert Venturi
Carrie Mae Weems
Karl Wirsum
Betty Woodman
George Woodman
Claire Zeisler
Rhonda Zwillinger

**Phillip Maberry**
*Four Seasons* banner,
1982
Pigment on cotton
sateen (autumn
colorway)
Width: 50 inches

**Dilys Blum** is curator of costumes and textiles, Philadelphia Museum of Art.

**Betsy Damos** is a sculptor who has designed and taught fabric printing for twenty-five years. She is coauthor of the chapter on fabric printing in *Screenprinting*, published by Holt, Rinehart & Winston.

**Mary Dellin,** an associate at the consulting firm David A. Hanks & Associates, served as exhibition coordinator for "Frank Lloyd Wright: Facets of Design," at the Chrysler Museum, Norfolk, Virginia, November 1990–January 1991.

**Anne d'Harnoncourt** is the George D. Widener Director, Philadelphia Museum of Art.

**Ruth E. Fine** is curator of modern prints and drawings, National Gallery of Art, Washington, D.C.

**Marian A. Godfrey** is program director for culture, The Pew Charitable Trusts, Philadelphia.

**David A. Hanks** established his own art advisory firm in 1980. Current projects for David A. Hanks & Associates include consulting work for the Montreal Museum of Decorative Arts, the Domino's Center for Architecture & Design, and the High Museum of Art.

**Alanna Heiss** is founder, president, and executive director of the Institute for Contemporary Art, Long Island City, New York.

**Janet Kardon** is director of the American Craft Museum, New York City.

**Paula Marincola** is a critic for *Artforum* and the director of the Beaver College Art Gallery, Glenside, Pennsylvania.

**Mark Rosenthal** is consultative curator at the Solomon R. Guggenheim Museum, New York. He has organized many exhibitions, including ones devoted to the work of Anselm Kiefer, Jasper Johns, Jonathan Borofsky, Juan Gris, and Neil Jenney.

**Richard Siegesmund** is a former executive director of The Fabric Workshop.

**Patterson Sims** is associate director for art and exhibitions and curator of modern art, Seattle Art Museum.

**Marion Boulton Stroud** is founder and artistic director of The Fabric Workshop.

**Charles Stuckey** is curator of twentieth-century painting and sculpture, Art Institute of Chicago.